ABSTRACT ART AGAINST AUTONOMY

Abstract Art Against Autonomy gives a revisionary account of abstract art since the decline of formalist paradigms in the 1960s. The narratives of purity and autonomy that ruled avant-garde abstraction in the mid-20th century have been opposed and eclipsed by practices of impurity. Driving this change is a discourse of biological infection that overturns the once-assumed goal of aesthetic autonomy. Cheetham identifies Kazimir Malevich's medical model of the infectious "additional element" as a source for and powerful trope through which to understand recent abstraction in its paradigmatic form, the monochrome, and in its less researched manifestations. He claims that abstract art remains a vital contributor to contemporary culture, but that it performs differently from its predecessors and cannot be adequately assessed without such new models of understanding.

Examining abstract art since the 1960s within a narrative of infection, resistance, and cure provides the opportunity to rethink abstraction's appearances within and beyond its traditional frames of reference. The book links in new ways artists whose work extends and complicates the traditions of abstract art, including Yves Klein, Robert Rauschenberg, Lucio Fontana, James Turrell, Robert Smithson, Gerhard Richter, Christian Eckart, Olafur Eliasson, Peter Halley, Jessica Stockholder, Lydia Dona, General Idea, and Taras Polataiko.

Mark A. Cheetham is professor of art history and director of the Canadian Studies Program at the University of Toronto. A recipient of fellowships and grants from The John Simon Guggenheim Foundation, the Sterling and Francine Clark Art Institute, and the Social Sciences and Humanities Research Council of Canada, he is the author and coeditor of seven books, including *Kant, Art, and Art History*, *The Subjects of Art History*, *The Rhetoric of Purity*, and *Theory Between the Disciplines: Authority/ Vision/ Politics*.

ABSTRACT ART AGAINST AUTONOMY

Infection, Resistance, and Cure Since the 60s

Mark A. Cheetham
University of Toronto

CAMBRIDGE
UNIVERSITY PRESS

CAMBRIDGE UNIVERSITY PRESS
Cambridge, New York, Melbourne, Madrid, Cape Town, Singapore, São Paulo

Cambridge University Press
40 West 20th Street, New York, NY 10011-4211, USA

www.cambridge.org
Information on this title: www.cambridge.org/9780521842068

First published 2006

Printed in Canada by Friesens

A catalog record for this publication is available from the British Library.

Library of Congress Cataloging in Publication Data

Cheetham, Mark A. (Mark Arthur), 1954–
Abstract art against autonomy : infection, resistance, and cure
since the '60s / Mark A. Cheetham.
 p. cm.
Includes bibliographical references and index.
ISBN-13: 978-0-521-84206-8 (hardback)
ISBN-10: 0-521-84206-9 (hardback)
1. Art, Abstract. 2. Art, Modern – 20th century. I. Title.
N6494.A2C43 2006
709.04′052 – dc22 2005031108

ISBN-13 978-0-521-84206-8 hardback
ISBN-10 0-521-84206-9 hardback

For

Elizabeth D. Harvey

Contents

List of Illustrations

Plates

Colour plates follow page 66

Acknowledgments

This book has had a lengthy incubation. Although there have been many moments when I wished I could see a conclusion, the protracted period of research and writing has been fortuitous. Research grants have been instrumental in providing this time, material support, and the confidence to pursue the topics of this book. It is a pleasure to record formally my sincere gratitude to the Social Sciences and Humanities Research Council of Canada, the Canada Council for the Arts, the Connaught Research Fellowship in the Humanities, University of Toronto, and, most recently, a publishing subvention from the University of Toronto that allowed Cambridge University Press to include colour reproductions in this book.

The opportunity to present my ideas publicly has been both a benefit intellectually and a pleasure. My thanks to the many interlocutors at York University, Toronto; Florida State University; the Art Gallery of Hamilton; the Art Gallery of Ontario; the Art Gallery of Greater Victoria; the Getty Research Institute; the Cleveland Institute of Art, Case Western Reserve University; Queen's University; McMaster University; the Kunsthaus Graz; and the Institute for International Visual Arts, London. The invitation to deliver the Teetzel Lectures at University College, University of Toronto, in 2004 was a tremendous honour and the catalyst for the final organization of this book. I am also grateful to the editors of *Paedagogica Historica*, the *Art Journal, Canadian Art,* and inIVA's publication series – as well as to the curatorial staff at the Art Gallery of Hamilton, the Art Gallery of Greater Victoria, the Art Gallery of Ontario, and the McMaster University Art Gallery – for permission to incorporate here versions of my ideas that have already been published. Many artists, collectors, and institutions have been both helpful and generous in supplying images for this book: Olafur Eliasson, Peter Halley, Theo and Else Hotz, Ute Mack, David Reed, Gerhard Richter, Michael Snow, the Anthony d'Offay Gallery, and the Lisson Gallery. I remain grateful to Beatrice Rehl at Cambridge University Press for supporting this project under trying circumstances.

For their help and intellectual stimulation, I thank the unequalled graduate and undergraduate students at the University of Toronto, especially Gillian Atkins, Heather Diack, Allan Doyle, Lise Hosein, Nina Kurtovic, Alma Mikulinsky, and particularly Sarah Stanners. Very special thanks to Anete Ivsiņa, whose dedication to this undertaking was matched only by her patience. Artists to whom I owe much for their time, insight, and inspiration include AA Bronson, Lydia Dona, Janice Gurney, Robert Houle, Gordon Lebredt, Ken Lum, An Te Liu, Fabian Marccacio, Demetrio Paparoni, Andy Patton, Jessica Stockholder, Ian Wallace, and C. Wells. Christian Eckart and Taras Polataiko have catalyzed and framed

my thinking about abstraction for many years. The attention to their work here is the best thanks I can give. I also wish to acknowledge Linda Browne, Françoise Boudreau, and Burt Konzak for their specialized expertise and the encouragement unique to true karate-ka.

I have been equally engaged and supported by the academic, museum, library, and gallery communities, especially Mark Antliff, Lisa Baldissera, Alan Bewell, Norman Bryson, Adam Budak, Erin Campbell, Margaret Dikovitskaya, Barbara Edwards, Margaret English, Mitchell Frank, Serge Guilbaut, John Hatch, Linda D. Henderson, Jane Huh, Linda Hutcheon, Michael Hutcheon, Denise Kera, Geurt Imanse, Elizabeth Legge, Hans Lücke, Mary Markou, Kobena Mercer, Marc Mayer, David Moos, Joanne Morra, John O'Brian, Jerry Onuch, Richard Rhodes, Jared Sable, Marquard Smith, Heinz Stalhut, Drew York, Mark Wieczorek, and Aida Yuen Wong. David Carrier has discussed and challenged the arguments I present here for more than a decade now, always with exemplary insight and generosity.

As it has been for more than twenty-five years and across the terrain of many projects, my deepest gratitude is to Elizabeth D. Harvey, to whom I dedicate this book.

ABSTRACT ART AGAINST AUTONOMY

1 Past to Present

A Diagnosis of Recent Abstraction

For us painting has become a body in which are laid out for inspection the painter's motives and state.

Kazimir Malevich[1]

The I, that expresses itself, is apprehended as an ego; it is a kind of infection *in virtue of which it establishes at once a unity with those who are aware of it, a spark that kindles a universal consciousness of self.*

G. W. F. Hegel[2]

The all-purpose picture plane underlying . . . post-Modernist painting has made the course of art once again non-linear and unpredictable . . . It is part of a shakeup which contaminates all purified categories.

Leo Steinberg[3]

One of the few viewpoints shared by the general public and the art world elite today is skepticism about abstract art.[4] Those in the know often see abstraction's heyday as past, as a vestige of high modernism. Almost synonymous with painting, it must be "over" in what Arthur Danto denotes famously as our posthistorical art world. In the public sphere, however defined, abstraction has never made sense or been accepted. At one extreme are the controversies over Barnett Newman's *Voice of Fire* (1967), purchased by the National Gallery of Canada in Ottawa in 1989 to great public consternation, and what amounted to the trial of abstraction before and after the removal of Richard Serra's 1981 *Tilted Arc*'s from its site in Manhattan (Senie). Equally revealing of habitual prejudices is the frequency with which abstract art is the locus of debate, scandal, and outright vandalism. Less vigorous but nonetheless indicative of the resistance to the form is Komar and Melamid's jocular *Most Wanted/Most Unwanted* painting project, in which the latter category is routinely and predictably filled by an abstract work to the extent that this pattern seems normal and receives almost no commentary. I return to the humorous and the disturbing aspects of abstraction's reception: both are important to the narrative I construct. But first a larger question: why would anyone compelled to understand recent visual culture focus on this apparently discredited form? Why, in the face of such resistance, am I undertaking a study of recent abstract art? My overarching

aim is to provide paradigms of abstraction's history since the 1960s that capture what I see as its ongoing innovations and vitality. Abstraction has not proved to be, as W. J. T. Mitchell prematurely forecasted in 1987, "a monument to an era that is passing from living memory into history."[5] I agree that grand narratives in art history seem to be over, or at least suspended, as Danto (1997), Belting (1987), and Lyotard (1984) have argued. In the case of abstraction, however, it is only the commanding narrative of purity and autonomy that has been opposed and eclipsed successfully. Abstraction remains not only empirically "on the ground" – there have been and continue to be a great numbers of small and large exhibitions of this work – or in retrospective dialogue with its avant-garde roots but also a vital contributor to contemporary art and culture. You might ask what this form can offer if art history's Hegelian paradigm of progress is short-circuited. The story of abstraction's supposed triumph in purity and autonomy in the middle of the 20th century does end, ironically, in the need to see abstraction (as a paradigm of "art") as a thing of the past in a Hegelian manner. Instead, I understand recent abstraction as an inevitably ongoing epidemiological discourse of infection and cure. To oversimplify, abstract art for some time has reacted to purity with impurity; the driving force of this change is a metaphorical practice of biological infection that overturns any claim to aesthetic autonomy. This potent story has its roots in contemporary abstract artists' relationships with their pioneering predecessors in the early and mid-20th century, especially Malevich and Klein. The medical discourses supporting and producing abstraction coalesce into a third alternative to the twin poles of 20th-century purist abstraction, both of which have been by turns ascendant and demonized: the transcendent (seen most clearly in Kandinsky) and the formal (epitomized by Greenberg's theories).[6] The medical coordinates of abstraction, however we may see them within the history of the genre, do not themselves seek or reach meta status. They were and remain fundamentally material and organic as they spread from aesthetic spawning grounds to include many contemporary social concerns. Beginning with Malevich's pose as an art doctor and continuing through Yves Klein and General Idea, I emphasize the performative and sometimes optimistically pedagogical aspects of abstraction, a symptom that binds the form to contemporary realities. To phrase this point in the terms I established in the final, rather hopeful, chapter of *The Rhetoric of Purity* in 1991, Paul Klee's impure abstraction is a potent model, if not so much as a historical influence, for the regeneration of the form that I will examine. Mine is also a more positive tale than that of the dangerous analogy between progressive art and disease, which found its nadir in the persecution of those who purportedly produced "Entartete Kunst."[7] Abstraction was central to modernism; it also has a present and a future. The narrative of infection and dissemination that I will trace remains reluctantly tied to the rhetoric of purity but maintains that abstraction should perdure in its pathologies. Aesthetic "cures" are prescribed today, but as critiques and correctives rather than the idealistic social engineering

seen in the days of De Stijl. To understand the range of its tenses and tensions, we can begin with the relationship of current abstract art to modernism in the visual arts.

Modernism is characterized in part by those theories and practices that define art as autonomous. Though some speculate that Luther's iconoclasm was the beginning of its history, an essential separation and specialization of disciplines and artistic media that subtends media and disciplinary autonomy was critical to the Enlightenment and to Kant in particular.[8] The rhetoric of purity served as a motivation and justification for many of the priorities of early 20th-century modernism, particularly in the visual arts, including the high value placed on aesthetic autonomy. As a goal and a working ethos, it was fundamental to the central pioneers of abstract painting (e.g., Mondrian, Kandinsky, Kupka, and Malevich; Cheetham 1991a, 1992); it enjoyed wide dissemination, through both institutional teaching – as in Malevich's case – and by example. The purist tradition reached its apex half a century ago in the United States with high modernist abstraction and in the late Clement Greenberg's formalist art criticism, which was quintessentially purist in its attempt to delimit the proper jurisdiction of painting and other art forms and in its proclamation of abstraction's centrality in this quest.[9] The case with purity is directly analogous to that of autonomy as a goal. Did abstract art ever achieve either state? No. Did it want to? Yes – passionately. In concert with the progenitors of abstract painting, Greenberg looked to a philosopher to legitimate his claims. Where Mondrian and Kandinsky depended on Hegel, for example, and on the Neoplatonics, Greenberg famously invoked Kant – a boundary surveyor par excellence – as his champion. I will have several occasions to insist that he did so in a remarkably Hegelian manner, seeing a Kantian, modern self-criticism as necessary in the evolution of art.[10]

Only recently have we been able to make sense of abstraction in the visual arts outside the chronological and theoretical strictures of modernism. Autonomy and purity as principles of art making, critical evaluation, and historical organization have been challenged successfully in recent decades, not least by a self-conscious tradition of abstraction that was once held to be the epitome of an independent, self-critical modernism. As Briony Fer has rightly insisted (1997, 4) and as a deconstructive reading of early abstraction reveals, elements that work against the hegemony of purity were part of the inception of the discourse and have since gained credence in the work of prominent practitioners such as Gerhard Richter. Although some recent abstraction works consciously with the originary priorities of purity and essence, whether material, formal, or transcendental, I examine some of those strains that resist the paradigm of autonomy and those that do not include the pole of impurity in only a dialectical manner. As I have argued elsewhere, Mondrian and Kandinsky framed abstraction initially in terms of a transcendental purity reflected in a strict formality of means (Cheetham, 1991a). Although they were not absolute purists, there was in the 1930s and

1940s, in France especially, a strongly negative reaction within abstract painting to the limitations of their work (Guilbaut, 1990). A second wave of purism in abstraction took hold mainly in the United States at midcentury in the work of Newman, Rothko, Ad Reinhardt, and especially post painterly abstraction. The containment or isolation of pure abstraction against the encroachments of "theatricality" in the mid-20th century was in retrospect, I believe, a relatively short-lived if central episode in the history of abstraction, not to mention art since the early 1960s. The counterhistory that I am proposing – and there are others[11] – reaches back to Malevich especially. At midcentury, it accentuates alternatives to the second wave of purism, especially Klein's. The practice of impure abstraction also includes Rauschenberg's monochromes of the early 1950s, Fontana, Manzoni, the Zero Group, and others who contributed to what I will claim is a "social" view of nonrepresentational art. Though there are of course prominent exceptions – Bridget Riley, Agnes Martin, and Joseph Marioni come to mind[12] – since the "new abstraction" of the 1980s, most artists who allow their work to be called abstract explicitly disavow autonomy or purity as a means or goal. I consider these and other artists, issues, and works pertaining to recent abstract art under three broad chapter headings: the monochrome, the mirror, and abstraction as infection and cure. My arguments are built on paradigms. Though I discuss a large number of artists and works, many in both categories will be overlooked by design but also no doubt through ignorance. But first I need to establish the heritage and import of a rubric that is especially useful for an understanding of its initial and recent manifestations. This paradigm sees abstraction as an "infection" and "pure" only as the medicinal grade of the antidote. Malevich's remarkable theory of the "additional element" is its foundation. It will find its way into unexpected contexts throughout abstraction's history since ca. 1960.

I. Testing Positive

Malevich's participation in the rhetoric of purity is clear. "Our world of art has become new, non-objective, pure," he wrote in "From Cubism & Futurism to Suprematism: The New Realism in Painting."[13] The Suprematist abstractions of ca. 1914–1918 were correspondingly simple in form and colour. Equally important to the argument I propose here is Malevich's habitual coupling of references to purity with a particular genealogy of artistic movements and artists. Thus the title of this essay maps the changes he wants to theorize: from Cubism and through Futurism in its Russian manifestations we come to the purity of Suprematism. John Hatch demonstrates that Malevich saw his Suprematist compositions as a narrative, almost as a drama that began with the black square and ended with images in which the form shaded off into the nonobjectivity of "zaum" space.[14] The completion of this cycle figured significantly – though not to the exclusion of personal and political upheavals – in Malevich's nearly complete abstinence from art making between ca. 1918 and 1928. Like many other abstractionists of his

generation, he frequently saw the ultimate purity of art in its self-transcendence. Purity in art and the purification of the artist were for Malevich essentials to be taught in the young Soviet society. Reacting against the pragmatism of constructivist art in the new communist schools, he developed an organic theory of art that linked the often philosophical and mystical rhetoric of purity with metaphors of the body, infection, evolution, and parentage.[15] "Professional artistic technological education," he wrote in 1921, "will not produce anything until the spirit of the Communist society becomes organically linked with the artist" (III, 86–7). Uncontextualized, this statement remains obscure (like so many by Malevich). But it is one of numerous applications of his notion of the "additional element"[16] in art, that germ that insinuates itself into artistic practices and determines their morphology. Malevich's difficult but seminal thoughts in "An Introduction to the Theory of the Additional Element in Painting" fundamentally reverse his transcendent impulses and provide an alternative narrative for his work and the future course of abstraction. His vitalist theory of abstraction as disease overturns the rhetoric of purity. Malevich was future oriented – if not exactly utopian – which partly explains his passion for teaching young Soviet artists. He called for new, Suprematist forms in art because the teacher and his or her art must have something new and significant to donate – like a gene – to the future. His "scientific" approach was to isolate in past and present art the "supplementary" or "additional" element. Malevich's notion of the additional element thus offers nothing less than a capacious and responsive interpretive matrix through which to understand change in art, both before and after his own contributions. It drives and exemplifies the purposeful integration of abstraction with surrounding aesthetic and social discourses; in other words, its struggle "against autonomy." In taking his theory of the additional element more seriously than is usually the case and looking at it in greater detail, I elaborate its historical efficacy and offer it as a supplement to other paradigmatic ways that we think about the advent and ongoing life of abstract art.

Like a Suprematist Morelli, Malevich sought the material symptoms of style and change in painting. As director of the State Institute of Artistic Culture in Leningrad from 1924 and as a teacher in what he titled its Department of Bacteriology of Art,[17] Malevich and his associates pursued his research on the sanctioned scientific model. Its collaborators, a formal report states, are "working on the problem of isolating from the whole historical material provided by the spatial arts the successive fundamental systems of painting" (Zhadova, 1982, 318). More specifically, he and his colleagues evolved a practice of aesthetic treatment in which he would administer "doses" of Suprematism, for example, to those students requiring it. The school, Malevich said in a submission to "The Work Plan of the Department of the Painterly Culture for 1926–1927," "considers all painters as medicine considers the sick . . . The Department of Painting of GINKhUK finds that various kinds of illnesses exist in the field of arts, too, that artists also can be

classified according to various kinds of these wonderful illnesses or states, thanks
to which an artist's organism produces one or another form of behaviour, what
we call art or artistic culture. According to their form of behaviour, artists can be
classified as naturalists, realists, geometricians, romantics, lyrical, mystics, meta-
physicians, etc. and prescribed treatment according to the diagnosis."[18] A decade
after the advent of Suprematism, then, Malevich developed an elaborate bacterio-
logical model to explain and affect change in art and as a conveyance for the future
deployment of his own work. "To explore the nature of an artist currently is the
most important task," Malevich said. "That was the basis of his school," remem-
bered K. I. Rozhdestvensky, one of the students. "The first phase of his pedagogy
was a purification from all the influences. The task was to achieve a pure painterly
culture and to bring into it additional elements. At that time it was important,
since we had very many influences from all sides" (Demosfenova, 1998, 13). His
theory of the additional element was based in part on his own familial experience
with tuberculosis and explicitly on the research of Dr. Robert Koch (1843–1910),
the Nobel Prize winner who in 1882 isolated the bacillus of the "white death"
that had caused such widespread suffering and mortality and who established
the then-revolutionary "germ theory" of disease transmission.[19] Koch was also
an innovator in photomicroscopy, whose, magnified images Malevich's draw-
ings on charts one through five most resemble. The medical context of infection
was on the artist's mind for the rest of his life. In a late autobiographical sketch,
for example, Malevich recalled that his first brushes "came from the pharmacy,
where they were used for painting the throats of children who had diphtheria"
(Zhadova, 291). It was one of Koch's pupils who, using his methods, discovered
the bacterium responsible for this disease. On his teaching rounds, Malevich wore
a white lab coat, calling himself the doctor and his students patients. He sought
earnestly to present "the science of 'artistic culture'" (147)[20] in a form sufficiently
rigorous to be accepted in the new Soviet Union. The derivation from medicine
and the biological effect of Malevich's additional element are clear:

> In medicine, a man's condition is explained by the addition, or appearance in the
> organism, of some extraneous element which changes his behaviour. (III, 148) In a
> blood or sputum test, additional elements are found which have some influence on
> the established normal functioning of the organism ... I should like to clarify which
> additional elements have managed to creep into the organism of the painter and
> changed his behaviour. (III, 148)

> The painterly study is similar to a bacteriological analysis clarifying the cause of sick-
> ness ... Koch found in the sickness of the lungs a bacillum which is called the tuber-
> cular bacillum of Koch. (III, 167)

To the analytical and pedagogical end of studying "all deviations in painting just
as one studies disease in medicine" (III, 171), Malevich required that each student
submit a still-life sample for diagnosis and potential treatment. His terminology

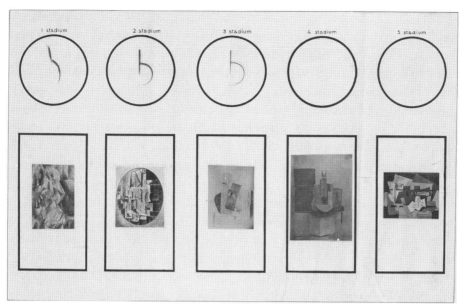

1. Kazimir Malevich, *Analytical Chart*, ca. 1925. Cut-and-pasted papers, pencil, and pen-and-ink on paper. 21 5/8 × 31″ (55.0 × 78.6 cm). Acquisition confirmed in 1999 by agreement with the Estate of Kazimir Malevich and made possible with funds from the Mrs. John Hay Whitney Bequest (by exchange). 821.1935. The Museum of Modern Art, New York, NY, U.S.A. Photo Credit: Digital Image © The Museum of Modern Art/Licensed by SCALA/Art Resource, NY.

is consistently medical; art is understood in terms of diagnosis, incubation, inoculation, and resistance. In one case, for example, Malevich affected what we might now term a genetic modification of artistic predilections. He reports that a student's "nervous system was tuned in accordance with the Cubist law . . . there were instances of an attraction towards the Suprematist straight line, but here I counteracted the development of this attraction by all available means . . . I strove to keep the painter in the pure culture of the Cubist additional element which was developing in him. I isolated him from Futurism and Suprematism . . . As soon as I removed the painterly isolation, his nervous system immediately began to feed on the new additional element, and on the negative of the Cubist system a new form or element was fixed" (179). He describes with pleasure how he performed such "experiments" on those students who were "under the influence of an additional element in a culture of painting," and, critical for my analysis here, he emphasizes that "[I] have reached a result in a positive sense" (172). Malevich prescribed various homeopathic additional elements in different dosages.[21] The straight line of Suprematism was his strongest corrective. His assistants duly recorded these findings on charts.[22] In one example,[23] the progressive changes from Cézanne through Cubism to Suprematism are schematized in circles that mirror the isolating confines of a Petri dish[24] in which different "cultures" may be grown, studied, and purified (Fig. 1).

How literally and how seriously should we take Malevich's unusual and radical theory of the additional element? T. J. Clark counsels that he and even Malevich's students would "soon nod off over [Malevich's] endless wall charts and additional elements. . . . What mattered [instead] was the madness lurking behind the platitudes about Cubism – what mattered were the circumstances in the streets, the soldiers in the streets, the news from Ukraine . . . In a word, what mattered was modernism" (1999, 286–87). I agree that what mattered was modernism. I argue, however, that the theory of the additional element was as genial as it was "mad" and that it derived precisely from and was intimately part of those only apparently extraaesthetic conditions that were in the streets, especially tuberculosis. Instead of nodding off, I propose that we look anew at Malevich's theory of the additional element, and, as a paradigm of its reception and the vitality of abstraction in our own time, at contemporary artist Taras Polataiko's use of his countryman's ideas and images.[25] Because the additional element was explicitly modeled on the behaviour of the tubercular bacillus, abstraction was construed by Malevich as a "disease" and put to work as both poison and cure in the Platonic and Derridean senses of the "pharmakon" (Cheetham, 1991a, 2001). His theory of infection is decidedly and surprisingly positive, both in its inception in artistic, theoretical, and pedagogical practices and in its recent reception via the metaphors and realities of viral transmission.[26] The notion of art itself as an organism that he – ultimately through the discovery and dissemination of the specific added elements of Suprematism – could treat beneficially was entirely affirmative. Even though for him tuberculosis was a tragic reality (he contracted it as a child; his second wife, Sofia Rafalovich, died from the disease in 1925; his friend El Lissitzky was afflicted), a much-publicized killer in the young Soviet Union, it was also a powerful metaphor for the evolution of painting and ultimately a transformative principle that gave art its social promise. His prescribed additional element was a "forming" – not a formal – agent (II, 8, 38). It was that which caused, and through which we can trace, change. This homeopathic, optimistic vision of abstract art stands in contrast to the usual connection between art and pathology in which modern art – and historically, abstraction as its epitome – is seen as a blight to be expunged, as a "degenerate" enemy. "Criticism has attempted to reduce all new forms of art to a whole series of diseases: rickets, psychic sickness, degenerate types, the mentally retarded, epileptics, lots, etc.," Malevich wrote disapprovingly (III, 168).[27] Demonstrating the extent to which he construed his culture in terms of the insinuation of a "bacterium" into the system, he commented with irony on how "society and enlightenment take all measures to disinfect the High Schools from the infiltration of the Futuristic germ" (III, 170). For him the public was by definition unwilling and unable to accept anything new. He proudly adopted the mantle of physician but never hoped that the infectious agents in art would be eradicated: "Here there is an analogy with the Peoples Committee for Health," he wrote in opposition to practices of isolation. This body takes "all measures to

annihilate all possible bacilli, by isolating the healthy from the sick, . . . so that the organism will not be derealized, [so that] that they will not infect the organism. . . . But despite all these hygienic conditions in medicine and in art, there is no possibility of being isolated from additional elements [because] such isolation would mean isolation from being" (III, 170). Disease keeps abstraction alive.[28]

One key to understanding the positive spin of Malevich's theory of infection is his theory of analogy, critical when we ask if illness here is "merely" a metaphor (an issue to which I will return). Early on in the tract on the additional element that formed the first part of *The World as Non-Objectivity*, he states that "in order to verify and classify the norms it is necessary to use the method of comparative analogy, by means of which we can find that point of relations [through] which we will be able to measure all the rest . . . If we discover a certain behaviour to have no analogy, then we would not know if it is normal or not normal" (III, 150). Malevich makes it clear that the curative effects of the additional element are beneficial *because* it is an analogy. It is a constructive force first in the "isolated" realm of art, though art and the artist can try to reform society at large. Through the metaphorics of disease, Malevich showed how the body of art perpetually renews itself. Personally – and despite the changes that his art underwent – Malevich remained a Suprematist in this sense. After his death in May 1935, he lay in state beneath a black Suprematist square. He wore the Suprematist colours: a white shirt, black trousers, and red shoes. He was displayed and then buried in a Suprematist coffin, and his grave was marked by a white cube on which floated a black square, designed and built by his student N. Suetin. The gravesite and its Suprematist headstone were destroyed in WWII, but the effects of his work were only sleeping. In 1919, the Russian poet Victor Shklovsky wrote that "the Suprematists did for art what chemistry has done for medicine: they isolated the active factor in the remedies" (Zhadova, 1982, 46). The prescribed remedies "can be of a Suprematist spatial [the straight line] or plane structure, which can be divided into dynamic Suprematism and non-objective, architectural statics according to the additional element of the square" (III, 188, italics removed). The effect of the additional element depends on reception – infection – rather than diagnosis. As suggested in this passage, the monochrome, especially the black square, emerged as the predominant, though not exclusive additional element that Malevich launched into the future. Monochromes were his "zero" of form, the material link to nonobjectivity, that with which he started after starting over with Suprematism. The black square was his first and last monochrome (Fig. 2). One version was placed prominently high up in a corner, iconlike, in the 0.10 exhibition of 1915 (though there were others in this show, all investigating the theme of "zero," presented by ten artists); an example appeared almost as his signature on the cover of the lithograph pamphlets *From Cubism and Futurism to Suprematism. A New Painterly Realism* of 1916 and *Suprematism. 34 Drawings* of 1920; the form centred his didactic charts in 1927; two others were exhibited as

2. Kazimir Malevich, *Black Square*, ca. 1923–1930. 36.7 × 36.7 cm. Musée National d'Art Moderne, Centre Georges Pompidou, Paris, France. Photo: Jacques Faujour. Photo Credit: CNAC/MNAM/Dist. Réunion des Musées Nationaux/Art Resource, NY.

late as 1932–1933 in Leningrad (Crone & Moos, 1991, 205). Diagrams for the film he planned to make with Hans Richter while in Germany begin with a black square that then morphs into other monochromes or shapes. If realized, the film would have enacted the dynamism found in his earlier *Suprematism. 34 Drawings* and that Malevich felt all important art required. In the film, he envisioned this process in a time frame much faster than that available with students in his art laboratories. Using the language of the additional element, he describes how "the black surface keeps moving and becomes an independent basic element, which engenders a whole system of new relationships" (Malevich, 2002, 55). Although for Malevich stasis – the naturalization of additional elements – is the natural end of any system, change is a higher value and can only come about through the initial disruption initiated by the "compelling, evolving element." As he diagnosed the art of the recent past and the present, Malevich drew on a traveling pharmacy of aesthetic remedies that, as we have seen, reached back to Cézannism, Cubism, and of course Suprematism. The supplemental factor

purified the art of the time for Malevich and it infected the art of the future. As Albert Camus wrote at the end of the *Plague*, "the plague bacillus never dies or disappears for good; . . . it can lie dormant for years and years . . . it bides its time. . . ."[29] This passage describes exactly how Malevich's art has infected the work of Taras Polataiko and demonstrates how artists of different generations will use metaphors of contamination that invoke the greatest threat to the body and self in their own cultures and times.

Polataiko's work in abstraction is a constant theme in this book, building as it does explicitly on Malevich's biological template. Polataiko was born in 1966 in Ukraine – Malevich's homeland – and emigrated to Canada in 1989. It was Polataiko who alerted me to the import of Malevich's theory of the additional element, a theory that had, for me, remained dormant and incomprehensible after a first reading years ago but was for the artist an active and potent agent of change. He studied art at the Stroganov Institute of Fine and Industrial Arts in Moscow, but as he noted in a recent interview, "In my generation in the Soviet Union, Malevich was not an approved artist: he was labeled as an elitist, bourgeois formalist . . . I came to know him [only] through Western books and mags."[30] Polataiko's work with Malevich's Suprematist imagery thematizes the potency of this latent effect. He and his work are living examples of Malevich's supplemental element, the

3. Taras Polataiko, *Glare Paintings*, 2001. Acrylic on canvas. Exhibition view at Sable-Castelli Gallery, Toronto (2002). Photo: Taras Polataiko.

"virus as a transforming agent, which sleeps inside the inner structure of ideologies and transforms them into something else when awoken."[31] His art becomes a willing carrier, not of Malevich's will to purity, but of an additional "something else." Polataiko's *Glare Paintings*, begun in 1992, evolved from his experience of Malevich's work through reproductions, a paradoxical contact, given that the originals were nearby, though deep in storage, both physically and ideologically. Polataiko embraces this paradox to make a point. The *Glare* series transmutes the fact that these are images after Malevich by emphasizing the trace of the camera flash and by manipulating the illustrations of Malevich's Suprematist compositions to accentuate the glare of the bent, glossy pages, then photographing these images and reproducing them in acrylic (Fig. 3). We see paintings of photographs of paintings. The glare becomes the new supplemental element. Malevich's agent is affirmed because it is replaced by a cipher of generational and ideological difference. Polataiko emphasizes that in the Suprematist paintings, the "underneath . . . has a lot of information (variety of curves, directions, contrasts, illusions, etc.)," so that it is Malevich's particular "arrangement of space that narrows my choices for where the glare should be . . . It isn't one way traffic."[32]

We can appreciate again in this context how Malevich was a Platonic apologist for painting, an artist who wanted painting to reach essences, to mold a new society, *and* who adopted the Platonic role of the good physician. Malevich's black square functioned in the subsequent history of abstraction as a *talisman* or *pharmakon*, a poison and cure in the Platonic and Derridean sense that was widely adopted in Malevich's time as a rationale for abstract art. Malevich's theory of the additional element thus has a double "medical" potency. It combined contemporary germ theory with an ancient metaphysical tradition of aesthetic doctoring. When the metaphysical dimension decreased in influence, as it tended to do in this trajectory of reception with and after Yves Klein, the epidemiological metaphors remained infectious. Polataiko's *Glare Paintings* exist at what Plato famously deemed in the *Republic* the third remove from reality: they are copies of copies. Yet photography is here no longer merely a reproductive medium, inferior to that which it supposedly records. His painting records photography, takes it as its subject, in part because he came to know Malevich's work – his "ghost" – through photographs that arrived from the West. For him, therefore, painting cannot be the creative, original medium that opposes photography. He calls these works an "impossible hybrid" and the glare a "transforming agent," impossible because for Malevich, painting's tradition of representation was overcome by Suprematism. There is a Derridean logic to the genealogical relationship between these two Ukrainian artists. Malevich initially sought to rid painting of the "infection" later reintroduced in mutated form by Polataiko. What was for Malevich "supplementary" – a "parergon," in Derrida's terms, something beside the work that was therefore to be purged from the work's core – becomes essential for Polataiko.

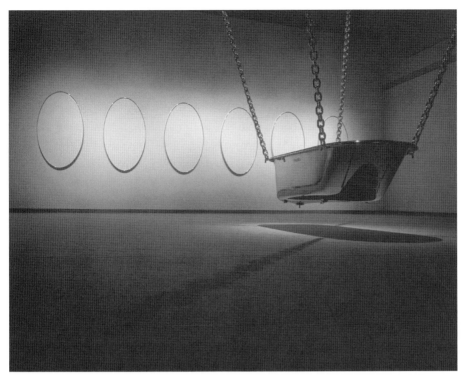

4. Taras Polataiko, *Cradle*, 1995. Nickle-plated cast-iron bathtub, anchor chains, artist's blood. Installation view, Mendel Art Gallery, Saskatoon, 1996. Collection of the artist. Photo: Grant Kernan, courtesy the artist.

In *Cradle* (1995, Fig. 4), a paradigmatic work for the concerns of *Abstract Art Against Autonomy*, it is the theme of infection and transmission that commands our attention. The centre piece of this installation is a nickel-plated bathtub dating from 1909 – Malevich's time – recovered by Polataiko from a Saskatoon hospital. Inside the tub, accessible only through a peephole, is blood, the artist's blood, donated and stored during the period after he returned from a 1994 trip to the "alienation zone" around the site of the nuclear cataclysm at Chernobyl, Ukraine, where he went expressly to infect himself with radiation from the still deadly nuclear accident. On the walls around the bathtub hang six "abstract" oval paintings. These were also made in a singular and aggressively corporeal manner: Polataiko mounted wallpaper on drywall, made a hole in it with his fist, then patched the hole to leave a perfect surface. He then painted faux wallpaper back onto this surface "so it looks as if nothing happened. [Yet] the patch is more noticeable . . . from the acute angle due to the glare it acquires after the whole surface of the painting is varnished" (Polataiko, 1995d). Here is another incarnation of the sometimes invisible, frequently dormant, yet always potentially powerful supplement. *Cradle* is at once stunningly visceral and coolly conceptual. Perhaps as much as what we see in the installation, the title alerts us to the theme of

rebirth and transformation. The cradle is a place where an infant's life is pro-
tected, encouraged to develop after its separation from the mother (in whose
body, significantly, its blood had been mixed with that of its parent). Polataiko's
blood is radioactive and can certainly behave as the ultimate "transforming agent,
both biologically and ideologically. No living organism is immune to the process
of mutation caused by radiation" (Polataiko, 1995d). Even though radiation is
used today to "purify" food, because in the public imagination nothing is more
"contagious" than radioactivity, nothing can be less pure than blood from a
radioactive body. Yet for Polataiko – who is interested in the ancient Maya belief
that they could communicate with their ancestors through blood-letting rituals –
this very impurity assures his relationship to Malevich. And because the glare
incorporated in the surrounding paintings appears only as we move around the
bathtub to an oblique angle, we are physically implicated in Polataiko's reference
to Malevich's theory of the additional element.

As we have seen, for the earlier artist this notion had social and political impli-
cations as abstract art tried to maintain a viable role in the new Soviet Union:
"Under the sign of the additional element is hidden a whole culture of action
which can be defined by a typical or characteristic state of straight and curved lines.
The introduction of new norms, the curved fibrous-shaped additional element
of Cézanne, will make the behaviour of the painter different from that caused by
the introduction of the sickle formula of Cubism or the straight line of Suprema-
tism. All manifestations whether aesthetic or productive, or industrial, religious
or political would change inasmuch as the painter is associated with them" (III,
156, italics removed). Though a revolutionary in 1917, Malevich had by the time
of this late text come to draw clear and deprecating analogies between fettered,
untalented "realist" artists and communism, so much so that the text could only
be published outside the Soviet Union: "Any state is . . . an apparatus by means of
which the nervous system of its inhabitants is regulated" (III, 154). For Polataiko,
the political is equally bound up with the artistic: "uncontrolled radiation is not
only changing the human genetic code in nations affected by it; it was also a cat-
alyst (it forced authorities to start disclosing previously restricted information)
in the transformation of the political consciousness which resulted in the col-
lapse of the Soviet Union" (1995d). Combined with the literal vulnerability of
our bodies to radiation, the sustained reference to glare as the supplement in art
make statements about the impurity of transmissions between generations and
the still idealized potential of art to raise our political consciousness. Polataiko is
a "contaminated" child of a relationship in which the Soviet Union dominated
Ukraine. He is simultaneously estranged from and closely related to Malevich. In
general terms, their relationship is typical of that between modernist purity and
postmodern impurity, a connection and rift that can be better understood in terms
of genealogy than through the now tired refrains about postmodern "appropri-
ation" and "pastiche." For Malevich, change in art and society was characterized

biologically, specifically through the additional element's metaphors of infection, treatment, and cleansing. For him and for Polataiko today, "once articulated and accepted, disease entities become 'actors' in a complex network of social negotiations" (Golden & Rosenberg, 1992, xviii). But these actors perform differently. Significantly, Polataiko replaces Malevich's bacilli with even more threatening impurities: the viruses and radioactivity so frightening and newsworthy today. Where for Malevich the supplemental element could get into the art and social systems and purify them through its very contagiousness, for Polataiko, contamination leads only to mutation and more accreted impurities, to communication but not to improvement.

In Polataiko, Malevich's additional element takes on a sinister and current vitalism. As he put it in conversation: "to me [a] virus is some hidden element that is always there in any ideology or organized structure. . . . It sleeps, and once it awakens, . . . then the mutation begins. It could be a disease, it could be radioactivity, it could be painterly space." In more recent work, the additional element, like the glare, is for Polataiko again a surface and its disruption now mutated in a tromp-l'oeil meditation on Lucio Fontana's famous *Spatial Conception: Attessa* series (Fig. 5). The *Cut* paintings look like Fontana's notorious slashes into the canvas and the space beyond. In fact they remain virtuoso surface exercises, but ones whose history rescinds the limits of flatness. Another recent work, which Polataiko often calls simply "Babushka" [officially, *Untitled, (Security Guard from National Museum Embroidering Cut Painting)*, 2001 (Fig. 6; front cover)] is again telling in its impure use of abstraction. In ways that will become clear in the next chapter, because the "portrait" of an abstract painting that she performs puts the monochrome against a white plane, she also allows us to recollect Yves Klein's scandalous denial of Malevich's priority in monochromatic painting. Here the woman methodically performs the reproduction, the figurative portrait, of a Polataiko *Cut* painting, itself an infected version of a Fontana. She reframes it. Close observation reveals that her "canvas" has been turned sideways so that the cut runs horizontally rather than vertically. She also gives the Fontana/Polataiko abstract a background that is anything but a formal assertion of what is and is not the proper work of art. The babushka embroiders the work, takes it from its high art plane, and returns it, not to "craft," as we might think, but rather to an early Soviet context in which Malevich's colleague Liubov Popova rendered Suprematist designs to be embroidered by rural women. She is making and remaking history in the art museum, that place that many commentators claim only kills art by ripping it from the supposedly original context.

To what extent is the language of disease, infection, and transformation initiated by Malevich and adopted by Polataiko "merely" metaphorical? Beyond isolating a recurrent use of a transformative agent analogous to Malevich's infectious additional element, we need to evaluate the status of "illness as metaphor,"

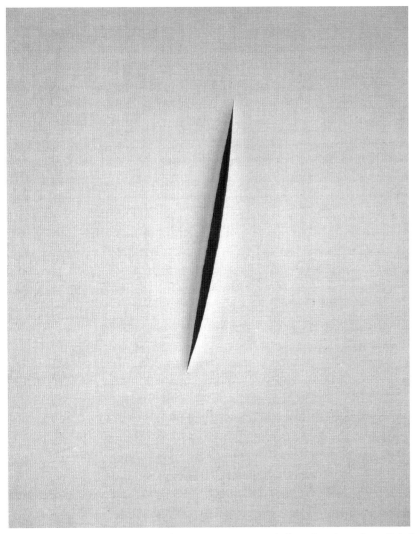

5. Lucio Fontana, *Concetto Spaziale: Attesa*, 1960. Tate Gallery, London, Great Britain. Photo Credit: Tate Gallery, London/Art Resource, NY.

to defer to the late Susan Sontag's famous phrase from her 1977 essay of the same name. The question is crucial because it is abstract art in its connections with the metaphorics of infection, transmission, and transmutation that helps us think through this ultimately social issue of the use of science in nonscience contexts. The practice of looking to medical discourse to understand Malevich is seconded by Rainer Crone and David Moos in *Kazimir Malevich: The Climax of Disclosure*: "each aspect of human culture can only be understood through its inter-relationship to neighbouring disciplines. When art is represented as one single sphere of the cultural enterprise, we experience nothing of its essence" (1991, 21). Malevich exemplified this view, one that, despite high modernist rhetoric from

Lessing to Michael Fried in the 1960s, is especially true of nonrepresentational art, as shown with Rauschenberg and Klein in Chapter 2. Crone and Moos also discuss AIDS, enjoined not as a metaphor of infection but as a model for scholarship "as self-reflexivity" (190), an awareness of context that for them reveals the dilemmas of AIDS research as a negative example of how certain patterns of thought – the early assumption that AIDS is a virus – can control and restrict understanding. In testing Malevich's notion of the additional element intermittently throughout this book, I claim that there is a way for abstract art to transmit itself into unexpected contexts without recourse to overused and abused transhistorical models of change, whether transcendental or formal. It is valid and instructive not only to read Malevich through medicine but to ally his theories with present concerns using his metaphors. Her diction of purity, resistance, and barrier should resonate effectively with the contexts I have so far developed. Evelyn Fox Keller has recently examined in detail how the words chosen for research programmes largely determine what is analyzed and what is left out (1995); discourses of illness and contagion frequently stigmatize those to whom they are attached and falsely promise genius, as in the case of the "consumptive." Science and ethics touch here, because – according to Sontag and following Aristotle – metaphor is

6. Taras Polataiko, *Untitled, (Security Guard from National Museum Embroidering Cut Painting)*, 2001. Installation from "Brand Ukrainian," Center for Contemporary Art, Kyiv, December 15, 2001–February 10, 2002. Collection of the artist. Photo: Ihor Haidai.

simply giving something a name that belongs to something else (1990, 93). Sontag, however, opens her essay "Illness as Metaphor" with the assertion that "illness is *not* a metaphor . . . the most truthful way of regarding illness – and the healthiest way of being ill – is one most purified of, most resistant to, metaphoric thinking" (1990, 3). Yet science would seem not to be able to proceed without words and metaphors. We cannot posit language over against something it more or less accurately mirrors, and it is productively difficult at times to decide what is an "art" and an "extraart" category, given that the borders float. Thinking of Malevich's additional element and its explicit invocation of Robert Koch's epidemiological discoveries, then, was the artist giving a name to processes in art that belonged only to disease, or was Malevich insisting justifiably on analogy as a rightful part of the definition of metaphor (as in the *Oxford English Dictionary* definition)? It can be offensive to take the suffering and loss from TB or AIDS and both generalize and distance them in an aesthetic application. At the same time, it is legitimate to use metaphors of disease within an aesthetic context. From what remove may we criticize Malevich for blurring boundaries of the street and art, or, as I ask in Chapter 4, General Idea, who generated monochrome medicines from the heart of their own experience with AIDS? Artists freely use medical metaphors to describe their socially minded work. They increasingly reject the purification and delimitation of borders called for by Sontag and instead live with, by revealing, the bleeds among words, disciplines of inquiry, and what General Idea, adapting William Burroughs, call "image viruses."

If we are to use metaphor responsibly, we must attend to its cultural specifics. Where Malevich for good reason focused on a bacteriological model of analysis through isolation and infection through contact, Polataiko freely and apparently without pause translates this thinking about the additional element into the current language of viral infection. For Malevich, bacteriology provided *the* metaphor of transmission and then change for the new art and new artist that he sought to be and produce through his teaching. He had no other model and TB devastated his family. In Koch's work on TB, the discovery of bacteria was a powerful analytic tool, not a social metaphor (though he ultimately conflates the two in the military language of a scientific battle that ends by routing the enemy within the society and its individual bodies). In Polataiko and many other artists whom I will examine, infection and even the notions of antidote and cure are similarly analytical but also predictive of the goals of art. The power of what we already know to guide what we may find – bacteria as an analogy for viruses – is illustrated by the discovery of viruses. In 1883, Adolf Mayer claimed to have found a submicroscopic bacterium that caused tobacco mosaic disease. But ten years on, Dmitri Ivanowsky demonstrated that there were living organisms smaller than known bacteria, leading to Wendell Stanley's proof in the 1930s that the infectious particle was a new agent, the virus. He received the Nobel Prize in chemistry in 1946 for this research. Tuberculosis persists as a serious infectious

disease, killing approximately 1.7 million worldwide every year. Another connection between the TB bacterium and viruses still makes the news in Russia especially. The World Health Organization asserts that since the early 1990s in Russia incidence of TB has increased threefold. So resistant to antibiotics are some new strains that researchers there are seeking ways to encourage viruses to attack this specific infection. Across the world, too, HIV has weakened patients to such an extent that they are particularly susceptible to tuberculosis (Reichman and Tanne). Although bacteria and viruses are of course different, and although specific fears of each may differ culturally and over time, science does not completely separate these infectious microorganisms but recognizes instead their interaction. Ours is the age of the virus – from computers, to health, to art[33] – so it is no surprise that this metaphor dominates. The connections with Malevich's bacteriological notion of the additional element, however, are if anything magnified by recent understandings of disease and its disregard for barriers, semantic or biological.

2. Inheritance and the Future

Let us begin to consider where my narrative of infection places us critically with respect to modernism and the notion of autonomy central to it. Meditations by Arthur Danto and Hal Foster on these themes offer a place to interject in the conversation. Foster's trenchant examination of the autonomy topos reveals that, like "essentialism," "autonomy is a bad word for many of us." We need to remember that it is always situated historically and used politically. Autonomy for Foster is therefore always "strategic autonomy" (2002b, 103). Arguing against Peter Bürger's famous assertion in *Theory of the Avant-Garde* that progressive art's definitive battle against autonomy in the arts ended with the mere repetitions of the neo-avant-garde of the 1960s, Foster not only extends into the present the importance of the issues surrounding autonomy but also helps to establish the credibility of more recent art practices. Bürger, he counters, "fails to recognize the ambitious art of his time" (1996, 11). Foster's masterly ability to define even the fraught territory of the postmodern is not in question. But his argument that autonomy is always "situated politically" (2002b, 103), however much it explains (or explains away) Greenberg's early claims for abstraction, produces its own blind spots. Yves Klein's work, for Foster, was nothing more than "Dadaist provocation...turned into bourgeois spectacle" (1996, 11). I argue in Chapter 2 that Klein's radical anti-autonomy was much more than this if we understand him to have developed a performative practice of infecting the world with monochromes. Strategically and politically, there was and remains something negative for abstraction about the principle of purist autonomy. The painter Stephen Ellis articulates a widespread complaint: "Greenberg's notion of shutting out the world shut off abstraction from innovation for nearly 20 years" (Madoff, 1992, 75). Factually hyperbolic, the sentiment is both honest and ironic in the context I am developing here, given that

even Greenberg employed the rhetoric of infection and cure to explain what Foster might deem the strategic use of abstraction. "Every civilization and every tradition of culture seem to possess capacities for self-cure and self-correction that go into operation automatically, unbidden," Greenberg claimed in his 1959 defence of abstraction, "The Case for Abstract Art" (Greenberg, 4, 76). If self-cure and self-correction are correlates for a Kantian[34] self-criticism typical of modernism for Greenberg, and if these protocols go into action automatically, then we see again what a Hegelian Kantian Greenberg was. Not unlike Kant in his relationship to medicine and to his own corporeality, Greenberg tried to purify abstraction of any references beyond itself. Not unlike Hegel, his purported grounding in history, in the intervention of an art form in its society, has less and less to do with immediate historical manifestations in the visual arts. The same can be said of Arthur Danto's powerful theory of the "end of art" and of the role in this drama he assigned to Greenberg.

Danto's arguments are crucial to any consideration of the nature and import of abstraction since the 1960s. For Danto the philosopher, "once art itself raised the true form of the philosophical question – that is, the question of the difference between artworks and real things – history was over. The philosophical moment had been attained . . . there is no longer a pale of history for works of art to fall outside of. Everything is possible. Anything can be art. And, because the present situation is essentially unstructured, one can no longer fit a master narrative to it. Greenberg is right: nothing has happened for thirty years" (1997, 113–14). If he is justified in the claim that the once-dominant narrative of art is over, that art and the philosophy of modernism that drove it have divorced, then how do we assess the specifics of the ongoing production of art in our posthistorical time? Given the centrality of abstract art in modernism, what should we now say about current work in this genre in relation to its history – to "itself" in an important sense – to the present art world and even to the future? My claim that recent antipurist abstraction has historically and continues to work against autonomy is a rebuttal of Danto's argument, both in its sweeping claims and immediate applications. His views, and to some extent those of Hans Belting about the end of art history, only make sense within the Hegelian framework that Danto readily admits is the "master in [his] inquiry." Danto believes "that the end of art consists in the coming to awareness of the true philosophical nature of art" (1997, 27, 30). Although claiming that the Hegelian pattern is truly and laudably historical, he also holds that "there is a kind of transhistorical essence in art, everywhere and always the same, but it only discloses itself in history" (28). History in this scheme happens when essences "are painfully brought to consciousness" in and through art (95). What Danto most admires about Greenberg, and what assures the latter's significance in his eyes, is that the late critic recognized that "providing a philosophical definition of art was what marked the drives of modernism" (68). In other words, Greenberg was a Hegelian.

Historicizing Greenberg's lament about nothing happening in recent art, Danto identifies the "passing of the pure," the "end of the exclusivity of pure painting as the vehicle of art history" (1997, xiii, 148), as what was transcended with Warhol, especially, in the 1960s. "The history of modernism is the history of purgation," Danto writes, "or generic cleansing, of ridding the art of whatever was inessential to it. It is not difficult to hear the political echoes of these notions of purity and purgation" (1997, 70). I elaborated this argument in detail in *The Rhetoric of Purity: Essentialist Theory and the Advent of Abstract Painting* (1991a) and thus agree both with the identification of the philosophical heritage Danto alludes to and his passing recognition of its social and political allegiances, however unintended on the part of most artists and writers. But why is it that the eclipse of this commanding and disturbing narrative, disorienting as its passing was for some, results in an "essentially unstructured" present? To throw up ones critical hands and say "everything is possible" is to ignore historical and contextual specifics. Human beings habitually structure what seems unstructured, at least provisionally. They do so using what is recognizable and available immediately. Not everything is possible, even when it comes to art. Losing the Hegelian thread did at one time leave a conceptual vacuum to be sure, but we can still tell effective (if not necessary or world historical) stories about the history of abstraction, stories that start when this art form begins and that show no sign of ending. David Carrier, a great admirer of Danto's work, offers this sort of corrective: "To say that the history of art has ended is only to indicate that one narrative has ended. In another historical story, the same events may be differently described. Mine is a limited kind of relativism. Danto is not a relativist" (1994b, 7). Such new narratives not only provide alternative ways to understand individual examples and larger patterns of development in abstract art. They also cast doubt on Danto's proud Hegelianism, which, ironically, he holds on to as an essentialist vantage point outside history to claim the passing of grand narratives and his sighting of the posthistorical. At the head of this chapter I quoted Hegel's image of the self as an infection: "The I, that expresses itself, is apprehended as an ego; it is a kind of infection in virtue of which it establishes at once a unity with those who are aware of it, a spark that kindles a universal consciousness of self." Hegel, Greenberg, and Danto cannot think of art without the universalizing impulse that is for them philosophy. What is most compelling and fascinating about the recent history of abstraction is its vitality in the face of the failed narrative of purity. Abstraction is an infection that will not go away.

Before I outline the plan for the balance of this book, let me consider briefly an alternative, and I believe misconceived, narrative for recent abstraction. *Pleasures of Sight and States of Being: Radical Abstract Painting Since 1990*[35] was an ambitious exhibition presented by Roald Nasgaard, who, overcoming the geographical and national misimprisonments that typically separate the artists he

included, assembled a bold sampling of work by fifteen American, European, and Canadian abstractionists such as Robert Ryman, Gerhard Richter, Bridget Riley, Agnes Martin, David Reed, and Guido Molinari. It was a superb show, but in my judgment the proclaimed radicality of the work did not lie where Nasgaard found it (or wanted it to be). Nasgaard claimed in the didactic panels and catalogue that "radical abstract painting is a reiteration of long-standing modernist precepts: an emphasis on the formal manipulation of materials, the reduction of the artistic process to aesthetic decisions that are essential to the medium at hand, a reconfirmed allegiance to the artistic object and a commitment to its autonomy, and the valorization of individual experience as realized in contemplation of the object" (2001, 24). This is an excellent summation of the modernist credo whose essential marker was abstract painting and its pure reception. But formalism's weaknesses have been well revealed, nowhere more tellingly than in the *locus classicus* of such disputes, Leo Steinberg's *Other Criteria* (1975, 64–5, 77). It is an ethos, too, that hopes to transcend peculiarities of language precisely through a supposedly universal lingo, that of the "formalesque," that is, the nonlinguistic. If any painting can be radical now – a moot point in our post-avant-garde Western cultures – it is not because it returns to or perpetuates a paradigm of abstraction that reached its apogee in the early 1960s. Philip Guston both challenged and historicized the radicality of abstraction promulgated by Nasgaard. "There is something ridiculous and miserly," he said in 1960, "in the myth we inherit form abstract art. That painting is autonomous, pure and for itself, and therefore we habitually analyze its ingredients and define its limits. But painting *is* 'impure.' It is the adjustment of 'impurities' which forces painting's continuities" (1960, 38).

The term *radical* is always relative to time and context. What Nasgaard found radical in the painting he exhibited was a reflection of his own nostalgia for a lost paradigm. He could have seen other radical characteristics in this work, Richter's especially, as shown in Chapter 3, and he could have presented other contemporary abstract art and artists that stake this claim with greater validity. My critique, then, is directed at the uses of language, at the spin the term *radical* supplies, one that harkens back to the avant-garde inception of abstraction. We cannot return to this time and should, I think, know better than to try. Can there be progressive abstract painting today? The odds might seem discouraging. Not only does the transformative, avant-garde status of art seem to be an achievement of the past not to be repeated, but what is now provocatively referred to as the endgame of painting and perhaps art itself was indeed integral to early abstraction.[36] To recall dominant paradigms, Kandinsky saw abstraction as a way to a higher state of consciousness. Mondrian hoped for Neo-Plastic social engineering. Rodchenko, with his three last monochromes of 1921 – one red, one yellow, one blue – thought he had made a material statement so fundamental as to be the last "word." Paradoxically, then, abstract painting has throughout its history been

about the repetition of its end and impossibility. There is no end, only a perpetual endgame, as Christian Eckart's work, for example, considered in the next chapter, shows especially well. Can we escape this eschatological circle? Does abstraction have a future as well as a venerable past, a "significant" future that registers art historically?

We know that abstract art will continue to be produced, but will it in some always-to-be-specified ways also be work that is talked about? If we may suspend for now the not unwarranted cynicism that sees everything in the artworld as a product of commercial manipulation, my answer would be yes, abstract art is and will likely continue to be part of well-informed discussions about the visual arts and visual culture. I would begin with examples by Gerhard Richter, Fabian Marcaccio, Taras Polataiko, Christian Eckart, Lydia Dona, Robert Houle, and Olafur Eliasson. The sorts of abstraction that will remain integral to today's art conversations will be hybrids in many ways. The work will integrate and react with, rather than separate from, elements of its society. Instead of nostalgia for the purity of most modernist abstraction, it will reveal and revel in the present. Of course abstraction today has its problems. As a genre, it has never and still does not attract many female practitioners or adherents from non-Western cultural traditions (though there are important exceptions, discussed, for example, in the works of Ann Gibson and Jackson Rushing, especially, on Abstract Expressionism, Kobena Mercer on British and African examples, and in the forthcoming collection *Discrepant Abstraction*). There is abstraction outside of painting – Flavin, Irwin, and Turrell showed the way taken up today most prominently by Olafur Eliasson – yet painting remains central to this work as it does not in most other contemporary art discourses. But painterly abstraction has evolved. Its future is in its localized accents, in its hybridity, or, if that term presents problems by implying a resolved blending, in its syncretism, not purity.

The systematic history of recent abstract art has yet to be written, but my efforts here are, again, not aimed in that direction. The volume and quality of contributions to aspects of such a history bear witness to the importance of the topic. Eric de Chassey's *La Peinture Efficace: Une Histoire de L'Abstraction aux Etats-Unis (1910–1960)* (2001) is a recent account of pioneering abstraction in the United States. Collections of essays edited by Frances Colpitt (*Abstract Art in the Late Twentieth Century* [2002]) and David Ryan (*Talking Painting: Dialogues with Twelve Contemporary Abstract Painters* [2002]) fill gaps in our knowledge of international abstraction since the 1960s and provide expert commentary on individual artists. The most comprehensive portrayal of abstract art now in print is the catalogue to Mark Rosenthal's New York Guggenheim exhibition, *Abstraction in the Twentieth Century: Total Risk, Freedom, Discipline* (1996). The curator's apologies for exclusions notwithstanding, here we have an extraordinarily valuable survey of themes and practices in the category from its inception. Instead of replicating Rosenthal's approach, however, I present a sustained critical reading of recent

abstraction through interlocking thematic narratives, a reading that will accentuate the surprising vitality of this still controversial genre. Briony Fer's 1997 *On Abstract Art* is the closest model. But where Fer embraces the entire history of abstraction, I focus on its recent development and especially its contributions to surrounding social concerns with infection. I also emphasize abstraction's growing social presence as it moves away from paradigms of aesthetic autonomy.

Abstract art is produced today by a great many internationally renowned artists (to name only a few: Daniel Buren, Jonathan Lasker, Sigmar Polke, David Reed, Gerhard Richter, Bridget Riley, and Sean Scully), and the bibliography on these and other artists is extensive. Similarly, prominent art historians writing on painting as a genre in the current artworld frequently discuss abstraction. The scholarship of Yve-Alain Bois (his recent catalogue on Kelly in France, for example), Thierry de Duve [*Voici* (2000)], David Carrier [numerous articles, catalogue essays, and *The Aesthete in the City: The Philosophy and Practice of American Abstract Painting in the 1980s* (1994b)], and Stephen Melville (2001) have been foundational for my own thinking. The theoretical coordinates of recent abstraction have been canvassed by Andrew Benjamin in his edited collection *Abstraction* (1995) and again in *What Is Abstraction?* (1996). Recent exhibitions have addressed themes important to my study, for example: *Hybrid Neutral: Modes of Abstraction and the Social* (1988), *Critiques of Pure Abstraction* (1995), *After the Fall: Aspects of Abstract Painting since 1970* (1997), and *Postmark: An Abstract Effect* (1999). Finally, two analyses of the monochrome are crucial to my own work on this important subspecies of abstraction but stop short of a fuller discussion of the genre: Denys Riout, *La Peinture Monochrome* (1996), and Beate Epperlein, *Monochrome Malerei* (1997). These contributions not only provide reference points for my own arguments but also are at times the subject of analysis.

The structure and content of this book have evolved over a number of years and in keeping, I hope, with several methodological protocols central to my sense of what academic writing should be. I have noted that this study is closely related to *The Rhetoric of Purity*. I not only extend the chronological reach of this work. More importantly, I show that the problematic paradigms of purity instrumental at the inception of abstract art continue to operate in post-1960s abstraction, if negatively. Only recently did I become aware of Richard Sennett's pioneering study of purity in the formation of personal and urban identity, *The Uses of Disorder* (1970). Sennett argues that the need for purity in the aesthetics of urban and social planning is an externalization of the personal requirement for order, a theme I examined in the context of abstract art and totalitarianism in the 1991 book. Whether or not one accepts Sennett's model of an "adolescent" need for purity and control giving way to a more "adult" acceptance of disorder, his insistence on a circuit of social cause and effect are germane to an understanding of recent abstract art. My book is divided into four chapters. The structuring

argument is that abstract art, though certainly contested as a leading genre in the 1970s and 1980s, has reinvented itself through a series of metamorphoses that I examine using the theme of impurity and the rhetorics of infection. Recent abstraction thus overturns what I have claimed is its paradigm from the early part of the 20th century: purity. But we do not witness a simple dialectical reversal. Pure abstraction and the many discourses that supported it suppressed rather than eradicated intrinsic and extrinsic elements of impurity. I have shown in this introductory chapter how such "additional elements" have been drawn out by a return to the work of Malevich. Because abstraction is vital today, and because some of its practitioners return to pioneering abstraction's rhetoric of purity, my study engages with the issues of inheritance, continuity, and discontinuity in the 100-year story of the form. Impurity as a trope and practice is crucial to contemporary abstraction, but it is not a sufficient rubric with which to understand abstract art since the 1960s. Thus in the next chapter, "White Mischief: Monochromes," I investigate the unbroken fascination with the monochrome, a highly charged mode often taken as the epitome of abstraction, and thus of modernism, and used experimentally by many artists not usually thought of as practicing in the abstract, for example, Robert Rauschenberg and Michael Snow. In addition to tracing recent manifestations of the monochrome, then, I argue that abstraction has to be recognized in the production and rhetoric of many artists, not only those who are primarily identified with this type of art. I am thus able to comment on the "viral" presence of abstraction in many contexts. One of my central claims is that recent abstraction is positioned against the autonomy of art. Much abstraction is by contrast "social" in its commitments. The paradigmatic impurity of contemporary abstraction is epitomized, I claim in Chapter 3, "Mirrors: Stages of Nonrepresentation," by its frequent use of mirrors. If mirrors cannot help but be social in the sense that they are image making machines, why are they employed, and carefully controlled, by Robert Morris, Michelangelo Pistoletto, Gerhard Richter, and many less famous artists to invoke the monochrome, the supposed epitome of self-sufficient abstraction? Although others have written on the use of mirrors in recent art (especially de Duve in *Voici*), their role in nonrepresentational practices has not been revealed. Other social aspects of abstraction are the main focus of Chapter 4, "Possible Futures: Abstraction as Infection and Cure," in which I discuss the analogies between abstraction and disease. Work by Andres Serrano can evoke bodily fluids as well as monochromatic paintings and thus gesture toward the history of abstraction and pressing social concerns at the same time. General Idea's "Infected Mondrians" series similarly engages with a specific art historical precedent and its supposed purity and with the AIDS epidemic. The themes of this final chapter pivot toward what has come before them here, invoking, for example, both the recent history of monochrome abstraction and the theme of impurity and infection embodied in the mirror. Each chapter

reflects the others in this way, providing a complex narrative about abstraction's predilections since 1960.

Abstract Art Against Autonomy offers a series of paradigms – of works, artists, relationships, issues, and debates – from which one can work inductively to premises about recent abstraction. Although a large number of artists, works, and writers is considered in the chapters that follow, selection is the rule. It is perhaps nothing more nor less than an aesthetic preference to believe that a small number of examples rallied to make a point is preferable to a long series of instances, duly recorded. My preference for inductive argument makes this a short book. In making my editorial decisions, I have tried on the one hand to be part of international conversations around abstract art. To do so means discussing canonized figures and addressing established debates, both of which I regard as important. On the other hand, I see no good reason not to introduce work by artists who may, largely by accident I think, be less known if that work is central to the arguments I seek to develop. Some of what I discuss may seem local to individual readers. If so, I would counter that any demand for the familiar names is potentially parochial and anti-intellectual. Finally, the book moves more or less chronologically in each chapter and overall, a pattern that allows me to under-score the connections among artists, works, and ideas across generations. The same advantage accrues from what may seem a traditional understanding of the specific modes of abstraction still found today, the monochrome, mirror-works, and the infected abstractions I discuss in the final chapter. Like the overarch-ing category of abstraction, these subgenres have a long and complex history. A prime example that needs to be revisited is the monochrome, the traditional quintessence of abstraction.

2 White Mischief

Monochromes

> *Even if it makes me physically ill that my best friend has bought a white painting, all the same I ought to avoid attacking him about it.*
>
> **Yasmina Reza, *Art*[1]**

Yasmina Reza's highly successful satirical play *Art* tells much about her pivotal character, a white monochrome. Although the term does not necessarily refer to painting or to abstract painting – it can allude to photography or to panels of colour, as in Giotto's fresco cycle in the Arena Chapel – here as in most art discourse the monochrome stands in for abstraction and avant-garde art generally. It is seen as the innermost Russian doll that sits inside abstract painting just as abstraction is the core of modernism.[2] Reza leaves no doubt that abstraction, and especially the white monochrome, remains topical and controversial. Though Malevich's and Rodchenko's early monochromes announced in their different ways the abandonment of art, the monochrome continues to thrive in the popular imagination, artistic practice, and scholarship of the 21st century. The threat and event of defacement motivate the emotion of *Art* and mirror public opinion, as we see happen, too, on a larger, public stage. Ambitious histories of the genre were published by both Riout and Epperlein in the mid-1990s as well as many important articles by a range of scholars and critics. Artists continue to work in this field both in painting and less traditional media. Numerous exhibitions have been mounted, both thematic and focused on individual artists.[3] This artistic and critical activity has, in its ongoing reference to the avant-garde, established a full picture of the long and complex history of the genre. It is part of the "endgame" to which reference is often made; however, what we know of the monochrome's recent past and future prospects generates rather than concludes speculation. Whether as a target for attacks on painting or modernism or in a positive, infectious role, the monochrome still earns its centrality. Ann Gibson offered an explanation in her trenchant 1992 reading: "Monochrome painting...brings several extremes together: It is just about as abstract –...nonmimetic – as you can get, and just about as real – as concrete – as it is possible to be: paint on a flat surface. At the same time it may be both programmatically or subjectively referential" (136). McEvilley's taxonomy of three

7. Yves Klein. *Le Vide*, 1958. Galerie Iris Clert, Paris, April or May. Photo: Archives Klein, Paris.
© Estate of Yves Klein/ADAGP (Paris)/SODRAC (Montréal) 2005.

types of monochrome – metaphysical, material, and formal – again puts the genre
and its practitioners at the centre of much of the history of modernism and its
aftermath (1993, 38). My title for this chapter suggests how I augment these
studies. It is borrowed from a film[4] based on a book and thus makes reference not
only to the ability that the monochrome still has to draw on and make "mischief"
in and beyond the art world, but also to its relationship to the literary, ultimately to
Mallarmé's blank white page, and its expansion into more contemporary formats.
One direction in that movement is toward various screens, whether of the cinema,
video monitor, or computer, an interest that was previewed to some extent by
Malevich's and then Klein's forays into film. Another move beyond the frame
is into environments, as in the work of Turrell and Eliasson, which again were
anticipated by Klein's performatively energized spaces, especially *Le Vide* and
the photos of his *Leap into the Void* (Figs. 7 and 8). To borrow the title of Eva
Hesse's 1966 work in the Art Institute of Chicago, the monochrome – where it
is and what it does – is a "hang-up" in recent art, not least when it is no longer
hung as a blank picture. Monochromes, like those who make and discuss them,
come in all colours.[5] As *White Mischief* in both its incarnations showed vividly,

however, "white" is dominant in ways revealed and criticized in the contemporary monochromatic work I discuss in Chapter 4. In revisiting the monochrome as central to abstract art, I emphasize its roles as a living crucible for experiments and models in art that now go beyond its avant-garde and even neo-avant-garde practices. I begin with Klein's and Rauschenberg's attention to the monochrome in the 1950s and 1960s. Although they were not the first to revive the genre,[6] these artists both recollected its avant-garde beginnings[7] and moved it beyond the frame of the support and the studio, which is the theme of the final section

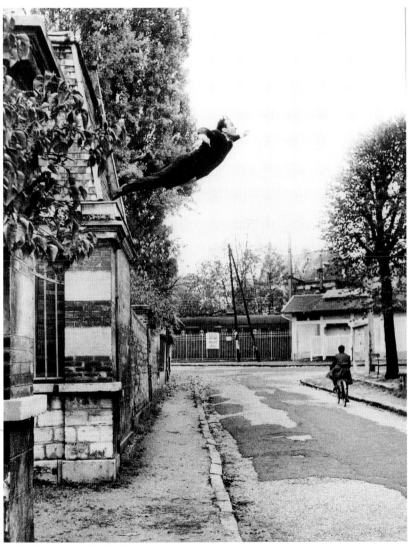

8. Yves Klein, *Leap into the Void*, October 1960. Subtitled "The Painter of Space Hurls Himself into the Void!" Photo: Harry Shunk, courtesy Archives Klein, Paris. © Estate of Yves Klein/ADAGP (Paris)/SODRAC (Montréal) 2005.

of this chapter. Most importantly to my arguments, both were infected by and transmitted the monochrome into the future that we now occupy.

1. Matting the Monochrome: Yves Klein

"Matting the Monochrome" refers simultaneously to the intrinsic and extrinsic contexts in which we need to consider this most rarefied type of abstraction. One "mats" a work of art as a way of presenting it. We define the work against a background, against something that it is not; this point applies to the installation and reception of the work as well as to its physical components. As Yves Klein shows us with reference to the history of the monochrome, matting in these senses is not a trivial concern. The monochrome was of crucial import to Klein, who came to call himself "Yves le monochrome" in the late 1950s. His other abiding passion – aside from self-aggrandizement and St. Rita of Cascia, patron of lost causes – was judo. Here again, mats are not merely supplemental. As a corrective to the balance of scholarly opinion, I argue that judo – "the way of gentleness," which Klein embraced before the monochrome – and the specifically Zen attributes of the form he studied in Japan and then taught in Spain and France, informed his innovations and excesses in abstract art throughout his short but prolific career.[8] The two types of matting, one intimate to art making and viewing, the other apparently extraneous, come together in a way that is paradigmatic of the productive theatricality of much abstract art since the 1960s.

Monochromes were Klein's first and omnipresent aesthetic obsession. He famously appropriated the unmarred back of the blue sky as his work in Nice in 1946, saying later that "I have hated birds ever since that day, I have hated them for trying to pierce great dark holes in my greatest and most beautiful work" (McEvilley, 1982a, 229). He painted the ceiling blue in the cavelike basement room in Arman's father's store where he and his youthful comrades hung out, produced fictive reproductions of putatively earlier monochromes in his booklet *Yves Peintures* of 1954, and conceived a film in this year in which the opening scenes moved from monochrome white through yellow and red to ultramarine blue. Klein's irrepressible imagination and inventiveness during what was only a seven-year career makes the list of his innovations much longer. Though as we will see his current reputation wavers, he was arguably *the* figure who foresaw and inspired many of the moves abstraction would make after WWII, not to mention an extraordinary array of the directions to be taken by other art forms, from kinetic to performance to conceptual art (McEvilley, 1999, 9). In 1955, a large orange monochrome that he submitted to the Salon des Réalités Nouvelles was rejected because of its lack of surface inflection, sparking the first in a long and productive series of public scandals around his work when his friends toured the exhibition, demanding to know where Klein's work was displayed. When he exhibited monochromes in Paris at the Galerie Colette Allendy in 1956,

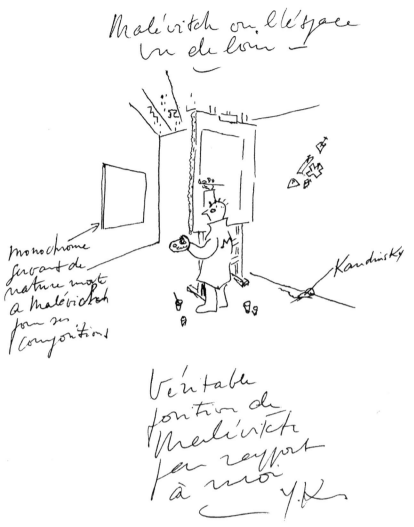

9. Yves Klein, *Malévitch ou l'espace vu de loin,* ca. 1958. Musée National d'Art Moderne, Centre Georges Pompidou, Paris, France. Photo: Archives Klein, Paris. SODRAC (Montréal) 2005.

comparisons with Malevich's heritage monochromes were made by Pierre Restany in his catalogue essay, and Klein soon responded (McEvilley, 1982a, 43). In texts and with several versions of a cartoon about the Ukranian artist, Yves the monochrome positioned his work as *prior* to Malevich's. *Malévitch ou l'espace vu de loin* [M. or space from a distance, also titled in another version "The True Position of Malevich in Relation to Me"] of 1958 (Fig. 9) shows Malevich anachronistically copying a Klein monochrome. Kandinsky's reputation seems also to be at stake in this struggle for priority: like a mouse, he is about to disappear into the wall. In his extensive writing project, the "Monochrome Adventure," Klein quotes Malevich's exhortation to the "aviators" of the future: "fly! White, free, and

endless, infinity is before you." But Malevich remains the earth-bound copyist in this caricature, painting only a lowly portrait or still-life "after" Klein. Klein wrote: "I can say at thirty years of age in 1958, that when Malevich burst into space like a tourist around 1915 or 1916, I welcomed him and he visited me because I was already, since always, owner, inhabitant . . ." (Stich, 72). Tinguely suggested that Klein had thus "dematerialized the fact that Malevich had preceded him" (Klein, 1999, 53); dematerialization was Klein's goal from 1958 on, as he attempted to move beyond the material monochrome. There is parodic humour here[9] and though Klein did have an ego the size of the sky, his cartoon broadcasts a serious, largely unacknowledged message. Thomas McEvilley takes the pessimistic view that Klein is here simply suffering from the anxiety of influence, as he did in relation to Marcel Duchamp and every other living artist. He writes that much of Klein's "own achievement paralleled works and attitudes that [these] two artists had expressed in the teens of the century. Sensitive to questions of priority, obsessed with the Modernist idea of the artist as innovator, and at the same time willing to play the fool, Klein argued that by a proper understanding of time he in fact preceded Malevich" (Klein, 1999, 7). But there is more than ego at stake here.

At the risk of seeming even more outrageous than Klein, I believe that his claim to be the first to have seen the monochrome in its most radical state, that which partook of what he, like Malevich before him, would call pure sensibility rather than merely art, should be understood as a valuable commentary on the nature of the monochrome and its legacy. Because his work is never framed by an atmospheric "background" suggesting a figure and ground, or three-dimensional space, as even Malevich's most radical black squares on white grounds were, Klein is in effect suggesting that the black square on a white ground is not properly a monochrome. Many historians now agree and thus cite Rodchenko's 1921 triptych as the first "proper" instance of the genre.[10] Malevich's slightly later *White on White* (1918) addressed this issue of image against ground but did not eradicate the dialectic. His *Large White Cross* of 1920 further exploits the power of a materialized internal image, however much this and other similar works enacted his principle that the white field equaled "nonexistence" and was an explicitly purifying, "economic movement of the form" towards infinity and invisibility (Malevich, 1968–1978, IV, 146; I,126). For Malevich and ultimately for Klein, too, white was but a cipher for dematerialized essence. Kazimir "le monochrome" wrote: "Our century is a huge boulder aimed with all its weight into space. From this follows the collapse of all the foundations in Art, as our consciousness is transferred onto completely different ground. The field of color must be annihilated, that is, must transform itself into white. . . . The development of white . . . points to my transformation in time. My imagining of color stops being colorful, it merges into one color – white" (Douglas, 1994, 100). Although he claimed that "painting was done for long ago," Malevich held equally that objects, painting, materiality in

general, should not be taken merely as instrumental and "expedient" (I, 127; IV, 148). Briony Fer reminds us that the American minimalist Don Judd contended a generation later that Klein's monochromes, by contrast, are not "spatial." They do not create the illusion or reality of space in the way that Cubism or collage did (Fer, 1997, 144ff.). Indeed, from Judd's perspective, Klein had emphasized the object status, not the illusory space, of his monochromes by hanging them well away from the wall on rails and rounding their corners in 1957 exhibitions in Milan and Düsseldorf. Later he made numerous three-dimensional IKB works. Unlike Judd's "specific objects," however, "pure sensibility" for Klein was more a mystical than a perceptual category, one drawn from his interests in Zen Buddhism, Bachelard's writings on space, and Rosicrucianism. He thought of his monochromes, and colour itself, as living presences, not fully belonging to the material world.

Yet Klein was not so advanced as he thought vis-à-vis Malevich. The Ukranian artist's Suprematism had little affinity with the old form of the easel painting with which Klein identified him; from today's perspective, if not Klein's, the cartoon is a misrepresentation in this regard. In the first place, Malevich *did* make monochromes without "matting," perhaps as early as 1915 and certainly later. Part of Malevich's focused experimentation with the black, square leading up to the 0.10 exhibition in 1915 resulted in a dark, possibly black, monochrome – one cannot tell from the extant black-and-white photograph – that is then framed in such a way that it looks in archival photos of the exhibition very much like the other, matted squares (see Nakov, 2002, #S-131). But this is a one-colour painted surface with a frame, a genre that was also exhibited in green by Ivan Puni, perhaps without a frame. Malevich wrote in 1918 that for the "intelligentsia...pictures frames are more readable than paintings" (Tupitsyn, 2002, 17), and at this time he was constantly experimenting with the relationship between the border and its "image." In 1923, two white monochromes from Malevich's circle if not his hand appeared in the "Petrograd Artists of All Trends" exhibition (Douglas, 1989, 167). Both titled *The Suprematist Mirror*, these lost canvases echoed the title of one of Malevich's theoretical essays of this time and reflected the minimal materiality and visibility of the nonobjective world he and his followers sought. Such paintings put Malevich at the beginning not only of the monochrome tradition but also, in the latter case, of the use of "mirrors" in abstraction that is my focus in Chapter 3. Predictably, they were derided in the contemporary press (Zhadova, 1982, 43). In company with all the pioneers of abstraction, Malevich saw his work as a transition to a higher state of consciousness for which most viewers were not prepared. Perhaps he presented his black squares with supplementary framing elements to claim their status as paintings and icons and to lead the audience to an understanding of their nature by presenting them in a familiar context, framed, and in the "red corner" of the room reserved traditionally for icons.[11] Even in this interpretation, however, Klein was right to the extent that he had done something

Malevich apparently had not. The black monochrome, however, was also a social icon, whether in the theatre, as in his design for the backdrop in *Victory over the Sun* in 1913, or in AgitProp excursions. It was a touchstone for Malevich's students, many of whom were oriented to Suprematism – and cured of their aesthetic ills – by coauthoring versions of the painting with the master. Malevich was certainly the first to be so completely identified with the monochrome, as images of his deathbed, his state funeral in Leningrad (the black square functions as an oversized hood ornament on his hearse; it is rumoured that one of the four black square paintings was carried in the procession [Balakhovskaya]). Malevich's coffin and gravesite were also marked by the black square.

This potent identification of Malevich with the black square and the black square with Suprematism and the Russian avant-garde continues. The recent acquisition by the Hermitage Museum of his final black square, likely painted in the late 1920s or early 1930s, is described in the following nationalistic terms: "It was the first time in Russia's modern history that an art-work of such an enormous cultural value was let for public sale. Debates in the press [raised] a number of legal questions regarding the special status of the Black Square, a unique masterpiece that had to be prevented from leaving the country" (Balakhovskaya). The Slovenian group IRWIN exhibited *The Corpse of Art*, a reconstructed version of Malevich's Suprematist deathbed tableau, at the Cornerhouse, Manchester in the spring of 2004.[12] The group's practice of appropriating Malevich's iconic square as a symbol of the failed utopia of the Russian Revolution and thus also the spectre of Soviet totalitarianism is in a sense homeopathic. The exhibition was called *Like to Like*. IRWIN is part of a larger collective called NSK (Neue Slowenische Kunst) that defines its return to Malevich and artists of this period as "Retro avant-garde... the basic artistic procedure of Neue Slowenische Kunst, based on the premise that traumas from the past affecting the present and the future can be healed only by returning to the initial conflicts."[13] The serious question of Klein's anxious cartoon – whether a true monochrome is in some way a picture against a ground or something less specific but more encompassing, such as pure sensibility, as both artists held – is also the context for other revisions of the monochrome. Malevich's pupil and then coworker Strzeminski removed the frame from his many white pieces.[14] Ellsworth Kelly made a *White Square* and *Black Square* pair in 1953 by reversing the ratios of black and white. Manzoni's "Achromes" – no colour instead of just one – responded initially to Klein's Milan exhibition of January 1957 – "Monochrome Proposition, Blue Period" – and brought the form back to everyday materials. The most prominent monochromist of recent times, Robert Ryman, also typically draws our attention to what is and is not the painting. In ways that are overtly sculptural in their commitment to space and that also investigate the imperative that no compositional comparisons can obtain in a true monochrome, both Günther Umberg and Anish Kapoor experiment with light- and sound-absorbing pigments. Kapoor's memorable three-part

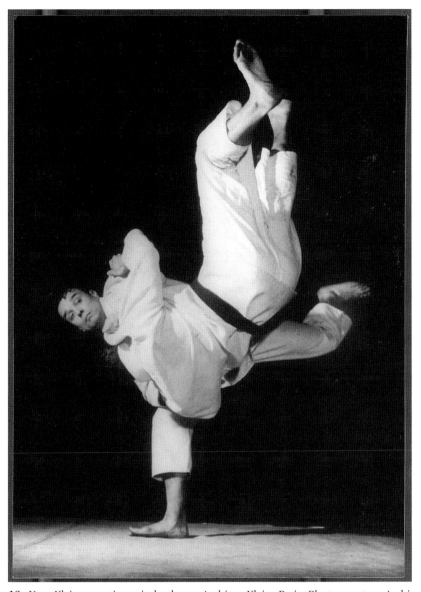

10. Yves Klein executing a judo throw. Archives Klein, Paris. Photo courtesy Archives Klein.
© Estate of Yves Klein/ADAGP (Paris)/SODRAC (Montréal) 2005.

installation of three large, hollow, bisected egg-forms (*Untitled*, 1990) both placed
and disoriented those who interacted with the piece ("viewer" is too limited a
term). Encouraged to stand at the centre point formed by the cones' axial rela-
tionship, the depth of the three circles one could see was literally inconceivable.
The perfect blue circles could be flat or infinitely deep. Both their shape and pig-
mentation also absorbed sound, thus constructing a monochrome environment
without sensory reference points, one that acknowledged Klein in hue, Turrell

in sensory manipulation, and Malevich as the progenitor of simple, monochromatic shape. Umberg's black wall-mounted squares of dammar-treated pigment on aluminum recall Malevich's prototypes but absorb light so completely that any picture/ground dialectic between the black surface and the white wall of the gallery is impossible.

How did Klein's lifelong commitment to judo affect his monochrome adventure? To assess this question in a richer context, I propose to add judo as a fourth, shaping "code" in Klein's work, an equal supplement to the three that McEvilley deems necessary to perceive his innovations fully: Rosicrucian mysticism, art-historical allusions such as the references he makes to Malevich, and the overturning of the traditional, viewer-centred phenomenological relationship between observer and work as the monochromes are set into a shared space (McEvilley, 1982a, 44). Judo was Klein's first passion; I argue that he never abandoned it (Fig. 10). In the early 1950s he envisioned a career as a high-ranking judoka, a champion and teacher of this martial art form, and, despite setbacks and constant battles with the judo association in France, to some extent he realized his goals. Historians have commented on Klein's early promotion to black belt in Nice, where he studied judo from 1947 to 1952, his training at the Kodokan Institute in Tokyo in 1952–1953 – the name means "the school to learn the way" and was the most prestigious in the world – and his controversial promotion there to a "4th-Dan" black belt. The scholarly literature duly notes that Klein made a film in Japan in 1953 (Stich, 1994, 34) about the correct performance of judo "kata" – the formal exercises that constitute the grammar of the discipline – and that stills were used to illustrate his book *Les Fondements du Judo*, published in France in 1954, which disseminated the "true" Japanese style of Kodokan in France. Klein planned two other publications on the subject (Stich, 55). In her detailed 1994 catalogue to a large Klein retrospective, Sidra Stich recorded new evidence of Klein's profound allegiance to the practice and philosophy of this martial art form. At this time, the study of judo was primary for Klein: it was "vast and great, even more, perhaps, than all those psychological worlds constructed by modern intellectualism" (Stich, 33). He supplemented the physical skills taught in the dojo in France with readings in Zen and Buddhist thought, and he deepened his understanding of these underpinnings of Kodokan judo in Japan. "Judo," he wrote early in his training, is "the discovery by the human body of a spiritual space" (Stich, 17). There was a clear connection in Klein's experience between the momentary weightlessness of a judo throw and his notorious *Leap into the Void* of 1960 (Fig. 8). As McEvilley suggests, too, "leap into the void" is a Zen phrase referring the total release from the Self (1982a, 251). In 1961, referring globally to his discoveries in monochromatic nondifferentiation, Klein reported that "I was no longer myself. I, without the 'I,' became one with life itself" (McEvilley, 1982a, 229). This passage is immediately followed by an oft-quoted but enigmatic statement: "It was at this time that I used to say," Klein recalled in this text

from 1961, that "'painting for me is more than a function of the eye. My works are but the ashes of my art'" (McEvilley, 1982a, 229). His words and approach to art closely mirror those of Eugen Herrigel from one of the best known Western source on Zen, *Zen in the Art of Archery*. Herrigel muses over the archery master's avoidance of the eye and what we normally think of as aiming in shooting an arrow at a target. The German student himself becomes a master archer and receives his teacher's best bow in recognition of his accomplishments – or in honour of the "it" that works through the archer. "When you have passed beyond" this bow, the master advises, "do not lay it up in remembrance! Destroy it, so that nothing remains but a heap of ashes" (66). Inasmuch as one may gloss such an enigmatic image used by Herrigel and then Klein, the lesson for art is to live only in the continual process of making, not in the product. Klein completely identified his art with his life and indeed with endangering his life. With his outrageous self-occupied adoption of the moniker "Yves le monochrome" in 1957, as Riout notes, Klein appropriated all the monochromes of the past, present, and future (1996, 27). Yet from the perspective of judo and the Kodokan, his gesture was also an ideal expression of losing oneself in the work, in colour, and in the void. A monochrome is one colour, theoretically, one thing without differentiation. Klein became one with the "it" of Herrigel's text.

Klein extolled the judo inspiration of the *Leap* in gloss on the famous photo published in a section of his mock newspaper, *Dimanche*, of 1960: "The monochrome, who is also a judo champion, black belt, 4th dan, trains regularly in dynamic levitation! (with or without a net, at great risk to his life)... Let's be honest," Klein continued, "in order to paint space, I must put myself on the spot, in space itself" (Stich, 217; McEvilley, 1982a, 235). His theoretical interest in levitation also stemmed from Max Heindel's Rosicrucianism texts (McEvilley, 1982a, 41), though the practice was pure judo. Enthused as he was about Gagarin's reports on the blue earth from space in 1961, Klein felt that using rockets was cheating. One expects Klein to have said that he was there before Gagarin, as he was before Malevich. "It is not with rockets, Sputniks, and missiles that modern man will achieve the conquest of space... it is by means of the powerful but pacific force of sensitivity..." (Klein, 1999, 33). Not only did judoka catch Klein in a tarpaulin on one of his attempts to fly – after the master purposefully landed unassisted once and twisted his ankle (Stich, 213–14) – but, as McEvilley has suggested, the personal risk of this embodied conceptual performance initiated the "self-endangerment" work of Joseph Beuys, Carolee Schneeman, and Paul McCarthy, who himself attempted Klein's leap. Klein wrote that for him, judo was "always abstract and spiritual" (Stich, 33). Clearly anticipating his still-controversial *Anthropometry* performances – which Klein, but virtually no one else, deemed spiritual – he had thought early on of tinting fellow judoka so that the imprints of their bodies could be preserved and contemplated during judo exercises (Arman in Stich, 269, n. 4). Klein appeared in formal attire as the

conductor of these events, orchestrating not only the visual but aural aspects of the evening, his "Monotone Symphony." Describing the first *Anthropometry* in 1960, he reported that "the time of the brush had ended and finally my knowledge of judo was going to be useful. My models were my brushes . . . [I] devised a sort of ballet of girls smeared on a grand canvas which resembled the white mat of judo contests" (Stich, 167–68).

Here then is the other sense of "matting the monochrome" crucial to Klein and typical of his spongelike penchant for finding inspiration beyond the art context. Ultimately, for Klein such a separation simply did not exist, which is why his martial and fine art activities should not be sequestered in our attempt to understand him. Buchloh expresses the standard view, one infused with (warranted) suspicion: "Klein's aspiration to be perceived as a judoka/artist made him the neo-avant-garde's first japoniste, one situated between the ancient culture of judo as a ritualistic performance of war and the contemporary condition after Hiroshima" (1995, 92). But the evidence suggests that judo was much more than another of Klein's publicity stunts. Its continuity with the *Leap* and *Anthropometries* has been noted. We also know that the prototype for their public performance in March 1960 was a private display in the home of Robert J. Godet in June 1958 (Stich, 172). Although Klein's intention was to have the pigmented model cover a white paper sheet on the floor to produce a blue monochrome – as he had envisioned judoka doing – the event degenerated into an erotic spectacle displeasing to Klein, if not Godet. Klein's friendship with Godet exemplifies again the artist's inability to acknowledge his sources, whether in art or elsewhere. In 1952, Godet, a black-belt judoka, published *Tout Le Judo: histoire, technique, philosophie, anecdotes*, which was in important ways the book Klein sought to write but never fully realized. Godet's elegant text expounds fully the connections between judo and Zen that remained integral to Klein's practice from his time in Japan but also stayed mostly in his notes for never-realized publications. As Klein did in *Les Fondements du Judo* two years later, Godet underlined the importance of kata, the fundamental distinctions between the martial arts and sport, and of the integration of judo and life. There was little in Godet's book that Klein would have disagreed with. Yet Klein did have reason to bring out his own work and to make large claims for it: he had studied at the Kodokan and was legitimately part of the Kano heritage. He also had his film stills, which in his book illustrated the accredited kata techniques.

As usual, Klein was both pirate and visionary. The canvas and judo mat were for him interchangeable, or indeed one, as were his "art" and his "life." He seems to have experimented with small monochromes while studying judo in Tokyo. His judo school in Madrid had monochromes on the walls in 1953–1954 (McEvilley, 1982a, 40); his ill-fated "Judo Académie de Paris" was home for three unusually large monochromes, no longer extant, each 7–8 m long – one blue, one white, one rose – as well as the orange monochrome that Klein

11. Advertisement for Yves Klein's Paris Judo School. Photo courtesy Archives Klein. © Estate of Yves Klein/ADAGP (Paris)/SODRAC (Montréal) 2005.

tried to exhibit in 1955 (Stich, 257 n. 11; 56–7). We also know that Klein's book on Judo was initially titled *L'aventure judo* (Stich, 257, n. 8), imbricating this practice with his "monochrome adventure." Klein's private school was viable for less than a year, but he was able to consolidate there the active meditation common to judo and the monochromes (Fig. 11). Both were sources of his stated goal of "sensibility." His collaborator Jean Tinguely recalled perhaps the most significant relationship between judo and art for Klein: balance. "He didn't do it as an athlete. Just as he didn't do monochromes as a 'space.' He didn't have . . . the balance within himself. He did monochromes in a panic . . . He had none of what it'd be normal to have to do monochromes . . . an equilibrium. He was the most

unbalanced man – totally unbalanced. He did monochromes as an iconoclastic anti-painter" (Tinguely, 49). Klein was an iconoclast because he would not create images, even paintings, but rather realms of sensibility. He was not a specialist in one medium but a consummate experimenter who lived the confluence of his art and life in every present moment, as both Zen and judo taught. Klein took his judo studies extremely seriously and derived some sense of balance from his high achievements. His partner in the late 1950s, expert judoka and architect Bernadette Allain, reported that "on the judo mats he was serene, strong, and inwardly at peace. He had learned in Japan the true judo, which was nonexistent in the French schools – judo as intensive discipline and ascesis, which confers on the body itself a knowledge that has never passed through the intellectual mind" (McEvilley, 1982a, 39). It is therefore all the more surprising that Stich, despite her detailed research into Klein's judo activities and willing acknowledgement of their importance, claims that Klein's visual art eventually overtook his interest in the martial arts. Thomas McEvilley initiated this "moving on from judo" topos by suggesting in his masterly 1982 catalogue on Klein that the artist evolved from the " 'kingdom of judo' in Spain" to the "kingdom of art in Paris" (1982a, 41). In the same catalogue, Nan Rosenthal elaborated this version of events: by mid-1954, "a career in the sport, which he had seriously contemplated, was apparently no longer a possibility for him. This point marks the real beginning of his career as an artist" (97).[15] Stich sets this transition later, after he stopped teaching. Because he was traveling frequently to Gelsenkirchen, Germany, for a major commission to decorate the new theatre there, Klein had trouble fulfilling his commitments as a judo teacher at the American Students and Artists Center, where he had taught since 1955, and did not have his contract renewed in 1959. He did not teach formally after this time. To suggest as she does that Klein "clearly had reached the point where his identity as an artist had surpassed his identity as a judoka" and that this and other difficulties conspired to bring an "end to his active involvement with judo" (Stich, 257, n. 16), however, is to overstate the case in a way that both flies in the face of Klein's activities before his premature death in 1962 and to miss an important dimension of his devotion to the plastic and martial arts.

For Klein, as a Kodokan judoka, judo was not a mere sport; he wrote his book and taught his classes to establish in France a fuller sense of the martial art.[16] Again, what difference does it make if we agree that Klein remained a judoka after he stopped teaching? Kodokan judo, the style Klein learned at its source, stressed the integration of body and spirit in the service of more than the self. Professor Jigoro Kano, the founder of judo and the Kodokan school, wrote: "The aim of judo is to utilize physical and mental strength most effectively. Its training is to understand the true meaning of life through the mental and physical training of attack and defense. You must develop yourself as a person and become a useful citizen to society."[17] In his comportment and in *Les Fondements du Judo*, Klein actively shaped his identity as an inheritor of the tradition of judo founded in

the 1882 by Kano, whose stern image is on the frontispiece of Klein's publication. Here we read the founder's statement that "the katas are the aesthetic of judo." On the next page is a photograph of Risei Kano, son of the founder, president of the Kodokan and of the Japan Judo Federation when Klein studied in Japan. Following this introduction and further establishing Klein's lineage and legitimacy are photos of his 4th dan certificate and a picture of Klein with Risei Kano at the Institute. Risei Kano wrote to Klein in 1953 on his achievement of the 4th dan: "Judo of the Kodokan, as you already know . . . [is] a moral ideal: it is the accomplishment of the perfect personality" (Stich, 37). No one would hold that Klein went very far in perfecting his immensely difficult personality, but neither did he give up the attempt. Though Klein did not study Zen extensively, he did explore, and more importantly, endorse, its relationships with judo (Stich, 40). The Zen of judo – or any martial art – is expressed in its seamless integration of the physical and the spiritual lived in the moment of action, exemplified by the kata. Zen finds the fullest sense of life to be that without any conscious purposiveness, without any differentiation between action and contemplation, inner and outer. There is every indication that Klein held such views as he focused on bringing an authentic Japanese interpretation of the judo kata to France (and to Spain, where he also taught extensively and graduated the first judo black belts in that country) with his book and his teaching, as we see on the advertisement for his Paris school, where he notes his Japanese qualifications (Fig. 11). Judo was one of his ways to a Zen sense of nondivision, a sensibility at the core of his aesthetic.

Klein's work may aptly be described as a sensible reminder or remainder of this belief. He did not want his monochromes to be a specialty within an artistic arsenal. They went beyond the genre of abstraction and especially beyond the gestural work of his famous mother, Marie Raymond, and all other tachiste work of the time. Klein worked on a larger and larger "canvas." His "Blue Revolution" sought to "impregnate" the world with pure sensibility. Judo's insistence on and then transcendence of technique is his expressed inspiration to this expanded purview. In a paragraph that typically meanders from thought to thought, Klein yokes his "aim . . . to tear down the temple veil of the studio. To keep nothing of my process hidden," he elaborated, could lead to the spontaneous invention of "new gimmicks of technique just as valuable as they had ever been, and just as unimportant." He refers to his art here, but then makes the analogy to judo: "'With or without technique, it is always a good thing to win' had been my motto in Japan . . . They taught me in judo that one must achieve technical perfection in order to be able to ignore it" (McEvilley, 1982a, 230). His many forms and projects might, as Stich notes, be interpreted as "divergent" (8), but his commitment to a Zen practice of the martial arts suggests another, more accurate interpretation. Klein sought to put himself and art in as many unusual predicaments as possible, all in the "now" or present. The purposeless purpose was not

to focus on style, technique, or showmanship, but rather to see what would transpire. Again, Herrigel is the likely inspiration: "The right frame of mind for the artist is only reached when the preparing and the creating, the technical and the artistic, the project and the object, flow together without a break.... The pupil sees himself on the brink of new possibilities, but discovers at the same time that their realization does not depend in the slightest degree on his good will" (43). Klein knew this text and others influential at the time, such as the writings of D. T. Suzuki (Westgeest, 1996, 110). What he believed about judo and brought home both personally and professionally is summed up in the following undated note: "The ordinary judoka does not practice spiritually but physically and emotionally. The true judoka practices spiritually and with a pure sensibility" (Stich, 256, n. 40). Just as Klein refused to separate the spiritual from the physical, so too should we be wary of the Hegelian drum beat that encourages us to think that Klein's art overtook his incarnation of judo principles. Artists and art do not need to be seen to progress. The monochrome, Rosicrucianism, and judo, plus many other initiatives and quirks, combined and mutated in Klein to form an "impure" but somehow consistent life as artwork. Klein believed that "painting is no longer a function of the eye today; it is a function of the only thing that is in us that does not belong to us: our LIFE" (Weitemeier, 1994, 34), which made him more like Leonardo da Vinci or Duchamp, or indeed Malevich, than the specialists typical of modernism. Klein seminally sought to defeat the autonomy of the individual senses, media, and the art object. Unwittingly but prophetically, he worked against Greenberg's theory of media "competence." The elements of space, duration, and touch crucial to his sense of judo in part led to Klein's holistic aesthetic. "Art does not depend on vision," he wrote, "but on the sensibility that affects us, on affectivity therefore, and on that much more than all that touches our five senses" (Stich, 138). Are Stich and McEvilley compelled to demote the import of judo because they assume, incorrectly, that visual art is primarily about the visual? Why is it that these and other scholars are comfortable detailing the importance of Max Heindel's Rosicrucian cosmology to Klein, a fairly clear case of source study in the discipline, for example, but stop short regarding the full impact of the martial arts?

Stich warrants that Klein's early monochromes "are conceptually more in tune with an Eastern, Zen approach to life . . ." (65), but especially as her account evolves, largely discusses Zen as a sensibility without its connection to judo practice. There is ample evidence that Klein continued to "practice" judo after his formal teaching ended in 1959. Judo students supported his leap into the void and he had pictures of his judo moves taken right after his documented *Leap* in October 1960 (220, n. 31). Members of the same group had acted as body guards at the notorious, almost riotous, opening of Klein's exhibition *Le Vide* in Paris in April 1958. The journal *Dimanche*, with its illustrations of and references to judo, went on sale on November 27, 1960. Stich also notes that Klein's long battle for

recognition by the French Judo Federation, the strongest such organization out-
side Japan, ended belatedly in success on April 24, 1961 (257, n. 16). Klein felt
vindicated. He was also asked to officiate at an international judo meet after he
ceased teaching, and during his largely disastrous exhibition at the Castelli Gallery
in New York in 1961, he annoyed everyone by boasting about his judo prowess
(Stich, 236). In living a radically expansive, inclusive life to the extreme, Klein
embodied what has become the hallmark of the most acclaimed artists since his
time: a protean creativity that refuses to respect modernist boundaries of medium
or method. This was his ascesis, as Allain put it, his Kodokan "discipline." The
American artist Larry Rivers put these strands of Klein's character and responses to
him together nicely. Writing in 1967, Rivers recalled that in New York, "Yves was
dismissed as a European upstart whose work was somehow derived from Ameri-
can art . . . I'm sure it made them feel better," he said, "but it hasn't done away for
a moment with the zany originality of what Yves brought together in the name
of art" (Rivers, 1967, 76). Klein's genial reductions, Rivers saw, came "through
Zen and Judo. It took twelve years for Yves to become the most naturalistic and
elemental artist of our times" (75).

Abstraction and especially the monochrome became, for many of these artists
as they were for Klein, not special areas of competence but rather experiments,
infections, contagions. Klein refers to the appeal of Japan and judo in the 1950s
as a virus in the positive sense. In a letter to his aunt and benefactor dated Novem-
ber 1, 1955, for example, he described his vision of another publication on judo
in these terms: ". . . all western judokas dream of the same adventure that I had
in going to study judo in Japan. I will romanticize and arrange this with a great
deal of the 'marvelous' and will thus define for eternity (I hope), one of the great
psychological viruses of the century" (Stich, 55). This expansion of the purview
of abstraction accords with Philip Guston's prophetic idea of the "adjustment of
impurities." The radicality of recent abstraction is not in the self-containment
of the visual language found in Kelly or early Caro, for example. This may have
been the case in the mid-20th century, as Greenberg and others argued so vigor-
ously, but assertions of aesthetic autonomy seem dated now. I argue against both
the possibility and desirability of autonomy in and of the aesthetic, beginning
with one of the touchstones of this view, Michael Fried's now classic views on
abstraction and minimalism, which he first articulated in the 1960s and defends
to this day. In his famous article "Art and Objecthood," first published in *Art-
forum* in June 1967, Fried, in a recent account, suggested that he had "described
the emergence of a basic opposition between the radically abstract painting and
sculpture I most admired and what I characterized, pejoratively, as the 'literalist'
and 'theatrical' work of a group of artists usually called the Minimalists" (1998,
14). Theatricality is defined by a particular relationship between viewer and work,
one that "solicited and included the beholder in a way that was fundamentally
antithetical to the expressive and presentational mode of the recent painting and

sculpture I most admired" (41). Although Fried is right to caution us against draw-
ing easy connections between his art criticism and his subsequent art historical
project of tracing the history of what he came, by 1980, to call "Absorption and
Theatricality" in the tradition of French art and criticism from ca. 1750 to ca.
1870, the opposition of these terms in his thinking is important to what I want to
argue about recent abstract art and perception. Fried wrote recently that "no one
with even the sketchiest awareness of recent history needs to be told that 'theatri-
cality'... went on to flourish spectacularly while abstraction in my sense of the
term became more and more beleaguered" (14). He stopped writing art criticism
largely for this reason. My claim is not the empirical one that theatrical art forms
won the day but rather that the interactive, social, and impure paradigms that they
presented offered a competing and substantial view of what abstraction could be.
A different relationship of absorption and theatricality functions in significant
abstract work from the 1960s to the present, beginning with Klein.

For Michael Fried, absorption in the French modernist tradition, which to
some extent figures as the genealogy of the mid-20th-century abstraction that
he championed (51), required that the painter "negate or neutralize... the pri-
mordial convention that paintings are made to be beheld" (47–8). Artists show
figures completely absorbed in their activities – in a Chardin or Greuze or David,
for example – to the extent that, Fried continues, "the painting appeared self-
sufficient, autonomous, a closed system independent of, in that sense blind to,
the world of the beholder" (48). That this grand fiction of the beholder's absence
drove much of modernism is irrefragable. But there were and are many competing
models of reception, one of which I would like to call the "infectious" as opposed
to the absorptive in Fried's prophylactic sense, in which the viewer and work are
held apart. This model is indeed more literal in the sense that it acknowledges
as a positive element the participation of the audience in the work. In exploit-
ing this relationship, and thus to some extent blending viewer and work, Klein
worked in a much more optimistic vein than, for example, Jonathan Borofsky
in his somewhat cynical *Chattering Man* (1983), where the mechanical viewer in
this installation seems – like Narcissus – only to be able to respond to what he
takes as an image of himself (in an abstract frame). Although there may be too
much "chattering" around abstraction, there is in Klein's work also a recognition
of the positive force of its emanations. His memorable sponge sculptures, for
example, were anthropomorphic bearers of "absorption" in a physical sense.[18]
The literalness of absorption was to be encouraged if art was to have a social
force: a theatricality of absorption defined the desired infection and transforma-
tion of the viewer through art. Klein emphasized the physical and metaphorical
receptivity of his sponge sculptures (Plate 1). Many were used to apply pigment.
Others he titled *IKB Watcher* and *IKB Reader*, called them "portraits," and cele-
brated these "readers of my monochromes who, after having seen, after having
traveled in the blue of my paintings, come back totally impregnated in sensibility

like the sponges" (Stich, 161). The prominent restorer of Klein's work, Jean-Paul Ledeur, certainly took care of these anthropomorphized "patients" dermatological needs after the fact. In a nicely posed image of Ledeur injecting pigment into an anemic sponge, we notice that the writing on his work coat states: "Art Doctor." Klein attempted to remove any permanent barriers and distinctions between art and life. Of course he was anything but alone is promoting a tradition of impure, environmental abstraction that was opposed both theoretically and in practice to the purity model presented by Greenberg and to some extent Michael Fried. Kazimir Malevich's odd but potent theory of the "additional element" – wherein change in art and society proceeds by analogy with the spread of tuberculosis, diagnosed and treated by Malevich as physician – is again the progenitor.

2. Rauschenberg's Antidote

Yves Klein promoted his art and vision through controversy. "All my exhibitions have been 'events,'" he wrote in a text accompanying a catalogue of the Zero Group, which he inspired through such spectacles (1973, 94). His opening at the Leo Castelli Gallery in New York City in April 1961, however, although scandalous in several respects, failed to deliver the accolades and widened reputation that Klein expected and felt he deserved. The exhibition of blue monochromes created none of the buzz he traded on in Europe and little of the publicity of his 1957 presentation in Milan, of *Le Vide*, or of the events and objects staged for the *Theatre of the Void*. In New York, few attended, reviews were negative, and no work was sold. Klein openly suspected sabotage and blamed a purportedly jealous Robert Rauschenberg, by then a Castelli artist who had shown there just a year earlier and with whom Klein had exchanged words.[19] Whatever the specifics and tone of their unpleasant interaction – accounts vary – it is tempting to inflate it into a symbolically negative, even agonistic, meeting between European and American abstraction as embodied by the monochrome. It is the case that Rauschenberg's and Susan Weil's blueprint nudes of 1949–1951 appeared before Klein's, and the American's passionate return to the avant-garde[20] monochrome with his white and black paintings of 1951–1953 almost certainly preceded Klein's work of this type, unless one takes literally the French artist's retrospective position in *Yves: Peintures* of 1954, where he documented putatively earlier work. As Benjamin Buchloh has insisted in this regard, and as the profound interaction between Klein and Malevich illustrates, however, temporal precedence is not the central issue: instead, "these phenomena must be addressed in a way that avoids mechanistic speculations about priority and influence."[21] Klein's use of coloured paper samples in this artist's book is in any case more historically significant than being the first to renew the monochrome in the post WWII period.[22] Unfortunately for a renewed reading of the monochrome, Rauschenberg's and Klein's experiments are not often compared in detail because the question of rivalry

(personal and national) too often predominates.[23] Certainly Rauschenberg had cause to be annoyed with Klein's pretensions to precedence in and ownership of monochromy, just as Ellsworth Kelly was, in these terms, justifiably aggrieved when he first saw Rauschenberg's white paintings, which he felt he had foreseen during his time in France.[24] Leo Steinberg reports a contemporary conversation that bears on these issues. "A party, early fall '61: I was sitting with Rauschenberg and Jasper Johns, and we were talking about the problem young artists face when they find themselves doing what someone else has been doing already. Johns said, well, you change course and do something else. And then Rauschenberg added: 'You see, you don't want to disturb'" (Steinberg, 2000, 10). "I always had enormous respect for other people's work, but I deliberately avoided using other people's styles," he said in a 1968 interview (Kostelanetz, 1968, 105). Perhaps he felt that Klein should have recognized *his* claim to the monochrome and moved on. That Klein had, by 1961, already developed his work well beyond the IKB paintings and was therefore frustrated with Castelli, who would only show what the artist thought was work that had been superceded in Klein's quest for the immaterial, serves to underline both artists' ignorance of the field at the time of their meeting. Looking beyond these conflicts, however, and without erasing the many differences between Klein and Rauschenberg, it is instructive to recall that these reinventors of the monochrome shared much, including a will to take this form beyond the frame and beyond the individual artist's psyche, a principled resistance to the dismissive tag "Dada,"[25] significant references to the monochromatic practices of the avant-garde, and, most tellingly for my arguments in this book, the deployment of the monochrome in a medical, even homeopathic, way designed not only to reform contemporary art but also to work against the autonomy of the aesthetic.

The narratives around Rauschenberg's *White Paintings* begin a decade before his meeting with Klein (Fig. 12). Fresh from an exhibition at the Betty Parsons Gallery in New York City in May 1951 and still studying at Black Mountain College, an exuberant Rauschenberg wrote to Parsons in October about his newest work. His comments have often been quoted but their urgency is undiminished. The *White Paintings* were for him "almost an emergency" to the extent that he was famously willing to forfeit any future prospects with the art dealer for the chance to show them immediately. "They are large white (1 white as 1 GOD) canvases organized and selected with the experience of time and presented with the innocence of a virgin. Dealing with the suspense, excitement and body of an organic silence, the restriction and freedom of absence, the plastic fullness of nothing, the point a circle begins and ends . . . It is completely irrelevant that I am making them," he concluded dramatically. "*Today* is their creator" (Hopps, 1991, 230). In a later interview, Rauschenberg described more prosaically why the six white monochromes he made at this time held such import: "I was so innocently and indulgently excited about the pieces because they worked. I did them as an

12. Robert Rauschenberg, *White Painting* (three panel), 1951. Oil on canvas. 182.88 cm × 274.32 cm. San Francisco Museum of Modern Art, purchased through a gift from Phyllis Wattis. © Robert Rauschenberg/VAGA (New York)/SODART (Montréal) 2005.

experiment to see how much you could pull away from an image and still have an image. I was frustrated because there was a restriction that something had to have an edge" (Rauschenberg, 1987, 45). Parsons waived her chance to exhibit what became some of the most controversial works of their time; several black-and-white monochromes (the two- and seven-panel versions) and Rauschenberg's "elemental sculptures" were first exhibited publicly at the Stable Gallery in New York in the fall of 1953. Different constellations have been shown several times since.[26] Though their art world notoriety would come only in 1953, Rauschenberg's monochromes were much discussed at Black Mountain from their inception. As Hopps suggests, they were "loved by few, hated by many, and generally misunderstood" (Hopps, 1991, 65). It is the nature and importance of this "white mischief" that concerns us here.

Radically simple but calculated for complexity, the *White Paintings* were neutral only in the sense that they were predictable in surface and dimension. Rauschenberg applied white house paint with a roller to different but regularly sized canvases designed be shown solo or in various modular combinations.[27] Although he wished to break the then-dominant expressionist circuit that coupled the artist's psyche to his materials and their application – "it is completely irrelevant that I am making them" – the paintings were anything but innocent. His suggestion to Parsons that these works were "organized and selected with the experience of time" implies that they were composed not only in themselves to

literalize the edge and to explore the minimal limits of the "image" but also strate-
gically with reference to art's history, past and present. His immediate interlocu-
tor was Barnett Newman, several of whose *Onement* paintings were shown at the
Betty Parsons Gallery in 1950 and 1951. As Charles F. Stuckey aptly suggests, there
was a practical advantage to modularity and the "real" lines between Rauschen-
berg's multipart works: they were portable in a way that Newman's large, one-
piece canvases with their characteristic painted zips were not (Stuckey, 1997, 35).
Newman's surfaces had both depicted and actual edges; Rauschenberg's worked
as images with only the latter, and these were expandable in novel ways. Para-
doxically, the physical edges of the module allowed the painting an extension
limited only externally by its place of display rather than by the dimensions of
the support, as in Newman's case or indeed that of most other painting on canvas
at this time. With an inventiveness characteristic of the artist, the new, "practical"
edges of the white and then the black monochromes freed Rauschenberg's work
from the individual picture frame and from the demands of expressivity.

To engage Newman's work in this way was not a David-and-Goliath strug-
gle, as we might think, looking back. The negative response to Newman's 1951
exhibition at Betty Parsons' was sufficient to keep the artist from exhibiting
again for seven years. As Feinstein writes, "that Rauschenberg chose to fol-
low in Newman's footsteps shows his willingness (and perhaps eagerness) to
court . . . controversy" (30). The monochromes were strategic *within* the art world
because Newman was himself addressing the avant-garde traditions of abstraction
and the monochrome; Rauschenberg has always opposed their contemporary
designation and dismissal as Dada gestures destructive of art, as Klein also did.[28]
In the first place, by anticipating that the white monochromes would need to
be repainted because the house paint would yellow, Rauschenberg made a com-
mitment to the ongoing presence and role of his canvases. White monochromes
were repainted in 1965 and again in 1968, when his then-assistant Brice Marden
recreated an "official," five-piece set. As Hopps emphasizes, these are dated 1951
(Rauschenberg, 1991, 80).[29] It was important for Rauschenberg to maintain the
surface quality of these monochromes because he came to see them as projection
and reception screens.[30] In 1968, when the white monochromes were exhibited
together at Castelli's, Rauschenberg insisted on their lasting significance: "No one
has ever bought one; but those paintings are still very full to me. I think of them
as anything but a way-out gesture. A gesture implies the denial of the existence
of the actual object. If it had been that, I wouldn't have had to have done them"
(Kostelanetz, 1968, 95). But he did and redid them so that, in John Cage's terms,
they would respond to shadows, to dust, in short, to the quotidian realities of
an environment and to being seen by an audience. Though the whites were not
meant to be touched or manipulated by viewers as some of Rauschenberg's sculp-
tures and constructions exhibited with them in the 1950s were, they did register
and act in their surroundings, however quietly. He remained devoted to their

production of "suspense, excitement and body of an organic silence." As Branden Joseph argues, building on Hopps' scholarship, Rauschenberg's friendship and collaboration with Cage encouraged this perception of the paintings' fortuitous "transparency" (2000, 96ff).[31] But as Cage would later say about Rauschenberg's affinity for Zen, the tendency was already there in his thoroughly corporealized and social description of his white monochromes of the 1951 letter to Parsons.[32] Not unlike Klein's blue sponge "readers" and *Cosmogenies*, these paintings facilitated and celebrated a theatrical absorption that linked painting, location, and spectator. One or possibly two of the white monochromes had a role in Cage's multimedia work staged at Black Mountain in 1952 and later titled *Theater Piece No. 1*. Though the ceiling-suspended white monochromes did not, apparently, work literally as projection screens in this performance, they were palpably part of the work and would have figured in Cage's later vision of them as "landing strips" for vagrant luminosity. It was their ability here and in the 1953 New York show to transmit what Rauschenberg had called accurately and poetically "the plastic fullness of nothing" that inspired Cage's notorious "silent" piano work *4' 33"*, first performed by David Tudor on August 29, 1952. Here the piano remained mute so that other sounds would inevitably emerge, just as the white of Rauschenberg's monochromes trapped and temporarily displayed elements in their environs. Literal silence was as impossible for Cage as literal emptiness was for Rauschenberg.[33] Cage recalled his reaction to Rauschenberg's *White Paintings*: "I responded immediately," he said, "not as objects, but as ways of seeing. I've said before that they were airports for shadows and for dust, but you could also say that they were mirrors of the air" (Cage, 1990, 26). Again parallel to Klein's, Rauschenberg's monochromes moved dramatically away from the ideology of the autonomous work of art.

There was another reason why Rauschenberg needed to have his *White Paintings* repainted in the 1960s: he had self-consciously used some of the 1951 originals in other paintings. White monochromes found their place, much transformed, in Combines such as *Yoicks* (1954), *K249765* (1956), *Trophy II (for Teeny and Marcel Duchamp)* (1961), *Stripper* (1962), and, most tellingly for the contexts I am developing here, *Collection* (1954).[34] Recycling materials, techniques, images, and meanings is, of course, typical of the artist and a significant part of both his popularity and historical legacy. The practice began in necessity and expediency – like most artists starting out, he needed materials and had little to buy them with – but grew into an informal method, one that exploited the aleatory and sated the need for constant experimentation that has always been crucial to Rauschenberg. The practice may have closed doors initially. Rauschenberg relates a colourful story of a studio visit by Betty Parsons and Clifford Still: "Betty was upset because she had come to see the paintings that I had showed her before . . . and I had painted over them all! Well, I thought that the new paintings were better" (Rauschenberg, 1987, 45). Given that Rauschenberg was, in the

mid-1950s, making an art that was transparent to the world rather than sepa-
rate from it, that both trapped and mirrored back its activities and materials –
a practice that began with the *White Paintings* – it seems right not only to view
the Combines as "almost literal 'receptors of the environment,'" as Feinstein has
it (32), but also to understand the white monochromes particularly as elements
that were ingested by two "bodies" of art, Rauschenberg's own and that of his
time. Rauschenberg's habit of incorporating *White Paintings* in the *Combines* was,
in ways that are analogous to repainting the "originals" to give them a longer life,
a conscious and effective strategy of transmutation.[35]

Joseph succinctly assesses the importance of *Collection* and establishes
Rauschenberg's place in recent art's history: "The destabalization of represen-
tation first effected within . . . *Collection* would help liberate a generation of subse-
quent artists" (2003, 117). We could call this innovation postmodern, as Joseph
justifiably does (15ff), but to comment in any detail here on that move would
be to take a detour from which we might never return to the monochrome and
to abstraction.[36] Closer to my purposes is to think about the ways the *White
Paintings* happily flaunt autonomy and the separation of media[37] in this trans-
position and also about Rauschenberg's dialogue with the avant-garde, this time
with one of the pioneers of the monochrome and of its putative finality, Alek-
sandr Rodchenko. *Collection* (Fig. 13) is clearly built on a tripartite modular base,
though the three white monochromes from 1951 were initially repainted in the
primary colours and enclosed in an outer frame and each has subsequently been
further divided in the bottom third into a further three, irregular colour bars.[38]
Little if any of the underlying white is visible, which makes one wonder what
difference it makes that the artist cannibalized his own "work" here and in the
other Combines mentioned above (contradicting his early assertion to Parsons
that the white monochromes were not Art with a capital *A*). Is the result dif-
ferent than in, say, *Co-Existence* of 1961, where Rauschenberg simply prepared
a white ground on which other elements collaborate, or even his *Pyramid Series*
from 1974, which uses monochromatic white paper? Phenomenologically – to
the eye innocent of this heritage and Rauschenberg's technique – there is no dif-
ference. We cannot *see* the entire genesis of the work. But if we know more, we
know better. Amounts of pigment, newsprint, and other detritus have landed on
Rauschenberg's perhaps overly commodious surfaces. Where, or on what, this
material lands is as important to an interpretation of the work as what arrives
and how it is disposed on the surface. *Collection* can be seen to combine the ges-
tural and field-oriented tendencies of abstract expressionism – de Kooning and
Newman, to simplify further an already primitive dichotomy – both of which
and whom Rauschenberg understood, respected, and sought interaction with,
but this reading holds only if we know that former monochromes in many
senses support the subsequent accretions. These additions are material but also
hermeneutic. Between their white state and *Collection* as we now see it, the three

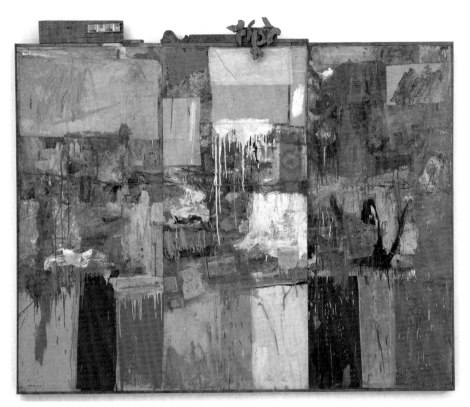

13. Robert Rauschenberg, *Collection* (formerly *Untitled*), 1954. Oil, paper, fabric, and metal on wood. 80 in. × 96 in. × 3 1/2 in. (203.2 cm × 243.84 cm × 8.89 cm). San Francisco Museum of Modern Art, gift of Harry W. and Mary Margaret Anderson. © Robert Rauschenberg/VAGA (New York)/SODART (Montréal) 2005.

monochromes picked up dramatic pigmentation that echoed – apparently innocently, as in Kelly's case too[39] – Rodchenko's famous 1921 *Pure Red Color, Pure Yellow Color, Pure Blue Color*, which I have discussed in connection with Klein and Newman. Rauschenberg did not need to know about the Russian artist's succinct presentation of the "last" autonomous painting to anticipate Newman's question, "Who's Afraid of Red, Yellow, and Blue." Mondrian's example of primary painting was close at hand. In general, it was not a large leap for an artist experimenting with black, white, and red monochromes to make some in the primary colours. In *Collection* as in their initial cladding, the monochromes were receptive. Asked in 1968 if the white monochromes were "a gesture toward a dead end," Rauschenberg disarmingly replied, "No. It just seemed like something interesting to do. I was aware that it was an extreme position; but I really wanted to see for myself whether there would be anything to look at. I did not do it as an extreme logical gesture" (Kostelanetz, 1968, 94). No Dada antiart, no endgame, but no lionizing of the past, either, whether his own or that of the monochrome. On the contrary, by remaining in the body of Rauschenberg's work for a time,

these monochromes extended a discourse of painting in a wildly mutated manner.

Rauschenberg's pioneering creation of receptive, "social" monochromes denied their potential endgame[40] in self-consumption and exhaustion and tied him to other directions taken by this genre in its earliest incarnations and in the work of Klein. As the genesis of *Collection* shows, the monochrome also performed as a catalyst and support within Rauschenberg's own evolving work. It might seem odd to suggest that there is a meaningful parallel between the additive, collecting activities of the *White Paintings* and Rauschenberg's most notorious early work, the *Erased de Kooning Drawing* of 1953 (Fig. 14), which was made by painstakingly erasing a drawing by the famous abstract expressionist. Yet in Joseph's terms, connecting Rauschenberg again to Cage and to Henri Bergson, this piece can "be understood as liberating the work from the limitations of imagery and individual expression and opening it to the reception of contingent visual sensations" (2000, 115). In addition, there is a connection between Cage's procedures in the composition of *4′33″* in 1952 and Rauschenberg's reopening of de Kooning's drawing in the following year. Cage apparently wrote his score with measures and rests that were performed as absences and silences (Solomon). As in the music, Rauschenberg's process of erasure yielded other "sounds" or graphic marks, some of which – the traces of the de Kooning drawing on the back of the sheet, for example – were already there but either invisible or considered beneath the limen of purposeful art. Rauschenberg was in the early 1950s acting on the notion of recycling materials of both "high" and "low" provenance in and through his pictures. *Erased de Kooning Drawing* is an antiheroic homage to de Kooning and to "Art" in a way congruent with how the *White Paintings* acknowledged Newman, that is, on the senior artist's terms but with a decidedly challenging difference. Rauschenberg hand laboured for four weeks to erase the darkly and densely articulated de Kooning (Rauscheberg, 1987, 51). Like de Kooning, he used a pencil. Rauschenberg also established in a subsequent interview that the project both expunged personal aesthetic problems and looked forward to new work: "It was nothing destructive. I unwrote that drawing because I was trying to write one with the other end of the pencil that had an eraser," he told Tanya Grosman. "I was trying . . . to purge myself of my teaching and at the same time exercise the possibilities [,] so I was doing monochrome no-image" (McKendry, 1976, 36).[41] Joseph holds that Rauschenberg's memorable descriptor refers to the *Erased de Kooning Drawing* (2000, 114–15), which it does in a general way. But the syntax – "so I *was* doing monochrome no-image" – can also be construed to refer to the artist's contemporary practice in the *White Paintings* and other monochromes, which he executed in part as "an experiment to see how much you could pull away from an image and still have an image" (Rauschenberg, 1987, 45). All of Rauschenberg's many white monochromes share the same strategies. We can think of the *Erased*

14. Robert Rauschenberg, *Erased de Kooning Drawing*, 1953. Traces of ink and crayon on paper, with mat and label on gold-leaf frame. 25 1/4 in. × 21 3/4 in. × 1/2 in. (64.14 cm × 55.25 cm × 1.27 cm). San Francisco Museum of Modern Art. Purchased through a gift of Phyllis Wattis. © Robert Rauschenberg/VAGA (New York)/SODART (Montréal) 2005.

de Kooning Drawing as his strategic emplacement of the monochrome – the heart of abstraction – not only as an active and transformative agent in his own work but also into the acknowledged centre of abstract expressionism in the 1950s, Willem de Kooning.

We have seen that Malevich offered his theory of the additional or supplementary element as a way to explain and induce progressive change in art. Inspired in turn initially by Taras Polataiko's reinvigoration today of Malevich's novel ideas and General Idea's infection by Klein, I have sought to develop a "medical" model of infection and change within the body and ongoing history of abstract art since the 1960s. The epidemiological basis of Malevich's theories

is clear. We can legitimately extend his metaphorical thinking into our own times when the virus, in addition to the TB bacterium (which, lamentably, still makes headlines) is a reality causing widespread fear. Neither Klein nor Rauschenberg address Malevich's theory of the supplementary element, but their deployment of the monochrome can be understood in these terms. To do so brings them into closer contact than is usually allowed and reveals, to summarize, that both used the monochrome to generate controversy around their art; both sought to extend monochromy beyond the studio, Klein with his ever more fantastic blue revolution and Rauschenberg in his collaboration with Cage on *Theater Piece No. 1* and the ingestion of white monochromes by his Combines. In concert, too, these artists resisted the frequent suggestion that their antics were antiart. Instead, they consistently deployed the monochrome against the aesthetic of autonomy to establish a close and at times critical relationship between art and the rest of life. These and other artists thus used the monochrome "homeopathically," that is, they administered like to like in a productive, if paradoxical, reversal of the usual sense in which the monochrome is taken as the pure essence of abstraction and abstraction is the core of modern art. That what I view as Malevich's medical model of abstract art's purpose can be used to other ends is dramatized by Clement Greenberg himself.

Greenberg's writings are as complex and nuanced as they are plentiful. His ideas were amenable to oversimplification and thus to almost religious adherence by some and vehement rejection by others.[42] Like it or not, however, his powerful narrative of modernism's evolution remains the dominant view of midcentury art, a story with abstraction as its climax. In "Towards a Newer Laocoon" of 1940, Greenberg argued for a new ranking of the arts based, as in the famous 1766 book by Lessing and on ancient and Renaissance systems of ordering the arts, on their differences and separation. Greenberg's watchword was purity: "Purists make extravagant claims for art, because usually they value it much more than anyone else does . . . We must respect this." Responding to Meyer Schapiro's antiformalist essay the "Nature of Abstract Art" of 1937 – itself a spirited rebuttal of Alfred Barr's delineation of the history of abstraction along formalist lines at the Museum of Modern Art in New York in 1936 – Greenberg goes on to claim, "It is quite easy to show that abstract art like every other cultural phenomenon reflects the social and other circumstances of the age in which its creators live, and that there is nothing inside art itself, disconnected from history . . . But it is not so easy to reject the purist's assertion that the best of contemporary plastic art is abstract. Here the purist does not have to support his position with metaphysical pretensions" (1, 23). The transcendental strain in much early abstraction is the sort of supposedly extraaesthetic "pretension" that Greenberg here rejects in the name of purism. Supposedly, we can simply see the quality of recent abstraction. He claims that modern art, thanks to the exclusionary rigours of abstraction, has

a future outside the blending of categories that he calls "kitsch" – and thus a role in our culture – *because* it turns self-critically inward. This powerful and ulti- mately historical argument was codified by 1959–1960. It is strong stuff. "Every civilization and every tradition of culture seem to possess capacities for self-cure and self-correction that go into operation automatically," Greenberg wrote in a moment of typically passionate Kantianism (4, 76). He calls abstract art an "anti- dote" (4, 80) to society's afflictions and claims that its "unique value" in the post-WWII period "lies in the high degree of detached contemplativeness that its appreciation requires" (4, 82).

In health care and in the Malevichian lineage set out here, however, contact and infection rather than prophylactic detachment promise change, which is why the analogy with homeopathy seems apt. Thinking of Greenberg's assertions about abstraction in light of Rauschenberg's radically different choices highlights a crux in the history and interpretation of modernism in the visual arts. As an antidote, poison, or medicine, abstract art has lead to both the largely inward- looking, self-critical, and "formal" values championed by Greenberg in the art of the 1950s and 1960s and to the impure, eclectic, strategic, and ultimately social abstraction produced in monochrome by Rauschenberg and Klein. The later choices, as Leo Steinberg claimed in broad strokes in the late 1960s, has become the dominant paradigm. Before adding detail and nuance to this shift in emphasis as it has been manifested in abstract work that uses mirrors, however, it is worth looking again at the monochrome tradition across this forty-five-year timeframe, specifically as it moved beyond the frame and canvas using light as its medium.

3. Beyond the Frame

Abstraction's originary endgame included the imperative to abandon paint- ing's surface and frame. Malevich and several after him envisioned an astro- nautical abstraction, the closest intimation of which was, for him, the film project with Hans Richter. Because Klein experimented with "pure" space and light in an emptied room at the home of Colette Allendy in Paris that was part of his May 1957 exhibition, he is again another apt reference point as we consider how the monochrome moved beyond the traditional frames of art. In ways that preview and link to the concerns of contemporary artist Olafur Eliasson's installations, Klein titled his 1957 zone of sensibility "Les surfaces et blocs de sensibilité picturale invisible." In addition to making experimen- tal films, he also created works for a 1958 exhibition at Galerie Iris Clert in Paris called "Pure Speed and Monochrome Stability" that included a round, vibrating version of an IKB monochrome made in collaboration with Jean Tinguely. Klein reveled in the infectious permutations of colour thrown off by the perturbations of his *Space Centrifuge* at ca. 4000 rpm or by *La Vitesse totale*

(Fig. 15). The nascent concept of the void as a palpably present absence would inspire his most notorious exhibition and performance, that of *Le Vide* in 1958, where he guided select viewers into an evenly lit, monochromatic space of meditation (Fig. 7). His Zen and mystical leanings drove a dematerialization in his art, which became more spiritual as Klein piloted the monochrome from pigment on canvas to light in space. Many recent monochromes are not paintings, a fact that deflates the complaint that abstract art is old news and witnesses its current vitality. The expansion of the monochrome into works of light and projection has a history that connects tellingly with current practices. Before examining this continuity in Fontana, the Zero Group in Germany, and especially in the work of James Turrell, Hiroshi Sugimoto, and Eliasson,[43] however, it is important to pause over my reiterated claim for Klein's pivotal, though not unique,[44] place between early abstraction and the abstraction of recent decades.

Because Klein systematically took the monochrome beyond the frame of painting, our assessment of his legacy is a touchstone for how we construe abstraction since the 1960s. Seeing his work as a precedent in this regard underscores Klein's historical importance and connects recent work not usually construed as monochromatic or abstract to a genealogy in which he is pivotal. Klein scholars and supporters – especially McEvilley, Restany, and Stich – document his legacy for recent and contemporary art, including abstraction. Others are at best ambivalent about the artist and his patrimony. The range of judgments about Klein is captured by a comparison of Stich and Buchloh, who claims that Klein, in company with Beuys, has been "overestimated in U.S. reception" (Buchloh, 2000, xxviii). De Duve's writing is nothing less than contorted in this respect. On the one hand, he asserts that Klein's "only tangible contribution to the history of painting is the chemical formula that allowed him to fix powdered pigment without diminishing its glow" (1989, 81), yet in an instructive endnote about his reception in the United States, de Duve struggles with the tension between Klein's alleged "failure" and the fact that he "is not a negligible artist" (90). More serious questions about the neo-avant-garde notwithstanding, an (usually) unspoken discomfort with Klein the provocateur and supposedly right-wing sympathizer colours the interpretation of his work.[45] Here again there is a connection with judo. During his second stay in Madrid as an instructor, Klein bragged about having the chief of police as a pupil. Restany claims that Klein actually trained military personnel in Franco's Spain. But as Stich argues, this does not make Klein or his work fascist. His comrade Arman underlines the irony of the situation: "Yves is often accused of being fascist, but if you knew Yves it is ridiculous to say this because Yves wouldn't abide by anything but his own fascism or imperialism" (Stich, 41–2). Even if we deny the validity of Klein's work on these grounds, can we rightly condemn his reception by shooting the messenger again, a reception that, as I elaborate on in Chapter 4, included the overtly and arguably redemptive adoption of his blue revolution by General Idea?

15. Yves Klein and Jean Tinguely, *La Vitesse totale*, 1958. Steel, iron, IKB paint, electric motor. 80 cm diameter, 20 cm depth. (Cat.rais.: Bischofberger 0094). Sammlung Theo und Elsa Hotz, Zürich. Photo: Christian Bauer, courtesy of the owner.

I have considered Klein's monochromes partly in terms of Malevich's materially anchored yet inspirational precedents. Contemporary artists have in turn extended Klein's prophetic and not completely self-serving experiments and are thus broadening the definition and import of the monochrome and abstraction generally in the present. Put another way, monochromatic abstraction can now be understood as the epitome of abstract art because of its expanded purview rather than its essentialist concentration. Klein's monochrome practice took colour beyond the frame. His kinetic sculptures, the empty rooms, the planned projection of blue light onto the obelisk in the Place de la Concorde, the blue cocktails imbibed and passed on by many attending the opening of *Le Vide*,[46] and, perhaps most dangerously, if we take the

idea seriously, the proposal to tint the radioactive fallout from French nuclear tests, all attest to his desire to create an ambience, not a work of art in any conventional sense. As Nan Rosenthal has emphasized, Klein painstakingly orchestrated the interactions of his monochrome paintings and monochrome spaces to create such effects (115). In a text from his 1960 newspaper work *Dimanche*, in which he described many aspects of his own work, both extant and anticipated, Klein imagined an installation called *Les cinqs salles*: "In order to promote the direct experience of feeling and matter without the intermediary of energy, spectators pass through five rooms, their feet bound by ball and chain. Nine monochrome blue paintings of the same format are in the first room; the second room is empty and entirely white; nine monogold paintings of the same format are in the third room; the fourth room is empty and dark, almost black; nine monopink paintings of the same format are in the fifth room" (Stich, 213). Whether purposefully or not, in *Five-Fold Tunnel*, seen at the Neue Galerie am Landesmuseum Joanneum, Graz, in 2000 (Fig. 16), Olafur Eliasson revisited the critical concerns of Klein's monochrome theatre.[47] About the yellow monochrome room that was part of this installation and with which he had also experimented in other works, such as *Curious Garden*, seen at the Kunsthalle Basel in 1997, Eliasson states: "By putting this yellow filter on top of everything [the room] becomes like a picture. But since we are in the picture and in fact experiencing it, . . . it becomes real again. By making it hyper-representational, we have a real experience – so that you see something that you don't normally see. The eyes have better vision when you have less color" (2001a, 20). Without becoming mired in terminological disputes, it is worth noting that for Klein as for Eliasson, "abstract" in the sense of "removed from experience" was not the goal. Both sought an experience of the "real." The question of their analogous five-part installations pose is "better vision" of what – and better in what senses? Is this more profound seeing targeted toward the ambient world or the constituents of vision "itself"? Would vision itself be what we call perception, and if so, do we have access to such a precultural operation?[48] If we do, what do we do with this knowledge within an art context? If, as I am suggesting, we think of both works under the art-historical rubric of the monochrome – to which they clearly, if not exclusively, refer – we operate on the plane of culture's *uses* of perception, which is where both artists also work and make their contributions. "My interest in science," Eliasson states disarmingly, "is [in] popular science. I am not *really* interested in science at all" (2001a, 22). Many of Eliasson's installations facilitate the impossible quest for the epiphany of "seeing yourself seeing." "Seeing" here is more cultural than physiological or neural. As Eliasson writes about "looking at nature," "I don't find anything out there . . . I find my own relation to the spaces. . . . We see nature with our cultivated eyes. Again, there is no true nature, there is only your and my construct" (2001b). Eliasson joins other artists who have used the monochrome (as we will see in the next chapter)

16. Olafur Eliasson, *Room for one Color 1998 and Five-Fold Tunnel*, 2000. Photo © Neue Galerie am Landesmuseum Joanneum, Graz, and the artist, courtesy nevgerriem-schneider Berlin and Tanya Bonaklar Gallery, New York.

to reflect our mediated perception of self and other, our double sense of agency and helplessness.

360 degree room for all colors of 2002 emphasizes his central interest in the production of vision and of nature through human interactions with phenomena, his passion with context, construction, and critical revelation. We enter a cylindrical chamber 320 cm high and 800 cm in diameter whose continuous white wall reflects monochromatic light that gradually changes through the spectrum.

Light becomes a palpable atmosphere that in some hues suppresses vision but is constantly present as the medium in which we exist. This installation is a dynamic extension of his earlier experiments with monochromatic light and colour. Two installations from 2000, *Your orange afterimage exposed* and *Your blue afterimage exposed*, used an increasingly intense projected light in an otherwise vacant room to impress a square coloured monochrome onto viewers' retinas. When the light was then turned off, the artist explains, "you actually project a reversed image with your eye, a complimentary image, and for a moment you've been turned into a projector" (Grynsztejn, 2002, 21). In *Room for one colour*, part of the *Five-Fold Tunnel* project (Fig. 16), he elaborates, the "yellow space organizes a green sweater and purple shoes into a monochrome field . . . The experience of being in the monochrome field varies, of course, from one person to the next, but . . . a certain perception is acquired. We become aware of this representational filter and with that we acquire an ability to see ourselves in a different light" (130). He extended this cultural exploration of colour perception in *Room for all colours* (1999), in which various monochromatic planes could appear at variable intensities. "Colour has in its abstraction enormous psychological and associative potential," Eliasson asserts. "Colour doesn't exist in itself, only when looked at. The fact that 'colour,' uniquely, only materializes when light bounces off it into our retinas indicates that analyzing colours is in fact about analyzing ourselves" (130).

Eliasson amplifies the monochrome into the environment through projection and through the process he calls "infusion." Again, both techniques link him to Klein's research as well as to other more recent practices that can productively be considered as monochromatic, Turrell's especially. On an intimate scale, *Spinning Mirror* of 1998 disseminates both light and motion beyond the intimacy of what seems to be a "conversation" between the elements of the piece. More or less at head height, a spinning mirror faces a stationary one. Light and vibration emanate, reminding us of the disks made by Klein and Tinguely (Fig. 15).[49] If apperception is the focus of this small piece, our sense of global environmental responsibility and citizenship figures in the performances and photo documentations of Eliasson's ongoing *Green River* project (begun in 2000). Calmly but outrageously, the artist infused the nontoxic but vibrantly hued dye uranin into prominent waterways, turning them partially or completely green. It is a cultural analysis, given the associations of "green" and "nature." He seeks to prod and disclose for self-analysis peoples' responses to what appears to be flagrant pollution. By tinting the Los Angeles River in this way, however, Eliasson set up a different set of possible reactions. Not only does this human-made concrete structure resemble a superhighway more than a river, but as Michael Speaks suggests, the association of green with nature is reversed: "Though uranin appears toxic, it is actually less toxic than the river water into which it is introduced . . . Artificial (non-toxic) dye commingles with natural (polluted) river water to form a new, hyperreal, 'green river' teeming with life" (Grynsztejn, 107). Green is a good thing

in this context. Despite its homophonic resonances with "uranium," then, uranin can appear as a positive infiltration.

Can Eliasson's spectacular and critically acclaimed installation at the Tate Modern in 2003, *The Weather Project* (Plate 2), also be thought of as a monochrome work in the Kleinean tradition? If so, the linkage again expands the boundaries of the monochrome rather than reducing the range of Eliasson's project by subscribing it to a tradition that began with painting. *The Weather Project* transformed the Tate's immense turbine hall into a microclimate replete with the changeability typical of the weather in England and references to industrially influenced climate patterns. Fogs appear and dissipate, distributing and altering the pervasive yellow light generated by Eliasson's technological sun. Susan May vividly describes this environment: "The wavelength generated by the yellow neon [lights of Eliasson's orb] leads the eye to record only colours ranging from yellow to black, transforming the visual field into an extraordinary monochrome landscape...The process of deciphering the boundaries of the actual room through the miasma is challenged, and the sensation of wandering across the space becomes progressively discombobulating" (2003, 26). Stressing how we are all affected by the weather, Eliasson reasserts an only apparently dormant principle of environmental contagion, that of the miasma. Until the later 19th century, as we have seen in the context of Malevich's interest in tuberculosis, it was widely believed that such vapours communicated infectious diseases. "Miasmas" were originally thought to be emanations from the earth; here, too, he has created a landscape specific to a formerly industrialized part of London; *The Weather Project* recalls the poisonous fogs that plagued London over much of its modern history. Yet typical of his socially minded trajectory, the miasmic monochrome released here also has positive effects. More benignly than the AIDS virus images circulated by General Idea, for example, Eliasson's weather project found its way not only into the art gallery system in the form of a survey and the installation itself, but also into the city in the form of yellow posters carrying weather questions that are also posted on a Web site designed to extend and prolong the interactivity of the project. It is "infectious" in the sense that it mediates personal and collective experience and promotes cultural analysis. As shown in Chapter 4, this sort of art moves beyond the traditional frames of references provided for abstraction.

Elements of Eliasson's weather installation were anticipated by Mack, a founding member of the Zero Group in Germany in 1957.[50] Named after the last number in a liftoff countdown – a delightfully fake-looking photo collage by Heinz Mack shows a rocket blasting into space, "ZERO" lettered on its side – the group saw itself as precipitated by and carrying on the experimental ethos of Klein and the Nouveaux Réalistes. As Otto Piene claimed, members sought to expand the purview of art, in company with Klein and Malevich, into space. Moving beyond the acclaimed victories of action painting and *Art Informel* because of their

"renunciation of the concept of purity of color, a concept that, although it was advocated more than fifty years ago, was never completely realized," Piene claimed, Zero emphasized the "one indispensable condition that had been overlooked: purity of light." In the spirit of Moholy-Nagy, Fontana, and Klein, he ends this article with the prognosis that "the purity of light will enable painting to arouse pure feeling" (Piene, 1973, 46–7). Mack's *Sahara Project* (Fig. 17) is an art of light on a large scale that realizes Piene's objectives. Critically for the genealogy I am establishing here, Mack collaborated with artists, including Arman, Fontana, Piene, and Klein himself, on a series of interconnected "stations," "apparitions of light and space" that would function in the open desert (Mack, 1973, 180). One was to be called "The Symposium" and was perhaps a place of homage to *Le Vide* for the participating artists: "A cube, hermetically sealed on the outside, whose walls are . . . made of milk-white marble, resting in a sea of quicksilver. A room of white light by Yves Klein" (Mack, 1973, 183). Most remarkable in the context of *The Weather Project* was "Station 12: The Artificial Suns." "Instead of a number of small light structures," Mack wrote, "I would like to have the open dimensions of a big plane of light . . . The phenomenon of fata morgana makes these artificial suns appear to hang in the sky as apparitions" (Mack, 1973, 183).[51] As Eliasson did at the Tate, Mack used mirrors to create the disks that would reflect a monochromatic light. Eliasson also played with multiple suns in a massive installation in Utrecht called *Double Sunset* (1999). Here an observer's surprise at seeing two stars exposes our conventional acceptance of nature and the value of a keener awareness. Eliasson properly contends that there is in fact nothing artificial about his work, including *The Weather Project*. Its construction and cultural mediation in the museum context is revealed, but it is not an illusion. Instructive in this regard is his earlier work titled *Your sun machine* (1997). An "empty" gallery space is illuminated through preexisting, high windows on one side and a round hole in the ceiling cut by the artist. The latter modification, used to similar effect since at least the Pantheon in Rome, allows a beam of light to project a mobile "sun" onto the floor. As the personal pronoun used frequently by Eliasson in his titles suggests, experience of this phenomenon is initially individual. Most will sense that the light moves, but the artist extends the implications of the work beyond the room's simple confines by claiming that "I generally say that the spot of light didn't move, which in fact it didn't; the gallery moves" because the earth, not the sun, is in motion (Grynsztejn, 2002, 22).

More important than the coincidental confluence of Eliasson's work with Mack's vision is the common link to Klein's use of light as a medium and the expansion of the monochrome into the environment. The most far-reaching contemporary practice that uses light in the monochrome tradition is that of James Turrell. Before turning to his work, however, mention should be made of the experimental light work of Lucio Fontana. Recent research has confirmed

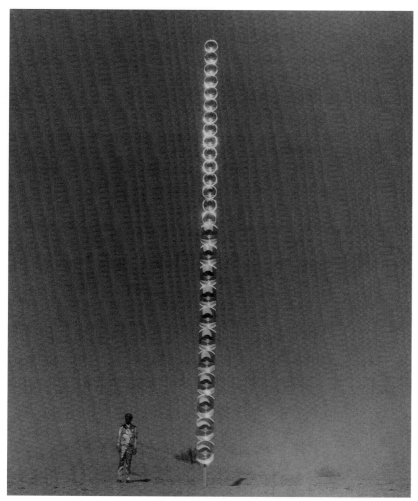

17. Heinz Mack, *Lichtstele in der Sahara (östlich der Oase Kebeli, Tunesien)*, part of the *Sahara Project*, 1968. 11 m. © Heinz Mack. Photo courtesy of the artist.

that although Fontana characterized himself as a sculptor and was passion-ately interested in space in all its dimensions as well as the materials bound-ing it, and although he was highly influential as a painter who pierced his can-vases instead of seeking flatness, he was always dedicated to what he termed *light painting* (Petersen, 2000, 53). Inspired by Moholy-Nagy's photograms, Fontana's monochromatic *Spatial Concepts* on paper from the early 1950s (as well as some canvases) were not primarily individual works but rather actors in what Peterson describes as "a larger luminous spectacle," a spatial theatre (54). Light would shine across and through these perforated surfaces, creat-ing shadow effects that were photographed and that projected what could be read as star maps. The *Spatial Concepts* are therefore allied with Fontana's larger

light installations, such as the *Spatial Environment* of 1949, in which excrescent sculptural forms appeared as phosphorescent emanations in a black light room. Fontana's example was acknowledged by the Zero artists with their mechanized light and shadow installation *Homage to Fontana* at Documenta, 1964 (Petersen, 2000, 57). Like Klein, whose monochromes he greatly admired and one of which he purchased from the 1957 Milan exhibition, Fontana was looking to the sky in the 1940s. For both, this was the source and direction of their own, initially telluric monochromy. Klein's outrageous claim to have signed the back of the sky was ultimately more laudable than laughable. A conceptual gesture but also a "work" comprised only of light, he intimated that a monochrome expanse can probe our theatrical relationship with the infinite. James Turrell's framings of the cosmos at Roden Crater, Arizona, belong in this lineage.

Turrell's luminous enterprises do not stand lonely in art history.[52] It takes nothing away from his uniqueness to claim that, on the contrary, Turrell's light pieces can fruitfully be understood in a line of monochromatic art that leads back to Klein and Malevich and of course bears comparison with other current work, such as that by Eliasson. The connections to Klein's monochrome experiments have been neither stressed nor investigated by other commentators but they are manifest. "My first attempts to use light as space were in 1965 and 1966," Turrell recalls, "using gas to create flat flames" (Brown, 1985, 42). John Coplans, one of Turrell's early supporters and commentators, confirms that Klein's fire pieces were an inspiration (Adcock, 1990, 6). It is not Turrell's preference to conceive of his efforts in art historical terms,[53] but like Klein, he does make reference to Malevich. In an interview published in 2002, Turrell noted that for him, "the history of art is a history of looking at light . . . I can remember Malevich talking about how the paint was on the surface like the thinnest of membranes." He goes on to state the central premise of his use of light as a medium and thus of his extension of Malevich's pull away from objects: "rather than being something that's about light, it is light" (King, 2002, 26). Another fundamental link to Malevich, as Richard Andrews suggests, is the concern for space and time that comes from creating with light, a genealogy that Turrell shares with Fontana and Klein. To what extent, then, can we compare Klein's notorious signing of the back of the blue sky as he lay on his back looking up in Nice in 1948 with Turrell's passion for the vault of light above us? We could emphasize their mystical leanings, Zen in both cases and also Rosicruciasnism in Klein's. But this propinquity masks much of what these artists have in common in the realm of the monochrome.[54] Turrell's *Roden Crater* is designed to allow us to experience the sky in the fullest sense by contriving to have the earth point to and gather light in particular ways. As in Eliasson's *Your sun machine* but without the mediation of an art gallery, individual perceptual experience is orchestrated by the movement of nothing

less than our planetary home. Calvin Tomkins supplies a memorable description of the experience:

> Two winding corridors lead off from the East Portal. One goes to the Crater's Eye, a skyspace with a circular oculus. The other leads up and out to the bowl itself, an immense space where bulldozers have moved more than a million cubic yards of rock and earth to shape a graceful oval whose rim is the same height all around. At the bowl's center, four massive, somewhat Pharaonic-looking limestone platforms surround the opening to the Crater's Eye. I do as Turrell directs, and lie down on one of these, on my back. The platform inclines so that my head is lower than my feet. All I can see is sky, more sky than I've ever seen in my life. It's an intensely blue, hemispherical dome, as enclosing and nearly as intimate as the sky in Giotto's frescoes in the Arena Chapel. What I'm experiencing is the perceptual phenomenon called celestial vaulting. (Tomkins, 2003, 65)

Klein made the same comparison with Giotto's blue vault and in his own comparably limited way sought to produce this enveloping monochrome experience. Klein and Turrell, however, typically take their inspiration from an intriguing combination of inner and outer perceptual experiences of light, space, and flight: "A lucid dream or a flight through deep, clear blue skies of winter in northern Arizona – experiences like these I use as source," Turrell reports (Brown, 1985, 19). Again like Klein and in concert with Eliasson, Turrell not only captures – signs? – the sky but also creates zones of single-colour luminescence, environments in which viewers are immersed in light and thrown back on their perceptual apparatus.

The creation of monochromatic nonobjects runs through Turrell's long career. Coplans relates that the artist's vocational epiphany occurred when he was a student at Pomona College in the 1960s. "One day, while reading an essay by ... Michael Fried, Turrell suddenly shouted, 'That's it! I've got it!' His eureka moment was triggered by a disparaging comment of Fried's about the work of Judd and other minimal artists – that their impersonal, machine-made sculptures had the look of images from projected slides" (Tomkins, 2003, 66). Turrell's idea was to literalize this use of light. He made a projection work that used a blank slide to beam light into a corner, creating what looked like a three-dimensional rectangle sitting out from the wall. *Afrum-Proto* (1966) and *Afrum I* (1967; Plate 3) are also – obviously – monochromatic, though for reasons I speculate on below, this feature is rarely recorded in the large bibliography on *Afrum* works and others by Turrell. At least in this art-historical context, it is not trivial to note that Turrell credits the advent of his work to his fascination with the high intensity light of slide projectors during art history classes.[55] He has created well over 100 projection works. Some take advantage of corners in rooms to create what we perceive as a solid object protruding into our space. Others address the flat walls of a room. He has augmented the range of colours from white to include blue, red, yellow, and

green (Adcock, 1990, 28). The hue, dimensions, and physical attitude of these works is carefully controlled in every case and produces a remarkable variety of radiant monochromes. Though what it is we so palpably experience in a Turrell projection piece may be difficult to specify, they are not illusions. We see light working in space and on hard surfaces. Like Eliasson's weather phenomena, light may be humanly produced and controlled, but it is hard to grasp how it could be "artificial" in its behaviour.

Turrell developed another series involving projection in his studio in the Mendota Hotel building in the late 1960s, though many of these were not realized until much later. The so-called "shallow space constructions" required the modification or outright construction of spaces designed to house light, whose source could be the outdoors, lamps, or a combination, as in *Rayzor* (1968 and 1982). In the earlier variation, white light emanating from three large windows behind the central panel seeps through and creates an intense border around the central blue monochromatic field. In *Amba* (1982) and other similar space constructions, the inside edges of the two deep pillars that separate the work into three parts, as well as the left and right lateral edges of the deep spaces, combine to create surfaces that glow with a deeper blue hue than that which fills what we read as a tripartite flat surface. The result – depending, as it always does with Turrell, on one's angle of vision – resembles three large, Joseph Albers-like abstract icons, each again bordered with just the right colour. Finally, in the rectangular *Skyspace I* (1972) and others originally from the Panza collection such as *Lunette, Varese* of 1974, the white architectural framing produces, at times of low illumination, a range of dark blue monochromes with a lighter blue border. The ultimate boundary line crafted by Turrell to promote vision is the lip of Roden Crater. Akin to many of his earlier works, the manipulated crater also provides areas where the visitor is bathed in ambient light, whether from our sun, the moon, or more distant planets and stars. Turrell's notably individual and extensive practice find a common denominator in monochromy. Both his light filled "voids" and immaterially bounded "abstracts" recall and greatly extend Klein's environments and his interrogation of Malevich over the issue of the work and its supplementary yet often definitive borders. His light monochromes make reference to the issues of paintings' "matting" discussed above only to show that such concerns have been left behind with the surfaces that supported them.

We have seen that the monochrome was the epitome of abstract painting in the 1960s, when Turrell came into the art world. In company with the artist, however, critics have been reluctant to make comparisons with painting, painters, and terms associated with a set of practices that Turrell was certainly working away from. The term monochrome is rarely used in the scholarly literature on Turrell; Coplans' pioneering article is the exception (Coplans, 1985, 91). Turrell's light installations operate beyond the historically loaded frame of painting; in this they realize rather than move away from one of the early dreams of the monochrome

1. Yves Klein, *Tree, Large Blue Sponge* (SE 71), 1962. Pure pigment and synthetic resin on sponge and plaster. Inv.: AM 1984-280. Musée National d'Art Moderne, Centre Georges Pompidou, Paris, France. Photo: Philippe Migeat. Photo Credit: CNAC/MNAM/Dist. Réunion des Musées Nationaux/Art Resource, NY. © Estate of Yves Klein/ADAGP (Paris)/SODRAC (Montreal) 2005.

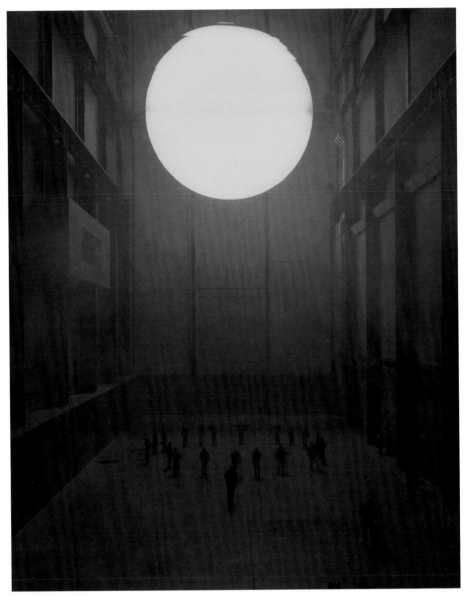

2. Olafur Eliasson, *The Weather Project* (installation view), October 16, 2003–March 21, 2004. Tate Modern, London, Great Britain. Photo Credit: Tate Gallery, London/Art Resource, NY. Tate Modern, London, Great Britain. © Olafur Eliasson.

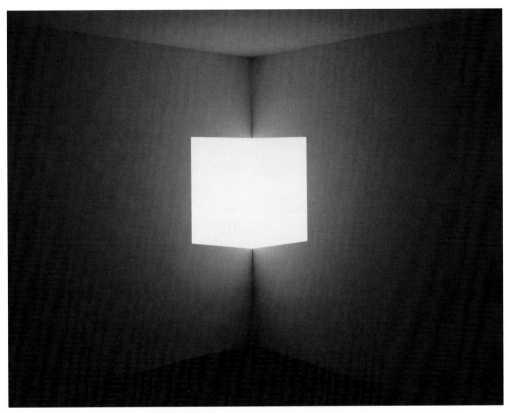

3. James Turrell, *Afrum I*, 1967. Xenon projection. Solomon R. Guggenheim Museum, Panza Collection, Gift, 1992. 92.4175. Photograph by David Heald © The Solomon R. Guggenheim Museum, New York.

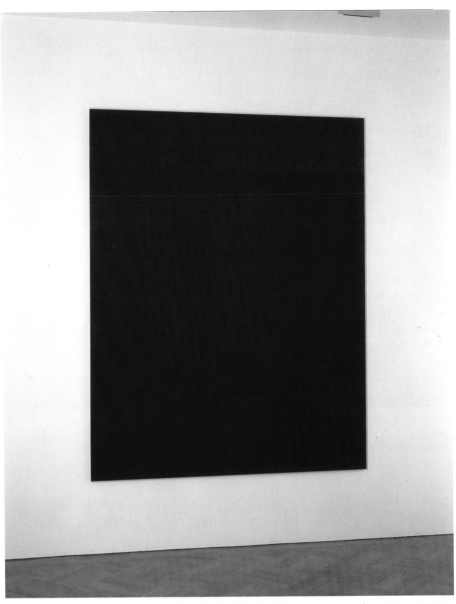

4. Gerhard Richter, *Mirror Painting (Blood Red) (736-6)*, 1991. Pigment on glass. 210 × 175 cm. Photo courtesy of Anthony d'Offay Ltd., London, and the artist.

5. Robert Smithson, *Fifth Mirror Displacement*, 1969. Solomon R. Guggenheim Museum, New York. Photo Estate of Robert Smithson. © Estate of Robert Smithson. VAGA (New York)/ SODART (Montréal) 2005.

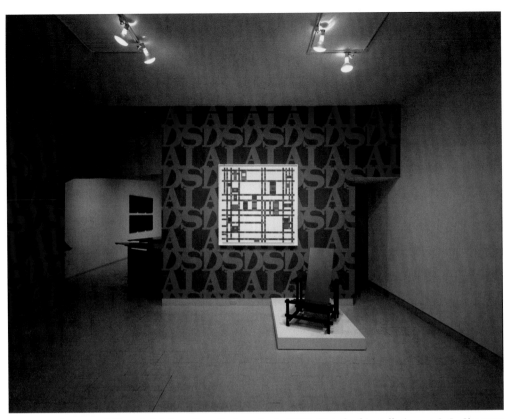

6. General Idea, *Infe©tions* (installation view), 1995. Detail of installation at S. L. Simpson Gallery, Toronto, June 1–July 4, 1995, includes, left to right on left wall: *AIDS Wallpaper*, 1989. Silkscreen on paper: each roll, 457.2 × 68.6 cm; *Infe©ted Mondrian #4* 1994. Acrylic on gatorboard. 44 × 48 cm. *Infe©ted Mondrian #1*, 1994. Acrylic on gatorboard. 102 × 103.5 cm. *Infe©ted Mondrian #9*, 1994. Acrylic on gatorboard. 51 × 51 cm. *Infe©ted Mondrian #5*, 1994. Acrylic on gatorboard, 61 × 40 cm. *Infe©ted Mondrian #2*, 1994. Acrylic on gatorboard, 109 × 109 cm. End wall: *AIDS Wallpaper*, 1989. Silkscreen on paper, each roll, 457.2 × 68.6 cm. *Infe©ted Mondrian #10*, 1994. Acrylic on gatorboard. 122 × 122 cm; *Infe©ted Rietveld*, 1994. Lacquer, acrylic on found wood chair. 90 × 60.3 × 87 cm. Edition of 5, plus 1 A/P, signed and numbered, Self-published. Collection of General Idea, Toronto. Photo credit: Peter MacCallum, Toronto, courtesy of AA Bronson.

7. Fabian Marcaccio and Greg Lynn. *The Predator*, 2001. Vacuformed plastic, silkscreened and painted, dimensions variable. Photo courtesy of F. Marcaccio.

8. Robert Houle, *Aboriginal Title*, 1989–1990. Oil on canvas. 228 × 167.6 cm. Collection of the Art Gallery of Hamilton. Photo courtesy of the Art Gallery of Hamilton and the artist.

and of abstract art. My claim is that the monochrome was in fact liberated from painting's frame in the work of Klein especially. We can in hindsight see Turrell as elaborating these tendencies. Framing as revealing constructed limits and the apparatus of seeing is a crucial theme of his endeavours. He is not alone in art history in the sense of being without precedent or aesthetic heritage nor of being unique in contemporary art. Recalling Klein, and in harmony with Eliasson and others today, his theatres of the monochrome tilt against autonomy.

Mack's *Sahara Project* included "The Parade," a complex installation that can function for us as the beginning of a conclusion to this meditation on the monochrome. Working with Klein, Mack envisioned "The Parade" as follows: "It is longer than any road in the world and stretches from a monochrome wall which is blue to a wall covered with pure silver light. Going up and down the parade, the walker remains in the field of influence of both surfaces. When he approaches the color, he is filled by blue; when he approaches the light, he is filled by it. When he is between the color and the light, he is filled by both color and light. The parade itself is made of mirrors. The costume worn by the walker is a spun web of mirrors. *So it is not the earth that carries the walker. We are walking on the mirror of the sky*" (Mack, 1973, 182; my italics). The profound connection between the earth and sky is common to Malevich, Fontana, Klein, Turrell, and Eliasson, particularly in the narrative I have been constructing, as are the importance of participation and change on the part of the viewer and the sense that colour and light actually enter those who view these works of art. For Mack too, there is no firm distinction between the perceiver and the environment in which s/he lives. The earth reflects the sky; the walker replicates the sky as well as the mirrors of the parade, which respond equally to his or her presence. Reflection does not imply metaphysical hierarchy − "mere" reflection − but rather a relative sharing in something continuous. Turrell phrases this nonduality explicitly in terms of Plato's cave.[56] Although Plato worked toward a state of oneness in his metaphysical dialectic, he famously denied that art could get us there (Cheetham, 1991a). Turrell counters Plato by reevaluating the projected light crucial to the myth. In a 1995 lecture he spoke about Book VII of the *Republic*:

> Plato's cave is an analogy of perception: The people are sitting in the cave with their backs to reality and then looking at the reflection of reality on the cave wall. This is one place from which I take my tradition, because, first of all, I'm interested in the analogy of seeing, in structuring spaces that themselves see, and in entering a space that sees...The camera obscura...is an image-making device, where, as in Plato's cave, we actually look at this imaged form. This kind of image projection did happen in a cave or a small, closed-out space...[but I am interested in] the making of this event in Plato's cave in a space raised above the surrounding terrain. (2000, 75–8)

At Roden Crater, as at prehistoric sites mentioned by Turrell, Newgrange in Ireland and Maisehowe in Scotland, we are able to see and value the way the image is made by light and the fact that even as shadow, what we see *is* light. Roden Crater

externalizes the crepuscular technology of Plato's cave and the camera obscura by leading our sight to the "engaged light" events captured by the now-perfected rim of the volcano and the interior chambers constructed by Turrell (2000, 80). Like Plato's prisoners, Turrell's viewer must leave the cave, or the cave externalized or inverted, to see fully. But the reflections that they saw in the cave, and which Turrell also reinstalls in Roden Crater's inner chambers, are not merely inferior "shadows of...artificial objects" (*Republic VII*, 515). This space sees light and light is real.

I have emphasized the monochromatic nature of the light projected, reflected, or trapped by Klein, Fontana, Mack, Eliasson, and Turrell and argued that resulting monochromatic works can productively be seen as connected to and extending painting's concerns with monochrome abstraction. Light is the new medium in this lineage, and light defines both colour and space. But hard surfaces are not completely revoked. Turrell's shallow space constructions receive and reflect light. They are monochromatic when the lights are off and formal monochromes when the installations are functioning. We can think of Plato's cave in the same way, with the help of Robert Smithson's fanciful drawing *Towards the Development of a "Cinema Cavern" or the movie goer as spelunker* (1971; Fig. 18). Smithson brilliantly and humorously pictures Plato's cave as an "underground" movie theatre in a "natural cave or abandoned mine," as he wrote on the drawing. A rustic wooden projection booth was to be set above and behind seats of rock from which the audience would view a film on the making of the cinema cavern.[57] Two points about Smithson's drawing have, to my knowledge, not been noted. First, although it is not surprising that Smithson would update Plato's light and puppet show with film, Francis MacDonald Cornford, in his definitive 1941 English translation of the *Republic*, had already drawn the analogy. "A modern Plato would compare his cave to an underground cinema," he wrote, "where the audience watch the play of shadows thrown by the film passing before a light at their backs" (1941, 228, n. 2). Critically for my arguments about the monochrome, we can also plainly see in the upper of Smithson's two drawings of the cinema cavern on this sheet that the rock surface that is the screen is itself blank and receives nothing but a beam of light. Bare rock was not adequate: Smithson states in "A Cinematic Atopia" (1971) that this screen must be "painted white" (Smithson, 1996, 142).

Like many artists in the 1960s, Smithson was interested in abstraction and in the monochrome – think of the opening sequences of dinosaur displays in the film *Spiral Jetty* or of his description of "monochrome 'stills'" in the unrealized "The Monument: Outline for a Film" (Tsai, 1991, 81) – but did not put the two together except as they might appear accidentally, in a mirror reflection. What links Smithson's cavern to the genealogy of the monochrome in my terms is his insistence on active viewing, the expansion of perception, and theatricality. The cinema cavern drawing and "A Cinematic Atopia" are critiques of what he thinks is the passivity of absorptive viewing and of aesthetic autonomy, both in general

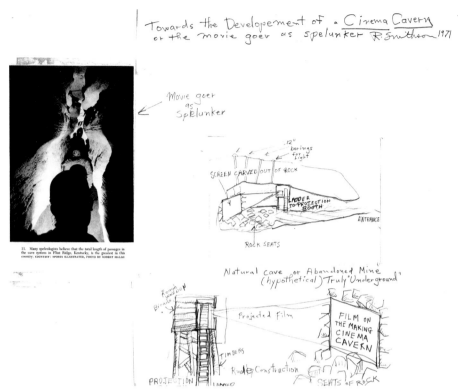

18. Robert Smithson, *Towards the Development of a "Cinema Cavern" or the Movie Goer as Spelunker*, 1971. Pencil, photograph, tape. 12 5/8 × 15 5/8 in. Estate of Robert Smithson. © Copyright Estate of Robert Smithson/VAGA (New York)/SODART (Montréal) 2005.

and with specific reference to Michael Fried's essay "Art and Objecthood," which Smithson had criticized in 1967 as the seat of "anti-theater" (Smithson, 1996, 66). "The simple rectangle of the movie screen contains . . . flux . . . , but no sooner have we fixed the order in our mind than it dissolves into limbo . . . The longer we look through a camera or watch a projected image the remoter the world becomes, yet we begin to understand that remoteness more . . . The ultimate film goer would be a captive sloth," he says echoing Plato's sentiments. "He would be the hermit dwelling among the elsewheres, forgoing the salvation of reality" (1996, 140). But Smithson seeks liberation, not because the shadows are not real, but because viewers need to be active. "Once when I was in Vancouver," he recalls, "I visited Britannia Copper Mines with a cameraman intending to make a film . . . I remember a horizontal tunnel that bored into the side of a mountain. When one was at the end of the tunnel inside the mine, and looked back at the entrance, only a pinpoint of light was visible. One shot I had in mind was to move slowly from the interior of the tunnel towards the entrance and end outside" (142). If we think this sequence recalls Plato's escaping prisoners finally reaching the full light of reality, another plan suggests Smithson's more sweeping

rejection of the allegory of the cave: "Yet another ill-fated project involved the American Cement Mines in California – I wanted to film the destruction of a disused cavern" (142). In Smithson, Turrell, and especially in Hiroshi Sugimoto's photographs of movie screens that appear as white monochromes because he opens the camera's shutter for the duration of the films showing on interior and drive-in screens, we participate in the monochrome theatre.[58] As Mack projected, the "earth" artists I have been discussing show that monochromatic light is our environment. "We are walking on the mirror of the sky," he wrote. Mirrors have been central to the expansion of abstract art since the 1960s.

3 Mirror Digressions

Stages of Nonrepresentation

Narcissus was "the inventor of painting."
Leon Battista Alberti[1]

*Jan Thorn-Prikker to Gerhard Richter: Would "the mirror . . .
be the perfect artist"? Richter: "so it seems."*[2]

Mirrors have a long fascinated artists and moti-
vated Western culture generally, a pattern that continues today in popular culture,
scholarship, and the art world. Art historians have pondered the use of mirrors in
Western art. Many will have favourite high-art examples, images that have become
chestnuts of speculation in the field because of their mirrors: the *Arnolfini Mar-
riage* (1434) or *Las Meninas* (1656) or Manet's *Bar at the Folies Bergère* of 1881–1882
[perhaps in tandem with Jeff Wall's masterly *Picture for Women* (1979), which, in
its mirroring of Manet's *Bar*, accentuates the multivalent capture of images in the
mirror, in the room, in the artist's camera, and in the eye]. In three-dimensional
art, think of Robert Morris's or Donald Judd's use of reflective surfaces or, more
recently, of Dan Graham's mirrored pavilions and the communal interactions
they stage. In photography, many ponder the *mis-en-abime* of Michael Snow's
heavily ironical *Authorization* (1969) or works by Michelangelo Pistoletto that
combine mirrors and photographic technology. In film, Robert Morris's 16-mm
short entitled *Mirror* (1969) and Joyce Wieland's potent *Water Sark* (1964–1966)
explore the philosophical and personal ramifications of reflection and surface.
Central to my discussions here are Robert Smithson's *Mirror Displacements* of the
late 1960s. It was Smithson who posed a question crucial to the investigations of
Turrell and Eliasson discussed in Chapter 2, whether mirrors involve us in "seeing
sight" as well as in viewing what is reflected. Developing a broad cultural perspec-
tive, Sabine Melchior-Bonnet (2001) reminds us that mirrors have for centuries
been art objects in their own right. Versailles is but the most renowned example
of the late 17th- and early 18th-century European penchant for spatial expan-
sion and social surveillance allowed by ever-larger and more plentiful mirrors.
Mark Pendergast's *Mirror Mirror* (2003) is a detailed account of the longstanding
fascination with and technologies of mirrors. The science of reflection contin-
ues to be important for artists. Richard Gregory supplied a definitive account of
catoptrics in *Mirrors in Mind* (1997), explaining for example why it is, as Umberto
Eco insisted in 1984, that "the mirror does not invert" (Eco, 204). Michelangelo
Pistoletto has expressed this counterintuitive fact well: "When I look in the mirror

I in fact see my image looking at me and towards the space behind me" (2000, 120). British artist David Hockney has stirred much debate with his book *Secret Knowledge: Rediscovering the Lost Techniques of the Old Masters* (2001). He describes, for example, how "a concave mirror has all the optical qualities of a lens and can project images onto a flat surface" (74) and insists that this method was used extensively by artists in the early modern period to achieve naturalism in two dimensions. An exhibition at the Getty Museum in 2001–2002 titled *Devices of Wonder* devoted a section to the technologies of mirroring as they helped artists to fix images with Claude glasses, the camera obscura, and many other contraptions. *Die Wunderkammer des Sehens: Aus der Sammlung Werner Nekes*, seen in Graz in 2003–2004, was similarly replete with mirroring devices. Polymath director and writer Jonathan Miller curated an exhibition in 1998 at the National Gallery in London titled "Mirror Image." For the exhibition and his book *On Reflection*, he selected excellent examples of how mirrors figure in paintings, and he explored the metaphorical operations of "reflection" inspired by mirrors. What Miller failed to consider, however, was the extent to which mirrors have worked *as art*, not in the material and decorative culture so important to Melchior-Bonnet, but in a some-times rarefied dialogue with painting, sculpture, film, and photography. Thierry de Duve's Brussels exhibition *Look: 100 Years of Contemporary Art* (2000–2001) has extended this inquiry through an entire section devoted to mirror works in recent art. We see here that recent art production has cast doubt on Arthur Danto's confident assertion that Socrates "must have recognized as well as the next man that mirror images of real things are not artworks as such" (1981, 8). Despite the abundant discourse on the mirror, however, what remains to be examined in detail is my prime topic in this chapter: the frequent and thoughtful use of mirrors in recent and contemporary abstract art, in other words, the inclusion of machines of representation within, or even as, the nonrepresentational.

1. Mirrors' Mythologies

Mirrors are the ultimate chameleons. They can look like monochromatic abstractions, as in Gerhard Richter's *Mirror Painting* (*Blood Red*) (*736-6*) (1991, Plate 4), or fool even the Sigmund Freud of "The Uncanny" with their seemingly authentic presentations. The gap we perceive between what a mirror presents and what *is* has held thinkers and artists alike in its thrall since Plato's myth of the cave. Equally compelling are the discourses of identity, ego formation, and social interaction that continue to turn around Narcissus, not only for Freud and psychoanalysis more generally, but also for artists working in an abstract idiom. Using both mythologies and crossing the poles of ontology and psyche, the 15th-century Italian artist and theorist Leon Battista Alberti claimed that Narcissus was "the inventor of painting." Why? Because, Alberti explained, invoking Ovid's ver-sion of the myth, "what is painting but the act of embracing by means of art the surface of the pool" (Alberti, 1991 [1435], 61)? In these early sources the

analogy between painting and mirror functions as a cautionary tale. Narcissus demonstrates both painting's skill in reflecting the world and also the ontological poverty of this ability. Plato and Narcissus desire a pure and unmediated coupling with reality, one that can be found in metaphysics and perhaps love but not through art. Plato is certain that rationality – rather than corporeal union – is the method to "embrace." Narcissus' physical strivings are thus, in Platonic terms, as naive and as pitiable as the prisoners chained in the cavern. But when an alternative to mimesis is imagined with abstraction, the unpredictable disseminations of mirrors take on positive roles that I detail in this chapter.[3]

Robert Smithson's art is not "abstract" in the purist terms common to painting in the 1950s and 1960s, but his self-consciously hybridic and expansive work is nonetheless a fruitful place to begin an examination of abstraction and the mirror. Not only does Smithson engage with the Platonic allegory of the cave, which turns on mimesis and labels painting mirrorlike in the most pejorative sense, but he also took midcentury American abstraction and its critical debates in the hands of Clement Greenberg and Michael Fried as a point of reference.[4] Smithson made his serious yet parodic interaction with contemporary hard edge and post painterly abstraction clear in a description of his three-dimensional mirrored structures of the mid-1960s. In these pieces, "the frameworks have broken through the surfaces, so to speak, and have become 'paintings.' Each framework supports the reflections of a concatenated mirror... The surfaces seem thrown back into the wall... The commonplace is transformed into a labyrinth of non-objective abstractions. Abstractions are never transformed into the commonplace" (1996, 328). Mixing references to the contemporary practice of abstraction with allusions to the abstract in the sense of the general, his pioneering reflective installations provide a point of comparison with earlier mirroring traditions and function as a critical opening for the work of Richter and other contemporary artists who have made mirror abstraction central to their practice.

Mirrors afford a surface support analogous to that of the easel painting, but anthropomorphism and self-contained autonomy is antithetical to their nature. Smithson thematized the ability of his mirror works to generate and promulgate, beyond the usual frames of reference, vagrant visual effects that run the gamut from monochrome to an anonymous expressionism. As he wrote in 1965 with reference to his coloured mirror sculptures, "the works feed back an infinite number of reflected 'ready-mades'" (328). In this they are paradigmatic of mirror abstraction since the 1960s and of abstraction's departures from the paradigms of purity and autonomy. Mirrors were crucial for Smithson's articulation of the "non-site," his brilliant invention for exploring the complex and never exactly corresponding relations between nature and art, a dialogue at once profoundly abstract (again in the sense of conceptual and general) and irrefragably material. Smithson would typically choose a site in nature, map and mine it, and then transport some of its displaced materials into a highly formalized gallery display, the nonsite. But his

19. Robert Smithson, *Enantiomorphic Chambers*, 1965. Painted steel, mirrors, two chambers. Courtesy of James Cohan Gallery, New York. © Estate of Robert Smithson/VAGA (New York)/SODART (Montréal) 2005.

point was not just the environmentalist one, whereby a site had been disrupted and a context sundered. For Smithson, neither the site nor the nonsite, even in their dialectical relationship, was whole. Neither was given priority. The absurd and entropy always remained for him. Sight always involved nonsight or blindness. In the mirror works, for example, because an observer cannot be in two places at once, one literally could not see the context of the other component in the site/nonsite pair. They couldn't be brought together, and neither was complete even in an ideal reunion. Other works elaborate the same entropic logic. About his now-lost *Enantiomorphic Chambers* of 1965 (Fig. 19), painted steel constructions with green, monochromatic panel insets and mirrors angled so that a viewer's image would disappear when s/he stood between these nonseeing yet reflective stand-ins for our binocular vision, he claimed that "to see one's own sight means visible blindness" (1996, 40). If you can see your image, the chambers demonstrate, then you are not in the place to see sight happening. If you are in this place, you cannot see anything because the angled mirrors erase any reflection of the self at this one point.[5] For Smithson and for the abstract art that uses mirrors considered here, mirrors provide neither the "truth" of seeing ourselves seeing nor are they condemned as a merely reflective and thus deceptive apparatus, as in Plato.

An enantiomorph is a "form which is related to another as an object is related to its image in a mirror; a mirror image" (*Oxford English Dictionary*). Smithson

provides an example from his meandering 1969 work in the Yucatán peninsula of Mexico, the so-called *Mirror Displacements*. "Enantiophorphs don't quite fit together," he wrote. "Two asymmetrical trails that mirror each other could be called enantiomorphic," he claimed, "after those two common enantiomorphs – the right and left hands" (1996, 131). By analogy, site and nonsite, seeing and not seeing, are also twinned yet ultimately incommensurate enantiomorphs. The careful placement of mirrors along his different stations in the Yucatán performance is paradigmatic of a critical question in art's relationship to perception addressed by several other mirror artists who followed Smithson. These mirror works give us neither a sense of how we see nor do they deceive: they "construct one's inability to see" (130). As the placed, photographed, then removed mirrors of the *Mirror Displacement* series attest, "the mirror itself is not subject to duration, because it is an ongoing abstraction that is always available and timeless. The reflections, on the other hand, are fleeting instances that evade measure" (122; Plate 5, Fig. 20). For Smithson, the questions of representation and its absence, of nature and culture, of what lasts and what disappears in mirrors, cannot be

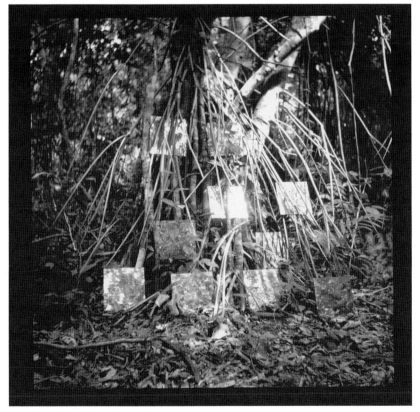

20. Robert Smithson, *Seventh Mirror Displacement*, 1969. Solomon R. Guggenheim Museum, New York. Photo Estate of Robert Smithson. © Estate of Robert Smithson/VAGA (New York)/ SODART (Montréal) 2005.

answered in a final way. Mirrors do not allow us to see sight, though they tempt us in that belief. This is what the mirror displacements show us. But let us recall *how* they show today, as this presentation is critical for contemporary artists who use mirrors in their abstract art: we see the *Displacements* through still photographs, carefully controlled by Smithson as records of the installations. He was aware of and exploited the fact that photography could not capture the mirrors' activities completely: "For the mirror pieces, there is no audience, yet if the work is strong enough, and photographed properly, it is fed back into a mass distribution system. There is a generative aspect to that. It defeats the idea of exhibition entirely" (235). Smithson seems to be claiming that there is never a complete or even privileged account of anything, not of site or non-site. Photographs are at best partial and mnemonic. About the record of the Yucatán displacements he famously wrote, "The camera is a portable tomb, you must remember that" (121). Smithson's 1971 drawing *Towards the Development of a "Cinema Cavern"* (Fig. 18), discussed in Chapter 2, points us to Plato's cave as this sort of tomb. In this way it is closely affiliated with his Cayuga mirror displacement of 1968, which featured blind mirrors, unable to reproduce visuality because they were inside the salt mine's dark caverns, as well as illuminated, reflective mirrors with piles of salt in the nearby Cornell University art gallery.[6]

Mirrors do not give us truth, even in their photographic, enantiomorphic remainders, but neither are they metaphysically challenged. For Smithson, and as we will see, Richter, it is not a matter of mere surface versus depth or illusion versus reality. If Smithson's passion for mirrors and caves can be related to Plato's metaphysics and the epistemology of mimetic art, so too his most famous earthwork, *Spiral Jetty* (1970), can be thought of as mirrorical[7] in another mythological sense, not least because it disappears periodically under the reflective surface of Great Salt Lake, Utah. When the piece was newly completed, Smithson manipulated the reflections of his crude, natural yet industrial materials in the surface of the lake. Viewing the photos and film of the artist walking on the jetty, reflected in its surface, we might also think of the structure as a foothold for the artist as Narcissus, a place from which to plumb the depths of nature. The best and now widely disseminated example is Gianfranco Gorgioni's famous 1970 photo of Smithson on the jetty, which graces the cover of Flam's edition of the artist's collected writings. The Narcissus trope makes new sense of what the reflection of the jetty might be in Smithson's terms, that is, a nonsite pointing toward the complex and never exactly corresponding mirror relation between nature and art, a dialogue at once profoundly abstract and assertively material. Though not an abstract work in itself in the terms set out by contemporary painting, *Spiral Jetty* does augment our understanding of what the mirror could mean for abstraction at this time. "My work is impure; it is clogged with matter . . . it is a quiet catastrope of mind and matter," Smithson wrote (1996, 194). He liked the fact that mirrors produce images without human control, but we have seen that he

also intervened by arranging these image machines in nature and photographing certain of their activities. Mirrors and nonsites are productive of what Smithson called "refuse," that unmanageable Derridean "remainder" between mind and matter. It was otherwise in the *Metamorphoses*, the primary classical source for the Narcissus story.

Ovid at first seems sympathetic to the frustrations Narcissus feels as he tries to grasp his own initially misrecognized image in the reflecting surface: "How often did he plunge his arms into the water seeking to clasp the neck he sees there . . ." (Ovid, 1916, 155). But he also censures Narcissus' strivings as superficial. "Why vainly seek to clasp a fleeting image?," the poet inquires, and then, more sternly, more Platonically, "That which you beheld is but the shadow of the reflected form." Alberti marvels at the naturalism that Ovid had criticized and to some extent participates in the philosopher's critique of superficiality, but recent artists working in an abstract idiom have looked more deeply into the reflective nature of painting. They are not solely concerned with visual mimeticism; for one thing, they have remembered the importance of touch in Ovid's Narcissus story. Ovid makes much of the disturbances Narcissus' touch effects in the reflective pool into which he stares. Contemporary artists have picked up this reference, in both their use of physical mirrors – in an early set of photos by Bruce Nauman, *Eleven Color Photographs*, from the late 1960s, two examples show hands pressing on and distorting a mirrored surface – and more metaphorically, as in Michael Snow's abstract *Narcissus Theme*, 1961 (Fig. 21), which, in its offsetting of the nonrepresentational reflection, suggests the enantiomorphic relationship explored by Smithson at about the same time. As I have noted, Robert Morris made a sixteen-millimeter silent film in 1969 called *Mirror*, which we could subtitle "a Platonic drama" because of its precise enactment of Plato's criticisms of art as mimetic in the *Republic*. Morris is seen walking around in the landscape holding a large mirror (about the size of a normal canvas): sometimes he points it at the camera, but more often he allows it to reflect the trees and sky. We could easily take these reflections as nature itself when the camera is close to the reflective surface. A decade later, Morris said of this and other early mirror works: "In the beginning I was ambivalent [about their] fraudulent space, [their] blatant illusionism. Later [this] very suspiciousness seemed a virtue. I came to like [the mirrors'] hovering connotation of abject narcissism" (1979, n.p.). It seems that he exorcized his latent Platonism and came to enjoy the mirror's habit of focusing on the artist and his work. For Morris mirrors are profoundly unstable in their procedures of imitation. He both accentuates the question of distortion [for example, in *Mirror Piece* (1978) – where the image is nomadic], and he insists on instability in another way by having mirrors themselves become moveable elements in a dynamic drama (*Twelve Mirrors*, 1976–1977). It might seem that Morris is most concerned with the optical properties of mirroring, with vision. But more recently – and in concert with other artists – he has returned to the tactile longing expressed by Narcissus as

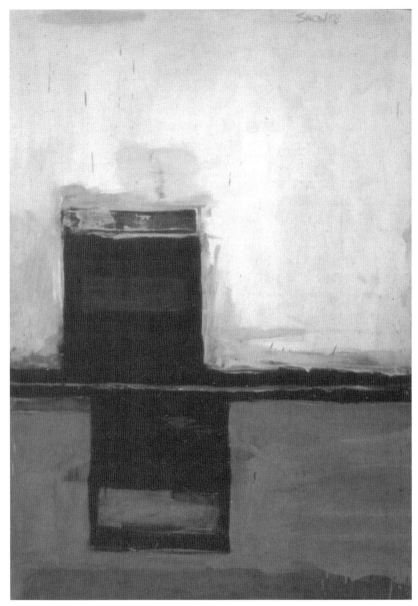

21. Michael Snow, *Narcissus Theme*, 1958. Oil on canvas. 153.1 × 106.9 cm. The Robert McLaughlin Gallery, Oshawa. Photography: Tom Moore. Courtesy of the artist.

the mythological figure tries to touch and indeed hold his own image. From this perspective, we can argue that the many minimalist objects that employ mirrors, those by Morris, especially, are primarily concerned with the corporeal aspects of bodies in space, with the "haptic and phenomenological," as Morris himself says (2000, 167), not with vision alone. The same might be said of Larry Bell's experiments in the 1960s with mirror surfaces, a connection that leads to the Light & Space artists whom I have inscribed in the trajectories of the monochrome. In

some ways, these various reflective surfaces work against speculation, as do Judd's reflective serials. Morris is particularly interested in the way "reflection," historical as well as optical, becomes corporeal. His extraordinary image of Jackson Pollock at work, *Monument Dead Monument/Rush Life Rush* (1990, Fig. 22), as captured

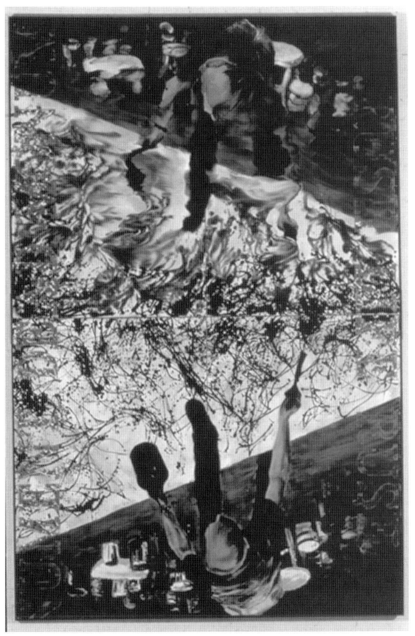

22. Robert Morris, *Monument Dead Monument/Rush Life Rush*, 1990. Encaustic on aluminum panel. 143 × 94 7/8 in. Photo courtesy of Castelli Gallery, New York. © Robert Morris/ARS (New York)/SODRAC (Montréal) 2005.

originally by the well-known Hans Namuth photographs, repainted by Morris in encaustic on a reflective metal surface, asserts both the physicality of Pollock's famous action painting as well as its historical evanescence. Whether or not Morris had the Narcissus episode in mind here, the parallels are suggestive. Narcissus expires from his obsession and eventually turns into a flower, the flower of art, as Alberti wittily calls painting. As Ovid expresses it, Narcissus wastes away "as the yellow wax melts before a gentle heat" (Ovid, 1916, 159). Very tactile indeed, and in revisiting Namuth's iconic photographs of Pollock in action, Morris addresses issues of the tactility of art and of the processes of recollection and mourning.

By setting up the image of Pollock as a reflection – and with the textual contrast between "dead monument dead" and "rush life rush" – Morris presents the possibility that pouring oneself into a painting might be a dead or at least futile activity. We have seen Rauschenberg remove this option in *Erased de Kooning Drawing* (Fig. 14). A related point could be made about Snow's mirror sculpture *Scope* (1967), which places the spectator physically rather than allowing one to see how sight works optically. In this example, too, the specific though unstable image of the author (or other participant) that we see is available only in the fixed state of a photograph. The precursor to these tactile mirror works is Lucio Fontana's *Concetto Spaziale: Attese*, an extensive and varied series executed ca. 1958–1968 that famously treats the surface as a limit to be transcended in what the artist believed to be a vision of the future and an assertion of freedom. Most of the *Attese* are painted on canvas. In Chapter 2, I noted Fontana's theatrical penetration of these surfaces, his acknowledgement and radical extension of touch (Fig. 5). But several pieces involve metallic, reflective surfaces into and through which Fontana hacked his way, making Ovid's gentle reference to the "ruffled" surface of Naricissus' pond seem either tame or idyllic by comparison. We might ask to what extent the nature of the reflective medium employed by the artist, plus of course its placement inside or outside a gallery, determines its invitation to the touch. Maya Lin's famous Vietnam Memorial, visited by an estimated thirty-three million people, for example, is highly polished and mirrorlike granite stone, just like mirrors in ancient Egypt and elsewhere. People can see themselves with the names of their lost relatives or loved ones, and touching – even making rubbings of the inscribed names – is encouraged. Yet this personal, potentially "narcissistic" emphasis on the individual touch is largely foreign to Smithson's aims. Ultimately, his version of Narcissus is more akin to that of Philostratus the Elder in the *Imagines* than to Ovid's. For the former, "the pool paints Narcissus" just as Smithson's many mirrors work vagrantly, without authorial control (Philostratus, Bk. I.; 23, 89).[8]

Gerhard Richter's preoccupation with mirrors is imbricated with his concern over four decades with the constantly intertwined discourses of painting and photography, abstraction and figuration. The monochrome has been a constant point of reference.[9] He is famous for taking and collecting banal photographs and then

selecting those portraits or landscapes that he wants to reproduce in paint. His habit of blurring these source images suggests a distance from, rather than any reverence for, the photo as document. Beginning in 1981 and several times since, Richter has used mirrors. These works have received relatively little commentary in an *oeuvre* that has been analyzed perhaps more than any other in the contemporary art world.[10] Like Robert Smithson, Richter appreciates the independence of mirrors. "What attracted me about [them]," he said in 1993, "was the idea of having nothing manipulated in them ... the mirrors ... were also certainly directed against Duchamp, against his *Large Glass*" (1995, 270–2). Richter may not have endorsed the evident authorial control seen in the *Large Glass*, its careful composition and hierarchy, but in concert with Duchamp, he does exploit the readymade. *Mirror (485–1)*, from 1981, is one of Richter's most complex inventions, one in which a mirror surface is the origin of the picture. We see a one-meter-square piece of crystal mirror glass mounted in seeming innocence in the artist's studio. Any photo of the piece belies what Richter most values in this type of work. A mirror painting "is the only picture that always looks different. And perhaps there's an allusion somewhere to the fact that every picture is a mirror" (273). What the camera freezes, however, is an intimate reflection of the artist's role as an image maker, a mirror in his own right. The central image is a reversed vision of Richter's painting of his daughter, Betty, who in turn is looking at one of his gray monochrome paintings from the 1970s, a nonreflective abstract image. The mirror painting shows the work *Betty*, in Richter's studio. We are reminded, too, of the readymade, domestic function of this mirror as it captures the edge of a door in his studio. Two other mirrors must be standing against an opposite wall, and from this angle, they capture yet another of Richter's artistic progeny. In ways analogous to Smithson's work, we are looking at species of generation, both genealogical and aesthetic; temporality – both long and short – combines with a clear but transient vision of space.

Where Richter's red monochrome seems much like a painting in some views and some photographs of it – and thus strikes me as a "readymade monochrome"[11] – at other angles, it captures floating imagery in Richter's studio or in a gallery installation (Plate 4). Richter typically uses mirrors in this abstract idiom to recall and investigate aspects of his earlier paintings *and* the discourses of photography that are never far from view. His gray mirror paintings of the early 1990s are back-painted pieces of glass that recall in hue his many gray, monochromatic, nonreflective paintings of the mid-1970s. Compared with these gray monochromes, the mirror pieces are remarkably figurative, paradigms of Richter's penchant for challenging all such categorical conventions. "This time," he reports, the glass he uses "doesn't show the picture behind it but repeats – mirrors – what is in front of it. And in the case of the coloured mirrors, the result was a kind of cross between a monochrome painting and a mirror, a 'Neither/Nor' – which is what I like about it" (225–6). Especially in his visually seductive and

23. Gerhard Richter, *Mirror Painting (Grey 735-2)*, 1991. Pigment on glass. 280 × 165 cm. Photo courtesy of Anthony d'Offay Ltd., London, and the artist.

intellectually captivating *Mirror Painting (Grey, 735-2)* of 1991 (Fig. 23), the artist plays with the dialectic of an apparently empty or blank monochrome and its inescapable visual inclusiveness. We see Richter in his studio, back turned and gazing at nature (or perhaps at his own reflection in the window pane), a theatrical, ironized modern-day Caspar David Friedrich figure. The gray back-painted mirror shows us nothing of its *own* materiality as a "painting," in fact as a ready-made it has very little of this quality to show, yet it reflects the studio where Richter works and even displays for our eye the stretchers of more traditional

paintings. In this frozen detail, we see the "back" of painting that we cannot otherwise see: the tain of the mirror, its painted part, allows us to see not itself as "back" or depth but the back of other figures. To suggest that the canvas is "in" the mirror, as we commonly say, is inaccurate because its image depends on a viewer. And there is another sense in which painting doesn't exist in the mirror work: *Mirror Painting* of 1991 does not have a stretcher. It has no depth. It is not canvas and it was not created by the artist's touch (though in a way it comes from his hand). The back of the canvas that we see because of the mirror itself echoes visually the mullions in the window out of which Richter gazes.[12] Paradoxically and profoundly, we are thus reminded by this mirror piece that art is not an Albertian window to the outside world – though painting has often wanted to be just this – nor is it a transcription of either nature or the artist's feelings. Presented in another space or even just at another instant, the decidedly figurative data disappears or at least changes. Here Richter erases himself as artist precisely by showing his reflection. Beginning with *4 Glasscheiben* (4 Panes of Glass) in 1967 and again recently with the large reflective surfaces of *Acht Grau (Eight Grey)* (2001, Fig. 24), Richter constructively elides "the painterly episteme of the window with the paradigm of the monochrome" (Buchloh, 2002, 14). Mirrors, or photographs of mirrors, can exploit this double and decidedly antiauthoritative effect, as in Snow's famous *Authorization*, where the "author" is presented in a grid system of potentially endless replication and dissipation, or, as we have also

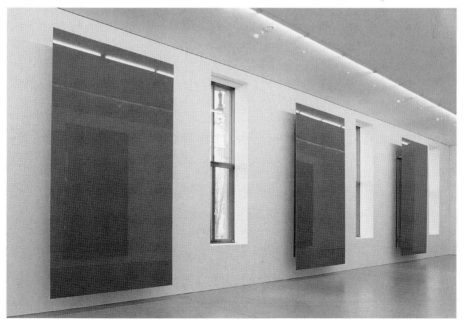

24. Gerhard Richter, *Acht Grau*, 2001. Installation Shot. Enameled glass panels, each 320 × 200 cm. Installation at the Guggenheim Museum, Berlin, 2002–2003. Photo Mathias Schorman. © Deutsche Guggenheim Berlin.

seen, in Smithson's *Enantiomorphic Chambers* (Fig. 19). For Richter (and also, for example, Alan Charlton and on occasion Rudolf de Crignis) gray is the colour of choice not only because it is the epitome of a nonstatement, as he said of his own, Newman-like *Two Greys Juxtaposed* of 1966, but also perhaps because it is extraordinarily receptive of our projected meanings and to our perceptual and intellectual puzzlements. Like Wittgenstein, who meditated on the unique oddities of gray in *Remarks on Colour* – "I am told that a substance burns with a grey flame. I don't know the colours of the flames of all substances; so why shouldn't that be possible?" (1977, #40) – Richter has for decades been captivated by the possibilities of this hue.

For Richter, art *should* travel beyond any imposed limits of support or place of presentation, and it should infect its receivers. Its life is in its impurity, in what we might call a principle of augmentation. Robert Morris has claimed that "with mirrors you can stretch the space and have the real and the illusory at the same time" (2000, 230). Richter's several long-exposure, so-called triple self-portrait photos from 1990 combine surface, depth, and mirrors to claim a potential for art to make contact with more than superficial reality. Here Richter himself circulates in a ghostly way, not only in the images of his corporeal form, but by reference to his paintings (and one sculpture, the mirror-like *Steel Ball* that we see on the floor). Temporality is doubly inscribed by the long exposure time and by references to works made over time. We are made certain of the artist's apparent existence *beneath* the surface of the image by his Pollock-like dribblings of paint onto the photograph, yet the serendipity of these images also suggests that the artist is not "behind" them in the sense of being their origin. Nonetheless, Richter poses important questions with these mirror works; we can use his work to ask questions about representation and nonrepresentation. Thinking about the genre of abstraction and its life in contemporary art, what I want most to know is whether Richter's mirror works, with their palpably controlled allusions to nonrepresentational, frequently monochromatic painting, give us privileged access to what Derrida has deemed "the truth in painting," to its essence as an impossible desire for replication, perhaps even for seeing and understanding our selves. Through the recapitulation and control of variables traditionally presented by monochromatic abstraction, that is, can we finally see sight?

Let me return to a conundrum that I have already illustrated: the ontological and typological status of photographical works, such as Snow's *Authorization*, in which the artist is reproduced photographically so often as to lose any sense of a first, authentic image, and, in the nonrepresentational idiom, Richter's many back-painted mirror monochromes as we see them in reproduction. I can write what I have about the mirror work that includes Richter's daughter, Betty, looking at another Richter painting or the gray mirror that reflects the artist, only if I refer to a carefully edited photographic presentation of the work, the work without

its vagrancies and impurities, in a sense, the work as we can see it in reproduction alone. But Richter, Smithson, and many others behave as anti-Platonists by purporting to appreciate and employ mirrors because their reflectivity cannot be controlled. Is this disingenuousness or merely wanting to have it both ways, the mirror as abstract and as figurative? Looking at a photo of a mirror work, do we believe that mirrors show us generally what is around to be reflected, almost in a random way, or do we sense that the mirror reflects something specific, this *particular* image controlled by the artist? If we are presented with a choice of this sort, there seems to be an important difference between general reflection, as in a Richter mirror work in his studio, and purposeful mirroring, as in the photos of his work in the studio and gallery. The fixed photograph, although not didactic, might seem to show us sight. Conversely, when we experience a mirror work by Richter or others in a gallery, its reflective activity is unceasing. Even if we stop moving, others in the space do not and neither does the light. If we recall that Richter especially works self-consciously within the tradition of monochrome nonrepresentation, that purportedly purest of all art forms, what then do mirrors have to do with this still-practiced genre of art? Do they not seem like the very worst medium in which to demonstrate art's essentials, as the genre has often purported to do? Richter has found ways to suggest not only the surface activities of the mirror monochrome – what we might see as its modernist heritage, deriving from Greenberg, as a flat surface – but also its back or depth (recall the back painting technique that produces some of this work as well as the reflection of the canvas stretcher). Because he shows that mirrors do more than reflect and are more than literally superficial, the Albertian image of painting as mimetic mirror is disturbed. Richter has in fact discovered a new and highly paradoxical way for "paintings" to be nonrepresentational even while they fleetingly contain figurative imagery. Mirror works of this sort are nonrepresentational in their surface effects, generic allusions, *and* in the fact that their images are never really "there." But because the mirror works remain dynamic and potentially uncontrollable, Richter doesn't reveal how sight works in some timeless, bodiless, "abstract" sense. This contention sheds light on Smithson's puzzling words about his third Yucatán mirror displacement: "The mirror itself is not subject to duration because it is an ongoing abstraction that is always available and timeless. The reflections, on the other hand, are fleeting instances that evade measure" (1995, 122). If we add the sense of touch crucial to my genealogy of nonrepresentational work using mirrors, Fontana's paradigmatically, then the message here could be that sight isn't exclusively optical but involves other senses. By analogy but also materially, neither is painting literally just painting. Here it is at least a mixture of painting, photography, and readymade mirror. These elements relate to one another as do Smithson's sites and nonsites, that is, in terms of circulation and recontextualization rather than priority.

2. Mirrors of Society

In their role as hybrids, these mirror monochromes function for Richter and in contemporary art as painted monochromes often did in the history of 20th-century art from Rodchenko and Malevich to Ad Reinhardt: as critically compressed (and only rhetorically final) statements about and instantiations of abstraction as *the* privileged locus for experimentation and commentary, if not for truth, within the visual arts. But more than the axiomatic monochromes of high modernism – Malevich's white and black squares or Klein's blue fields – these hybrids purposefully eschew purity and finality by invoking the untamable activities of mirroring. Instead of the last gambit in an endgame of painting, the mirror monochrome endlessly generates more images and abstractions. It includes the figurative within the abstract and vice versa. With the mirror as its support, abstraction reflects the social more readily than its supposedly internal aesthetic concerns. Narcissus's sin was to prefer himself (or the other that he then recognized as himself) over all others; the same could be said about formalist abstraction in the mid-20th century. One way to break out of the infinite self interest of mirrors is to focus on their reduplicative possibilities, a strategy that can, ironically, provide a response to the charge that mirrors merely reflect. To put the point another way, abstraction can lend a positive spin to iconoclasm.

Michelangelo Pistoletto's work, as he recognized in 1982, "is mostly known for its use of the mirror" (2000, 119). Beginning in 1961, his many "mirror paintings" have investigated the role of the observer and of freezing his or her behaviour by fixing a photograph of a human figure or figures onto the surface of a mirror. Some look out, others in – as we do facing the mirror – or the "real" and simulated viewers can gaze together at a seen or unseen point. In situ and in reproductions of this work, we can thus watch two types of observers, one fixed and the other in motion, in the mirror surface. Explicitly trying to escape the absorption of Narcissus and what Danto colourfully calls his "epistemological suicide" (1981, 9), Pistoletto's mirrors double our perception of viewing to provide distance from the experience and thereby allow us entrance into a "rational" dimension. "This myth presents a man still guided exclusively by instinct" and desire, he has written (2000, 119). Although the distancing he seeks in the mirror works is itself "abstract," Pistoletto also makes reference to this term as it implies the recent history of painting. His various *Divisione dello specchio* (Division of the Mirror [Fig. 25]) pieces from the mid 1970s present mirrors with the ornate frames typical of older paintings. What we see inside these frames, which are set into a corner of a gallery space or found leaning or stacked against a wall, can range from a monochromatic "nothing" to a partial but purposeful and thus highly self-conscious fragment of the artist photographing himself in a double mirror. In a text from 1993, Pistoletto elaborated a history that gives a good sense

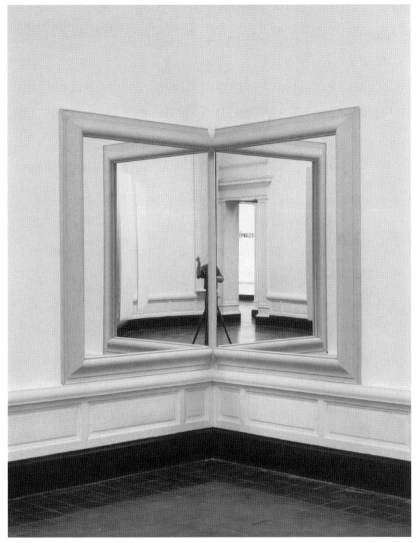

25. Michelangelo Pistoletto, *Divisione e moltiplicazione dello specchio-angolo*, 1975. Mirror and golden frame. Two elements, each 150 × 120 cm. Collection of the artist. Photo: Paolo Pellion, courtesy of Fondazione Pistoletto.

of what he hoped to accomplish with his mirror works and that resonates closely with the history of recent abstract art I have formulated:

> Fontana lacerated the canvas, always in a perspectival direction; Pollock stuck on the wall, at window height, the painting he'd first walked all over. Duchamp's glass hadn't succeeded in truly blazing a trail, since it continued indicating a progressive direction in terms of traditional perspective and was shown at window height. At the end of the 50s, Yves Klein launched himself into the emptiness of this window. Subjectivity had no further hope of finding a way out ... I made ... man and the whole picture come

down to earth, I relieved him of any expression of anguish, I made him stand on the floor and . . . I transformed the space surrounding him into a reflective surface: from the window it had been, the picture became a door (2000, 167).

For Pistoletto, "the equation 'personal style/art's autonomy' ceased to function" in art since the mid-20th century (2000, 166). Not unlike Smithson and Richter, what he discovers through the mirror is the impossibility of the self and the fascinating futility of representation. Functioning as an alternative to if not an escape from images, some of Pistoletto's mirror works perform without attached photographs. They reflect what light levels and their immediate physical context make available and thus can appear as monochromes or complex figurations. *La tavole della legge* (The Tables of the Law [Fig. 26]) of 1979, for example, can appear

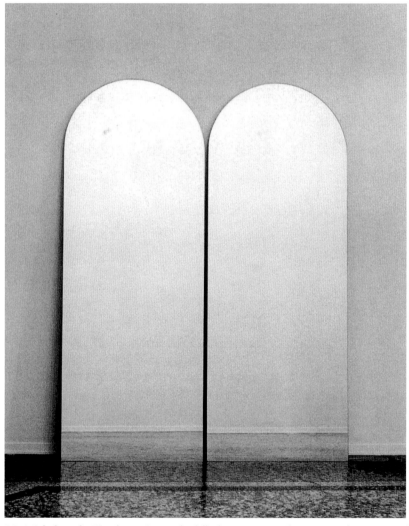

26. Michelangelo Pistoletto, *La tavole della legge*, 1979. Mirror. Two elements, each 200 × 180 cm. Collection of the artist. Photo: Paolo Pellion, courtesy of Fondazione Pistoletto.

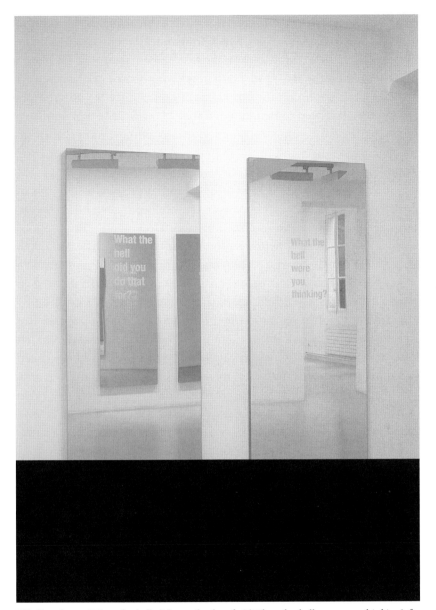

27. Ken Lum, *What the hell did you do that for?/What the hell were you thinking?* from *Mirror Mirror*, 2004. Frost etched glass, lacquer coated aluminum. Each panel 74 × 31 in. with 12 in. between = 74 × 74 in. Photo courtesy of Galerie Nelson, Paris, and the artist.

(before one notices the title) as a double shaped canvas, a double window, or a twin portal. Unlike his mirror paintings but in concert with many corner mirror works by Richter or Art & Language (for example, *Untitled* of 1965), this piece does not support the physical frames typical of painting. Nonetheless, one of its references is still to painting, to the "unframed" edges typical in the 1960s. If this time is "reflected" here, so too is the textuality that was eschewed from

pure abstraction. Language is invoked but not shown. The reference is of course to Moses' prohibition of graven images, which Immanuel Kant proclaimed in the *Critique of Judgment* (1987[1790]) as "the most sublime passage in the Jewish Law" because it abjured the day-to-day baseness of the senses and allowed, in his terms, for a concentration on the moral law (1987[1790], 274). But mirrors cannot be senseless. We need to be reminded that *La tavole della legge*'s mirrors are not providing images or idolatrous reproductions but are, rather, abstract. In the light they must reflect and in the dark they still invite touch. Pistoletto's *tavole* can and sometimes do refuse to create imagery. They can appear as "blank" abstract monochromes and thus supply a defense against the proscription of imagery. Without the invocation of the Moses text supplied by the title, however, the work cannot be abstract. The mirrors' inevitably fleeting and thus tenuous membership in this category depends on the impurity of textual allusion. Ken Lum's recent mirror panels and mazes reiterate this point. *The Mirror Maze with 12 Signs of Depression*, seen at Documenta 11 in 2002, combines his interests in common and clichéd language, the look of text, and mirrors. His mirror diptychs of 2004 present emotive phrases etched onto mirrors so that a viewer can potentially map a sense of despair (for example, "What the hell did you do that for? / "What the hell were you thinking?" or "I can't go on like this / I can't keep this up anymore") onto his or her visual image (Figs. 27 and 28). But not only the hackneyed and ultimately impersonal resonance of these phrases keeps them from sticking to any one person, a technique he established and extends with his photo and text panels. Inevitably, the mirrors bounce any amount of other irrelevant visual information around the room in which these pieces work. Language itself appears as a contaminant on Lum's 2 × 1 meter surfaces, supports that are carefully wrought and linked with painted frames and perfect dimensions to remind us of painting in a minimalist tradition. And the texts cannot function directly either, given the inevitable interference of other visual data, both other, competing texts from Lum's related diptychs and that of less controllable sorts. In conversation, the artist mentions that adopting the ideal viewpoint directly between the pairs of mirrors has the effect making both texts legible but erasing the image of the self/viewer, which again recalls Smithson's *Enantiomorphic Chambers* (Fig. 19).

Pistoletto's passion for the social behaviour of abstract reflective surfaces is shared by other artists who strive to augment and disturb the nature of abstract art in the present. Christian Eckart's series of abstract, constructed paintings, both extend Pistoletto's concerns and offer increased critical purchase on issues I have articulated. His *Endless Line Paintings, Polychrome Paintings, Zootropes, Circuit Paintings,* and *Curved Monochromes* utilize highly polished reflective surfaces achieved through extreme-effect coating technologies on shaped aluminum armatures and supports. Each group is both rigorous enough to specify particular aesthetic and social issues and sufficiently capacious to allow experimentation. Eckart

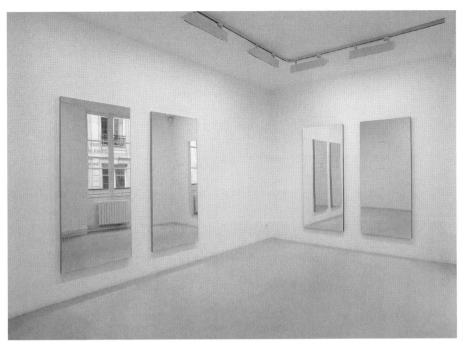

28. Ken Lum, *I must be losing my mind./Am I really losing my mind?* from *Mirror Mirror*, 2004. Frost etched glass, lacquer coated aluminum. Each panel 74 × 31 in. with 12 in. between = 74 × 74 in. Photo courtesy of Galerie Nelson, Paris, and the artist.

notes that in all his current series, "some of the 'paintings' change colors contingent upon lighting conditions and the relative position of the viewer to the work, ultimately enhancing and exaggerating the works dynamism,"[13] but his *Curved Monochromes* especially emphasize the interaction with the tradition of monochrome painting. One of his largest and most challenging groups, the range of the *Curved Monochromes* is shown by distinctions in hue and format: canvas-shaped metal curves in the mid-1990s, works with integral "frames" and abstract "subjects" from later in that decade, current pieces that are highly coloured and revel in their distortions of reflected space (Fig. 29; dustjacket). I return to these paintings but want to begin with links to two frameworks: that of the frame as limit and vehicle of presentation pursued with mirrors by Pistoletto and the question of propinquity and tactility that we find in Smithson's stacks of mirrors, Eliasson's spinning mirrors, Nauman's *Green Light Corridor* of 1970, and Lili Dujourie's *Between Black and Pink*, 1986.[14] Eckart's memorable *White Paintings* feature hand-crafted gold frames that border sliced and displaced fields of monochromatic white. His *Andachtsbild Paintings* are nearly all gold frame and allow us to meditate on the contemporary role of personal devotional objects. The *Eidolons* – phantoms or specters – frame an "empty," white gallery wall space with carefully designed gold frames, thus impossibly exhibiting or gesturing toward the void, as so many monochromes have done in other ways (Fig. 30).[15] None

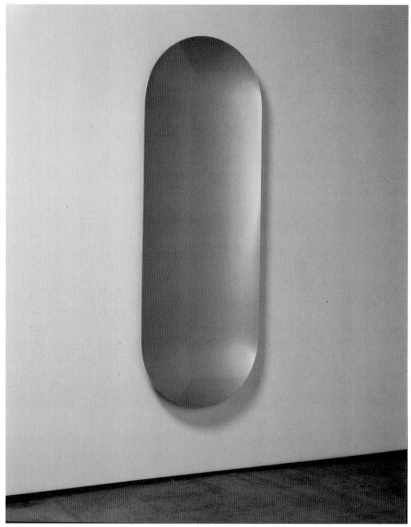

29. Christian Eckart, *Curved Monochrome painting, Fifth Variation # 2001*, 2000. Acrylic on aluminum. 90 × 30 in. Photo courtesy of the artist.

of these abstracts use mirrors or reflective surfaces. In fact, Eckart has avoided actual mirrors, with one important exception. *Noumena*, a multiple from 1990 (Fig. 31), is constructed of two square domestic mirrors bracketed together so that their reflective faces are turned inward. What we see as the piece hangs on the wall like a normal painting is the dull gray mat back of one mirror surface. We see a monochrome, one reminiscent in a different chromatic register of Robert Ryman's because of the prominent hardware Eckart uses to fasten the mirrors together.[16] What do the mirrors replicate? What can they see? Light does enter along the beveled edges of the piece, but we cannot visually access the space of mimesis. The title posits that something beyond the ordinary is taking place, but

we cannot know what that is through vision alone. In the examples cited above, Nauman and, more recently, Dujourie used facing mirrors to invite our gaze. The tactile objects that Dujourie places between the proximate mirror surfaces are intriguing, and Nauman offers an empty space for potential occupation. Only in the Eckart, however, is touch a reality, not the touch of an artist/Narcissus figure but that of the reflecting mirrors. Looking outward, by contrast, the high-gloss, variously coloured surfaces of Eckart's numerous *Curved Monochrome Paintings* respond to their environments in ways analogous to Richter's monochromatic mirrors. Eckart designs these innovatively and precisely shaped monochromes and places them, whether in the gallery or a public space in the case of large

30. Christian Eckart, *Eidolon # 1103*, 1989. Twenty-three-carat gold leaf on poplar moulding with iron hardware. 96 × 78 in. Collection: Bob Feldman. Photo courtesy of the artist.

31. Christian Eckart, *Noumena*, 1990. Multiple, edition of twelve 2 1/4 in. mirrors clamped face to face in hand-fabricated aluminum bracket (with travel case). Photo courtesy of the artist.

commissions,[17] so that they may interact with their settings. In some of the rectangular members of the series, the curve of the support is calibrated first to embrace a viewer and to acknowledge the human scale of the work by providing his or her reflection. As we move toward these pieces, however, the curved surface seems to collapse on itself. It finally erases the reflection and any concomitant sense of self or "subject" in a monochrome wash. His *Curved Monochrome Painting, Fifth Variation #2001* (2000; Fig. 29) is recognizably part of the large *Curved Monochrome* family but also different from its siblings. Like many of its colour field interlocutors, it stands alone as an object. Its hue is light and opalescent. Though the form is concave, it can appear to protrude toward the viewer. Isolating this highly reflective work in an individual photograph denies much of its nature. Meticulously planned and executed though it is, the work is not precious and cannot be autonomous. Because it has a human scale and vertical orientation, it promises interaction, not separation. It also works constantly as a mirror, imbibing and emitting quotidian changes in it surroundings. Eckart thus extends the innovations of recent artists, Pistoletto and Richter, for example, who use the mirror surface to trouble the autonomy of abstraction. Surface qualities could

not be given more consideration in the experimental finishes Eckart seeks out and by the craftspeople employed in their application, but the purpose of this attention to detail and the final destination of these reflective wall pieces remains outward. To what is Eckart's precision directed? Choosing his words as carefully as his colours and shapes, he has written that "the production of the various series of *Curved Monochrome Paintings* is generated by interests in ideas such as emptiness, nothingness, fullness, presence, absence, materiality and immateriality as well as continuing an inquiry into the emblematic properties and tropes of the Sublime as it pertains to Western painting." The key term here is *emblematic*. Eckart is careful not to say that this work *is* sublime, but rather that it represents, abstractly, that set of extreme aesthetic aspirations. In recalling that tradition, he extends its relevance into contemporary culture. As in Pistoletto's mirror works and Smithson's *Enantiomorphic Chambers*, the artist as creator is secondary to the interaction that he, or other observers, can have with the reflective abstract piece and with the environment it galvanizes.

More elaborately staged to reflect the social than even Eckart's reflective public commissions are the many mirror works by Dan Graham (Fig. 32). Although none of Graham's work is abstract in any sense linked to the heritage of painting, his *Mirror Pavilions* recapitulate the capture and dissemination of nonrepresentational

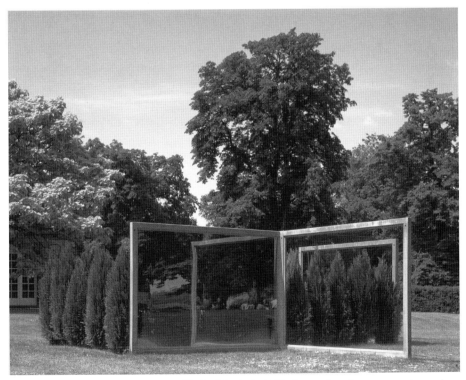

32. Dan Graham, *two-way mirror and hedge labyrinth*, 1989. Sprayed steel, two way mirror, clear glass, and blue cypress trees. 220 × 600 × 900 cm. Courtesy of Lisson Gallery and the artist.

pattern and colour. This dimension of Graham's work has been occluded by its overt social concerns and by most viewers' penchant for identifying the "readable" imagery that his installations and performances readily and critically supply. Comparisons with abstraction in the work of Smithson, Richter and other artists considered here, however, can show us this "additional element" in Graham. These new contexts reveal unremarked aspects of Graham's obsession with mirroring and, reciprocally, emphasize the social aspects of mirror abstraction that epitomize the genre's move away from autonomy. In company with Smithson, Morris, and Richter, Graham has exhaustively explored the conventions and technologies of reflectivity. His "Essay on Video, Architecture, and Television" (1979) details the range of interconnected concerns he addresses with mirror surfaces and their transparent and translucent relatives. He might have added photography to the list in the title, for as Ken Lum has noted, traditionally, "a camera isn't much more than a series of mirrors" (1998, 15). In his writing and material production, however, Graham addresses the subtle shifts of temporality and visuality among these forms. Using video and mirrors together emphasizes their differences. "A mirror's image optically responds to a human observer's movements, varying as a function of his position," Graham writes. "By contrast, a video image on a monitor does not shift in perspective with a viewer's shift in position . . . A video monitor's projected image of a spectator observing it depends on that spectator's relation to the position of the camera, but not on his relation to the monitor" (1999, 54). All these reflections focus on and explore the "self," as Graham notes, whether from the vantage of individual self-observation in a one-way mirror to the opportunities for surveillance exploited by two-way versions. Although the presentation and investigation of this self image is primary in Graham's work, other, "abstract" visual phenomena necessarily appear. One of his earliest designs, *Project For Slide Projector* of 1966 keys us to an awareness of this abstract visual static caught by Graham's better known installations. An eighty slide carousel was set to project automatically, at five-second intervals, "images" made by photographing the interior of a four-sided glass box with a mirror on the bottom. The shots prescribed by Graham for his slide show move clockwise around the box and back in depth. "The image – the subject matter – is transparent, illusionistic (mirror) space," he claimed (Pelzer, 2001, 45). Unlike Turrell in his *Afrum* projections, which create an illusion, Graham's project beams a still image of reflection. Without his notes, it would be difficult to read what we see in *Project For Slide Projector* as images *of* anything. The slide projector work can remind us of the issue I raised above with reference to documentary photographs of Richter's mirror monochromes. What we see in the photo *could* be seen in situ, but it might not be and much else would be in view even if a viewer stood still. Both Pistoletto and Lum have explored this predicament by attaching stills to mirrors and in the latter's case by adding text to the reflecting surface as a semiotic anchor, if not a fixed point of reference. However important the recognition of the specifics of site and cultural

nuance is in each of Graham's many mirror pavilions since the early 1980s, there will always also be specific if fleeting "abstract" reflections on the surfaces he constructs. Seeing and registering them in the contexts of abstract art developed here is a matter of attention and volition. If indexed in this way, it is evident that these visual imperfections of pattern, colour, and light circulate freely and perpetually in our visual environment, waiting to be caught, however temporarily, and contextualized.

Eliasson joins other notable artists who have used the mirror to reflect our sense of awe, agency, and sometimes helplessness in the mediated perception of self and other. As shown in Chapter 2 with reference to Mack's *Artificial Suns*, Eliasson's magisterial *Weather Project* (Plate 2) deployed mirrors to reproduce sublime natural effects as a monochrome ecosystem. Although even here he does not divide our sense of "nature" from the "culture" that projects it, as we will see, many of his works are less celebratory. Some, such as the double spinning mirror kinetic sculpture discussed above, employ mirrors to acquit or frustrate the doubleness of self-surveillance; in this he can be compared with Dan Graham. Others reveal the futility of the quest for the epiphany of "seeing yourself seeing." Though much of his work engages the marvels and limits of (self) perception with mirrors, light, colour, texture, and other materials, one recent installation addresses these issues with particular directness and effect. *Seeing Yourself Sensing*, a screen of vertical reflective bands applied to the courtyard windows of the Museum of Modern Art in New York as part of the "Projects" series in 2001, allowed spectators both to see out to the sculpture court as they moved up or down the escalators and to catch glimpses of themselves and others "sensing." Eliasson talks frequently about seeing, the sense most invoked in the art museum, yet sight for him never succumbs to the mythology of pure scientific objectivity. As he asserts about "looking at nature" in general, "I don't find anything out there . . . I find my own relation to the spaces. . . . We see nature with our cultivated eyes. Again, there is no true nature, there is only your and my construct" (2001b). A small, closely related work from the same year as the MoMA installation carries the more symmetrical title *Seeing yourself seeing*. It is simply a one-meter-square framed piece of glass on which vertical mirror strips have been applied in a regular spatial order. A viewer can see through this piece and also perceive him- or herself in the act of looking. The MoMA treatment subtly replaces the second iteration of "seeing" with "sensing," which can embrace a greater range of response, from the palpability of touch so important to Narcissus to the intellectual animation of metaphoric and spatial proximity. Although the main thrust of this installation was thus to show "how cultural sites mediate our perception of pure processes" (Eliasson, 2001a), its mirror effects were, again inevitably, also "abstract," and not only because fragmented form and colour appeared across the bands and Eliasson's veil of mirrors itself forms an abstract surface pattern. Associations with the recent history of abstraction in the hands of Stella, Riley, Rosenquist,

and Molinari are contiguous with this work because it was sited at the edge of the world's greatest collection of such art.

Eliasson participates in contemporary practices and discourse about abstract art and perception; however odd the juxtaposition may seem initially, his work offers an instructive point of comparison with that of Bridget Riley on the issue of abstraction's autonomy versus infectious dissemination. His two after-image installations, *Your orange afterimage exposed* and *Your blue afterimage exposed* discussed in Chapter 2, for example, use the genitive pronoun to underscore the viewer's share in experience and how difficult it is to generalize perception, even though the possibility of communication assumes some common basis of experience. In the gallery, artists initially stimulate an individual viewer's cognition: this is true of works as different as Riley's paintings and Eliasson's installations. In principled contrast to Klein's goal of "impregnating" the environment with blue, Riley focuses on the effects she can create in the viewer with limited means and on a demarcated surface. Colour may seem to lift from the plane or forms undulate thanks to a black-and-white pattern, but these effects are carefully controlled. We are assured in audio notes to Riley's retrospective at the Tate Britain in 2003, for example, that "there's no reference to anything outside the painting," even in a piece such as *Breathe* (1966), with its apparently referential title, because Riley titles such work after she executes it and therefore does not in any way start with or illustrate the notion of breathing. The commentator elaborates: "*Breathe* is a response to the purely visual sensation conveyed by the painting," its in and out undulations are analogous to those of the body's respiration, as Riley herself explains in the audio clip. Why is this putative autonomy so important? Can language be held at bay until after the "pure" operations of perception have occurred? Although Riley did not begin with the metaphor of breathing, clearly she thought this association important enough to make it palpable as part of the experience of the finished painting (if we read the title, as most observers do in our culture). Again in *White Disks* of 1964, the title may seem superfluous but in fact augments the work with irony. What we see initially are black disks; white disks appear as afterimages and are thus in a sense not there physically, except in the title of the work. An artist can exploit or seek to curtail the "impregnations" of colour and shape's associations (even with very good reason, as in Riley's case, where her early work was, if you can tolerate the pun, "co-opted" by commercial interests), but it seems impossible to edit them out completely, especially in the communal and culturally over determined space of the art gallery.

The visual fragmentations proliferated by mirrors in several of Eliasson's installations operate both perceptually and metaphorically (one could also say "figuratively") to disseminate rather than consolidate the abstract. Three works from 1998 − *Fensterkaleidoscope*, *Well for Villa Medici*, and *Your Compound View* − take what could be straightforward mimetic phenomena such as seeing oneself or framing a view of a proximate building and make them at once difficult and

fascinating. In the first of these three, Eliasson has constructed a minimal tech-
nology to direct our view toward a building seen through a window across from
his gallery installation. We are reminded, as in much of his work, that windows
frame in this way but are never transparent in the full sense. Here the rectangular
box down which we stare is lined with tinfoil. We can see part of the building
clearly but our field of vision must now also include other abstract information
generated by the uncontrolled interactions of light and colour. Both *Fensterkalei-
doscope* and *Your Compound View* play with our sensation of two and three dimen-
sionality, in terms of the traditions of abstraction, whether what we see is flat
or deep. Even the eight-meter-long narrowing tunnel that forms *Your Compound
View* appears at its mouth as an abstract "picture," a flat play of pattern. The same
can be said of the collagelike rectangles that form visually at the viewing end of
Fensterkaleidoscope. Well for Villa Medici and *Your Compound View* are sophisticated
machines for breaking up any direct correspondence between our image of self
and what we see in the many mirrors they use. Looking down into the portable
well, for example, we cannot (like Narcissus, again) be entranced by an image of
self or other because the mirrors on the sides of the structure ceaselessly produce
distracting, impure, abstract visual data. We cannot have an affirming "Renais-
sance" perspective here, even in the Medici gardens, nor can we revel in a romantic
sense of the endless depth of the bottom of the well. Fontana's distressed mirror
surfaces in the *Concetto spaziale* series, discussed above, stand behind Eliasson's
disseminative practices and suggest that this sort of worldly abstraction is not so
much new in the genre as recessive. No less when using mirrors than in other
projects, Eliasson is always concerned to show the mechanics of his creations, to
dispel mystery and encourage analysis. A noisy pumping machine manipulates
the round mirror disk in *Konvex/Koncav* (1995/2000) by forcing the surface into
one, then the other, disposition. Vagrant visual effects change constantly, as they
do because of the "interference" paint on Eckart's recent curved monochrome
paintings and on the highly polished surfaces of interior and exterior disks by
Anish Kapoor.[18] The basic mechanics necessary for the dynamism of *Spinning
Mirror* are also deployed in *Eine Beschreibung einer Reflexion* (A Description of a
Reflection), 1995. A kinetic mirror disk throws a dancing, abstract light form onto
a large, concave projection foil and simultaneously creates a yellow monochro-
matic miasma in the room. Behind these examples stand the experimental films
of Moholy-Nagy, such as *Lightplay: Black, White, Grey* of 1930, where the inventor
of the term *kinetic sculpture* plays with forms and transitions created by his "light
space modulator." In all these cases, the optics are those of the eye, the aesthetic
that of abstraction.

Taras Polataiko's abstract practices allude to those of his predecessors –
Malevich and Fontana especially – but incorporate reflection on art as an agent
in society and state politics. His use of abstraction is paradigmatic of the genre's
contemporary inclusiveness and generative impurity of method and import, that

is, its deployment of the "additional element." His 1996 installation piece entitled *Cradle* (Fig. 4), to return to this graphic example discussed in Chapter 1, can be understood in terms of Narcissus and abstract mirroring, but given the hybridity of mirrors and especially of those that we may see in passing as abstract, this work, akin to many I have discussed, will not seem abstract to those of a more purist cast of mind. It is this restriction that I seek to abandon. The central element is a nickle-plated bathtub suspended by plated chains, which allow it to move slightly. The tub is sealed below its rim by a highly reflective surface, a stainless steel sheet fixed to the rim at a normal water level for bathing. If you bend over this skin, like Narcissus, you might be tempted to touch the image that you would see, but the surface would be hard, physically unyielding, yet optically responsive. As if thinking of the Narcissus episode in Ovid, Polataiko describes the effect of causing the cradle to sway: "The movement looked like ripples on the water and turned the ceiling into the pond of sorts. Soon you realized that the ripples on the ceiling corresponded to your movements, and only later you realized that they are caused by the beam of light coming from the ceiling (only one for the tub) reflected back to the ceiling by the imperfections (minimal unevenness) of the mirror-like surface."[19] And in addition to the large reflecting surface covering the tub, an observer enjoys privileged ocular access to the surface under the mirror provided by a drain-sized hole in the middle of the plate. Think of Fontana. But this is a private view, requiring choice and courage to initiate. You have to lift the lid on the stainless steel sheet and look inside. Here you sense another reflective surface, see it, and indeed smell it. This is the artist's blood, drained over a 15-month span by a helpful dentist. This isn't ordinary blood; it's radioactive. Polataiko is from the Ukraine. To make *Cradle*, he visited the sealed-off site of the Chernobyl nuclear accident and purposefully contaminated himself. He became a "carrier," and we can think of the two reflective surfaces of the tub and of the six oval forms that are also part of the installation as "infected monochromes."

The ovals look from some angles very much like domestic mirrors. On close inspection, though, they are much less perfect. In fact they are made of drywall and wallpaper, reconstructed by the artist after the banal wall coverings he saw in the alienation zone. These reflective surfaces are imperfect in other ways controlled by Polataiko. Once more there is the question of penetrating the mirrorlike surface because, as we can see only from an anamorphic viewpoint, he has put his fist through each skin and then patched up the damage, even copying the pattern back onto the scar to make the intrusion less visible. The surface flecks can be construed as the visual register of radioactivity. There can be no traceless recovery in the ovals any more than the radioactivity he infected himself with will simply vanish in some act of bodily purification. As shown again in Chapter 4, Polataiko is dedicated to the idea of art as a pathological condition. His *Glare* series (Fig. 3), literally and metaphorically reflective paintings of photos of paintings, responds to Malevich's Suprematist compositions, which were, as we know,

to Polataiko studying in Moscow in the 1980s, available only as readymades, as monochromatic images in Western coffee-table books. In both purpose and appearance, Polataiko remains consistent with Malevich's enigmatic invocation of the "Suprematist mirror" in 1923. Malevich and his associates searched for connections between the material world and Suprematist nonobjectivity, but this philosophical poem to the nothingness of nonobjectivity could only have the most minimal of painterly correlates. Polataiko remembers reading "about Malevich thinking of those empty peasant faces as suprematist mirrors."[20] His ovals from *Cradle* return to Malevich for their potency not only because they embody the additional elements of glare and, arguably, radioactivity, but also because they are reminders of Malevich's own late transmutations of Suprematism in the blank, oval faces of his figures.

In an earlier series called *YOU*, from 1994, Polataiko uses the appearance of his own face to question issues of originality, identity, and authorship. When the series is installed, a viewer's sense of self and other is constantly invoked and upset. Standing in front of one "YOU" painting, one is unavoidably seen from behind or from the side, made into a "YOU" or object by the gaze of other portraits in the room. We could say that these "portraits" reflect the self, though conceptually rather than optically. And they are mirrors in other ways: one is titled *Perseus's Shield*; others include *YOU and the Artist*, *Eyes for YOU*, *Photograph*, and *On the Face of It*. Polataiko even went so far as to cast a chrome-plated bronze helmet of his own head and insert one-way mirror-film into the eyes. The piece is called *Mirror Helmet*; he wore it at the show's opening, both drawing attention to himself as author and reflecting all viewers' attentions back on themselves. *You as Narcissus* (Fig. 33) is a monochrome whose face alludes to Narcissus's pool. It is important to note that we see the letters *Y*, *O*, and *U* in the "ruffled" mirror, to use Ovid's translated term, just as we do on the ceiling in the *Cradle* installation. Language habitually accompanies abstract form, as we saw in Pistoletto and Lum. The reflection cannot be perfect because something has penetrated and disturbed its skin. What does it reflect? Again, the letters *Y*, *O*, and *U*, which appear and then disappear because of (or in) the glaring "imperfections" of the linen, grounded in patches, as Polataiko puts it. If what we see as observers of Polataiko's Narcissus painting is not obviously ourselves, neither is it the artist. Both artist and audience can only be approximate versions of themselves in this mirror. Similarly, it is in an unavoidable sense "Polataiko" whom we encounter beneath the plated surface of the bathtub in *Cradle*, but in the act of looking, we reflect ourselves. What of Alberti's notion that Narcissus was the inventor of painting? What we learn from recent revisions of this theme is a version of what Alberti himself went on to say: "it is of little concern to us to discover the first painters or the inventors of the art, since we are not writing a history of painting like Pliny, but treating of the art in an entirely new way" (61–2). Narcissus continues to be mirrored in the perpetual reconstruction of abstract art.

33. Taras Polataiko, *YOU as Narcissus*, 1992. Acrylic on linen. 190 × 190 cm. Collection of the artist. Photo: Arni Haraldsson. Courtesy of the artist.

Bird's Eye View, Polataiko's contribution to the XXV São Paulo Biennale in 2002, used mirror abstraction in both literal and subversively lateral ways to address the announced curatorial theme of metropolitan iconography (Fig. 34). Polataiko lifted military satellite images of eleven prominent world cities from the Internet, printed them, and had them cut into puzzle pieces. He installed eleven large mirrors that would form the supports for the reassembled pictures and then hired two teams of eleven unemployed local residents to "do" the puzzles.[21] Mirror monochromes were transformed gradually into diagrams as they performed an act of re-creation over seven days, accompanied musically by Igor Stravinsky's *Lord's Prayer*. Although he carefully orchestrated the work, Polataiko nonetheless distanced himself from the process of its authorship. The result broadcast both irony and certainty: people who normally have neither a "bird's-eye view" of the world, nor a significant role in its development were made the agents of the reconstruction. No one could deny their authorship, but their creative agency (reflected in the mirrors as they worked) seemed less prominent over time, as the "puzzle" of each city's image reasserted itself (and thus masking the mirror). The work

34. Taras Polataiko, *Bird's Eye View*, 2002. Installation at the 25th São Paulo Biennale of Contemporary Art, São Paulo, Brazil (national representation of Ukraine). Eleven unemployed persons, eleven mirrors, eleven infrared satellite photos, each mounted on reinforced plastic and cut into 225 puzzle pieces. Collection of the artist. Photo: Taras Polataiko.

simultaneously addressed the painterly discourses of abstraction and figuration: detailed satellite photographs of the cities were initially abstract patterns "reminiscent of Gerhard Richter's abstract paintings (e.g., the Squeegee Series)," Polataiko claimed in his project description for this work. The source photos were also a conscious homage to the German artist's *grisaille*, aerial paintings of urban Madrid. The supporting mirrors – another reference to Richter – were rendered invisible when the puzzles were completed. In the final installation, however, shardlike reflections from the mirrors' now-submerged surfaces caught the eye. These random "glares" are abstract surface notations and a reminder once again of the hidden but never absent "additional element" of abstract art's infectious nature.

4 Possible Futures

Abstraction as Infection and Cure

> *I believe that the most compelling art-historical issues also have meaning outside the art world...I see my work as antidotal.*
>
> Sherri Levine[1]

> *If my work is abstract, it is because what we call abstraction, with its emptying and systematizing tendencies, is the operative force today in the realm of the social.*
>
> Peter Halley[2]

Few entities or processes challenge notions of autonomy in our society as potently as those associated with infection. I have noted Charles E. Rosenberg's point regarding disease in a large social frame, "once articulated and accepted, disease entities become 'actors' in a complex network of social negotiations" (Golden and Rosenberg, 1992, xviii). The group General Idea (GI) amplifies the genealogy of "infected" abstraction that I have traced from Malevich to Klein and epitomizes the model of abstraction as infection and cure, a pattern of transmutation that is crucial to current abstraction seen as socially active. More often than not, abstraction now labours against autonomy rather than extending the pattern described by Frances Colpitt. In "Abstraction at Eighty," we read that "contemporary abstract painting does not picture or refer outside itself..." (1988, 15). Although there is some important work that answers to this description – see my response in Chapter 1 to the exhibition *Pleasures of Sight* – autonomy has since the 1970s been decidedly recessive. In fact, this belated plea for the separateness of the aesthetic could be taken as blind to the suffering through AIDS experienced by GI, for example, or to the excruciating public disputes endured by Andreas Serrano over his "abstract" photos and other work, discussed below. All of the work to be discussed here again sees abstraction in a social context. Some is explicitly "infectious," whereas other examples can be understood within this large rubric.

I. General Idea's Infected Abstraction

GI came together as a collective in Toronto in 1968 and ceased to exist in 1994 soon after two of its members – Felix Partz and Jorge Zontal – died of AIDS-related illnesses. GI has represented Canada at the Venice Biennale, the Sydney

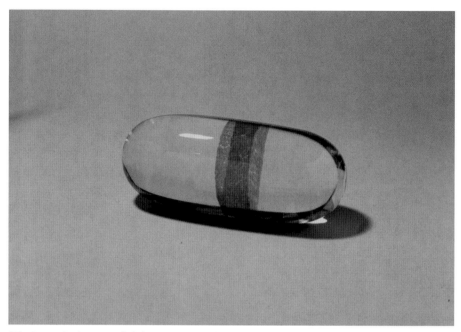

35. General Idea, *Untitled (AZT Paperweight)*, 1993/1996. Handblown glass. 8.4 × 20.7 × 8.8 cm. Prototype for an edition never completed. Collection of General Idea. Photo credit: Peter MacCallum, Toronto, courtesy of AA Bronson.

Biennial, the Paris Biennale and twice at Documenta. From the beginning, the collective's often humorous work challenged the pieties and purities of the artworld, not least by revisiting and subtly revising canonical abstraction in Mondrian, Rietveld, Reinhardt, and, most importantly, Yves Klein. GI's debts to the Klein of monochromatic blue impregnations are much greater than has been articulated in the extensive literature on the group. Although Klein's idiosyncrasies were clearly inspirational, GI also changed his work profoundly. It would be difficult to imagine a more political reception and redeployment of Klein's art, which in its original social contexts was allegedly right wing and at the least quietistic.[3] GI rightly perceived Klein as radical in his relationship to the purity of his forebears; the group adopted and transmuted his methods for a postmodern time.[4] In Klein's work, colour, the monochrome, and abstraction are never pure and autonomous. The strongest contrast is with Mondrian. Whatever tension the Dutch artist may have integrated into his neoplastic canvases or spatial constructions in the arrangement of his studios, for example, impurities necessary for the ideal of purity to function dialectically, his work has frequently been received as doctrinaire and restrictive. Tinguely reports that even before his 1957 blue exhibition, Klein "played with Mondrian" by arranging his own diminutive monochromes on his walls, as Mondrian had done before him with pure colour. We learn that "Klein always took green and . . . added purple, he always added orange, green, colors which are not Mondrian's." He said: 'I'm going beyond

Mondrian' "(Tinguely, 53). Tinguely claims not to know what his friend meant, but it is clear in retrospect that Klein purposefully disturbed Mondrian's hierarchies and stained his beloved purities. Before Mondrian and indeed before General Idea, he projected an impure and unbridled abstraction that went beyond Mondrian's architectural decoration and projected human harmony to a state of social engagement.

As early as their film *Test Tube* in 1979 – with its "blue moment" – and up to the dissolution of the group more than a decade ago, GI engaged in extensive "monochrome research" inspired by Yves le monochrome himself.[5] Happily borrowing the "chroma key blue" used in this film, they flaunted copyright by mirroring Klein's IKB and inaugurated a "blue period" as Klein had done, garnering as Klein before them not only an echo of an outrageous reference to Picasso but now an allusion to the later artist as well. An untitled multiple from 1993 to 1994, subtitled "for Joseph Beuys" (#9308), shows a chroma key blue bottom of a pair of jeans. Another untitled multiple, #9307, *Untitled* (*AZT Paperweight*), is a pill-shaped glass object, banded with CKB pigment, a Klein pill ready for circulation (Fig. 35). In a parodic homage to Klein's *Anthropometries*, the three GI artists deployed poodles – their canine alter egos at the time – as nonhuman brushes to inscribe "XXX Blue" (Fig. 36).[6] Blue shards of collapsed architecture and a commemorative blue pamphlet issued from the 1985 exhibition in Middelburg, Holland: *Khroma Key Klub: The Blue Ruins from the 1984 Miss General Idea*

36. General Idea, *XXX bleu*, 1984. Installation (three paintings: acrylic on canvas; three poodles: synthetic fur, straw, life-size, standard breed). Overall installation size: 3.5 × 10 × 2.5 m. Collection of the Art Gallery of Ontario, Toronto. Gift of Sandra Simpson 1993. Photo courtesy of AA Bronson.

Pavilion. Again like Klein before them, who produced a catalogue of putatively earlier monochromes that he likely never executed, GI recreated that which never existed and thus contoured their history as artists. GI's AIDS postage stamps of 1988 invoke Klein's IKB stamps (in addition to Robert Indiana's LOVE icon) in their format, their signature CKB blue, and in their performative dissemination. The stamps were seen again, in large format, as wallpaper behind the "Infected Mondrians" series of the 1994–1995 *Infe©tions* exhibition, to which I will return (Plate 6). The AIDS work began as a painting for a fundraiser in New York in 1987: "it was in such bad taste. We couldn't imagine ever doing it...that's why we did it," AA Bronson, the surviving member of the group, recalls (Sheehan). From here, the new AIDS logo mutated uncontrollably on posters and wallpaper, even appearing on a lottery ticket in Germany. Like the disease that it so powerfully yet ambiguously references, the logo infected not only the art world but also its supplementary borderlands. Latterly, the group took on the guise of doctors, attending not only to their own health but prescribing aesthetic antidotes to the viral outbreak of AIDS. Their deference to Klein takes the form of extending his practices of impregnation through colour and circulating their own aesthetic symptoms and cures in and beyond the art world. Quoting Klein, they fastened on artistic borrowing as what he called "'seizing'...through impregnation in sensibility" (1992, 60). For ideas to be "in the air" was, for Klein, a sign of their immateriality and sophistication. Punning on the metaphors so important to Klein's "urbanism of the air," GI enthused that "inspiration from other artists continued to arrive out of the blue." The text concludes with a section (later made into an artist's book) titled "XXX Voto," a reference to Klein's devotion to Saint Rita (ca. 1381–ca. 1456), patron saint of lost causes and impossible projects, whose shrine in Cascia, Italy, he visited many times, finally depositing there an elaborate Ex Voto in 1958. For the saint, GI substituted their fictive muse, Miss General Idea, and thanked her for her "aeration of the breathlessness of ultramarine" (63). In their prayers to the "XXX" patron of their lives, they ask that she might prevent enemies "from infecting us with anything that contaminates us, ever; please make us, and all your works, totally invulnerable" (64). Their Kleinean prayer was the ultimate impossibility. GI's fantasy of playing doctor was dystopian, as were some of their final collaborations, the "infected abstracts" of Reinhardt, Mondrian, and Rietveldt.

Reinhardt – like Malevich – was an art teacher for much of his career and outspokenly concerned with the evolution of art. He was introduced to art history at Columbia University by no less a figure than Meyer Schapiro. In his copious writings, Reinhardt was also "a teacher of moral lessons" (Rose, 1991, xv), the first of which was "the uncompromising 'purity' of art, and the consciousness that art comes from art only, not from anything else" (Reinhardt, 1991a, 54). Thus in his 1957 essay "Twelve Rules for a New Academy," he wrote that "the first rule and absolute standard of fine art, and painting,...is the purity of it"

(204). His relentless polemics against what art is not might well have included the phrase "art is not glare" to recall the work of Taras Polataiko on visual infection and transmission. Reinhardt deplored such distractions on his paintings. His notorious black monochromes of the 1960s were in part created so that they could not be photographically reproduced. He also thought they wouldn't sell: no glare, no sales . . . no potentially impure circulation outside the essential experience of viewing. So extreme was his purity – in this case as a shield against his works' reproducibility and possible three-dimensional implications – that he "grayed-out [black paintings because of] . . . his fear of [the] interference of actual space caused by reflections" (Bois, 1991, 13). Polataiko's *Glare* paintings thus comment on and contaminate the ideology of this central second generation progenitor of modernist purity. In fact, the younger artist initially began this with a Reinhardt black monochrome but didn't follow this avenue because he felt it was "too much of an assassination and not enough of a transformation."[7] Reinhardt saw pure, abstract art as both an evolved, historical form and as somehow timeless. He contrasted "pure" with a fair sampling of the art movements of his time: "Pop, Op, Ob, Brut, Junk, Kinetic, Plastics" (153). Again like Malevich, Reinhardt was a pure colourist. How he made black pure in these works is suggested in his description of reactions to his black monochrome exhibition between 1963 and 1965. "They are the logical development of my personal art history," he wrote, "and [of] the historic traditions of Eastern and Western pure painting" (84). With the allusion to Eastern monochrome painting, he implies that it is not his works' formal simplicity, their minimal means, but rather their contemplative nature that embodies their purity. Reinhardt's additional element was the mysticism of the East – an enriched purity – which is perhaps not as discontinuous as we might expect from Malevich's iconlike Suprematist compositions, influenced as they were by the Byzantine reverberations in the Russian Orthodox faith. In both cases, any sort of "glare" is an unallowable interference.[8]

Reinhardt's work and polemics were lampooned in the 1950s by Elaine de Kooning. Strikingly for the epidemiological strain in abstraction I am emphasizing, part of her jocular description of the artist she named "Adolf M. Pure"[9] is couched in medical metaphors. Young Pure's predilections developed under the influence of the distant cousin who brought him up. The cousin, she writes, "sterilized milk cans for a farmer's cooperative" for his living (de Kooning, 85). No doubt the whiteness of the milk is an important element in her story. As an established artist, Pure dines nightly in a drugstore. He claims that "activity is the ultimate impurity" and goes so far as to buy and store art materials "for future rejection" (85–6). Pure's creed of painting's autonomy – Art-as-Art – is also made to seem ridiculous by analogy. "Art is always getting involved with things outside itself and that keeps it from being fine. Take food . . . I don't approve of the relationship between food and life and artists. Too interdependent. An artist is dependent *on* food *for* life . . . Food is food; life is life; an artist is an artist. Why

this confusion between the boundaries?" (87). As we've seen with reference to the black monochromes, Reinhardt also tried to control the circumstances in which his works would be received. "The painting leaves the studio as a purist, abstract, non-objective object of art," he wrote of his black-square paintings in 1963 (1991a, 83), and he wanted to maintain their untarnished presence. In addition to calling for a new art academy that would keep artists and art pure, albeit with more sarcasm than idealism, Reinhardt championed the fine art museum as a pure environment for the experience of "art emptied and purified of all other-than-art meanings" (204).

Left-leaning politically, Reinhardt was nonetheless one of the last highly influential artists to hold onto the notion of aesthetic purity as a regulative norm. His views, like those of Greenberg and Fried, were in the minority in the 1960s and 1970s,[10] partly for reasons internal to art discourse (the ascension of arguments and practices that counteracted purism) and because the utopianism possible in Malevich's and Mondrian's worlds seemed forever lost. General Idea's infection of Reinhardt's pure black monochromes with the logo and thus the implications of AIDS is part of a pattern of dissemination and inheritance that constantly disrupts the rhetoric of purity. GI first envisioned an AIDS version of white-on-white work by Robert Ryman, and "around the time Jorge [Zontal] tested [HIV] positive" in 1989 or 1990, Bronson reports,[11] they first thought of inscribing AIDS onto Reinhardt's signature black monochromes. One way to see the result is as a radically impure compound of "Indiana" and "Reinhardt" elements, a mutant but reproductively viable host image retroactively infected by GI's supplement, the word-image AIDS. Inspired by the American novelist William Burroughs, GI's "Reinhardts" as image viruses deny the spirit and possibility of their originator's attempts to keep his black paintings sealed off in an ideal spectatorship. Purity is now inconceivable, its associations with the puritanical unbearable in queer contexts.

AIDS is both contagious and lethal. The would-be hermetic paintings are infected by the AIDS image, but given the horrendous impact that the disease has had on artists, does it come from "outside," is it not-art, as we must assume Reinhardt would have thought, or is impurity somehow latent within even this rigorous abstract art? Such open-ended questions about art in the world are consistent with GI's work over almost three decades. In 1972, the group started *FILE Megazine*, a *LIFE* look-alike that created its own art scene in Toronto. The anagrammatic transformation here, which, like a viral rearrangement of a cell's purpose, once infected, produces a cognate but twisted or queer replica, is the model for the LOVE-to-AIDS transmutation. "By placing *FILE* on the newsstands," GI writes, "we found ourselves face to face with a 'popular' audience. *FILE* had appropriated *LIFE*: with its *LIFE*-like format and esoteric content, it no longer functioned simply as a metaphor for that same process by which *LIFE* created news" (1984, 34). "We saw *FILE* as a virus put into the newsstands. It created this sense of familiarity, almost of safety, and people would pick it up unwittingly, not knowing

that they would be infected with new ideas" (cited in Carr, 2003). One precedent was Klein's version of the newspaper *Dimanche*, discussed in Chapter 2. Like the AIDS images, "*FILE* was conceived as a parasite . . . in the distribution system" (GI, 1995). It is here that we see the connection with the AIDS images. In addition to its colour properties and its status as a symptomatic marker of 1960s culture, GI was interested in Indiana's LOVE image because of the copyright issues involved in redeploying it as an AIDS "virus." Executives at *LIFE* brought the real world close with a lawsuit over copyright (settled out of court). Indiana had no rights to his LOVE logo; though the group did seek his permission to use it, GI wanted to see what would follow when an altered image "crossed the borderline from the art world into the real world" (Interview). Indiana's "LOVE icon" came to GI "degraded and humiliated after a freefall in the free market, badly abused due to its lack of copyright. We adopted it. We hoped to breathe new life into it + nurse it back to health . . . but with a difference" (1992, 59). The difference, of course – GI's supplemental element – was the AIDS logo and its many associations. With it, they again crossed the art/non-art border and revealed the very protocols that maintain distinctions on either side, fundamentally, the ever-present need for a distinction between art and non-art. This effect outlives GI itself. Bronson notes that "If anyone wants permission to use [the AIDS logo] in any way whatsoever, we always say yes" (Hanna, 1995).

Unlike their modernist predecessors, GI didn't believe that their work could change the "real" world. They had no such purity of purpose. "Does art have a use-value?" they asked. "Puritanically we tried to separate this elusive germ from any of art's well-known pleasurable side-effects. But we could not. We could not document one single case of art as the direct cause of the remission of societal ills" (1992, 58). What they did do very effectively – in words that uncannily echo Shklovsky's assessment of Suprematism discussed earlier – is stated in "The Word That Dares not Speak Its Name": like "the biologists, we had also isolated an image" (59; Fig. 37). After the work with Indiana's image, then, GI energetically "isolated and made visible" the "contaminant" (58). Simultaneously pursuing their colour research into the uses of red, green, and blue – and suggesting too their inevitable medical impotency in the AIDS crisis – they made three *PLA©EBO* works in 1991–1992. These consisted of three giant gel caps – one for each member of the group – flanked in each case by eighty-one smaller wall-mounted capsules. They produced *One Year of AZT and One Day of AZT* (1991), an immense installation that alluded to the magnitude of the AIDS epidemic and to its personal impact in the hoped-for "cure" of medication. These and many other related works appeared in GI's international touring exhibitions *Fin de siècle* in 1991 and *Pharma©opia* the following year.

Art can be likened to a virus, crossing social and political borders, always mutating, illuminating the structures that it temporarily inhabits – this is the lesson GI donated to *fin de siècle*, postmodern culture. Though group members were never formal teachers like Malevich or Reinhardt, GI's work instructs. Again in

37. General Idea, *Playing Doctor*, 1992. Chromogenic print (Ektachrome): 76.2 × 53.3 cm. Edition of twelve plus three A/Ps and 1 P/P, signed and numbered. Self-published. Collection of General Idea, Toronto. Photo credit: General Idea, Toronto, courtesy of AA Bronson.

contrast to these modernists forebears, but in company with Klein, Polataiko, and others, GI was never didactic. In fact, the work was kept purposefully ambiguous. What do the AIDS-Indianas mean, for example? Different things to different people, which, in spite of initial criticism in the United States especially that the works didn't deliver a message about the disease, is perhaps the secret of their extraordinary infiltration of society. The copyright issue addressed so frequently by GI – and which was latterly visualized by the noncopyrighted © symbol in the titles of many of their exhibitions and works – is a part of the same lesson. Usually in a medical-commercial context such as "Pla©ebo" or "©linique," the symbol replaces a "healthy," normal letter *c* and thus suggests that the potential

copying of material that necessitates the protection of copyright in the first place is – like the copying of genetic material performed so catastrophically by the AIDS and other viruses – always a transformation of the "original." The impurities and impieties of dissemination render impossible, if not unthinkable, the ownership and thus the desired control built into the copyright symbol. In art as in AIDS, uncontrollable transactions always take place. GI teaches us that there can be no pure relationship between art and its precedents or between artists and their ancestors. Neither can we control the purity of a work's reception, as Reinhardt tried to do in suppressing "glare" and sculpturality in his black paintings. Is this free promulgation of image and metaphor critically suspect? In Chapter 1, I discussed the status of metaphors of disease and infection with reference to the late Susan Sontag and disagreed with her position against the use of metaphor in this context. AA Bronson writes on what I take to be the productive inevitability of metaphoric dispersion:

> Robert Indiana's *LOVE* painting of 1966 is an example of an artist's work that escaped copyright and entered the public realm, appearing as ... commercial paraphernalia. We might think of this as an image virus gone awry, a sort of image cancer. Similarly,

38. General Idea, *Infe©tions* (installation view), 1995. Detail of installation at S. L. Simpson Gallery, Toronto, 1 June–4 July 1995, includes: *AIDS Wallpaper*, 1989. Silkscreen on paper: each roll, 457.2 × 68.6 cm; *Infe©ted Mondrian #10* 1994, Acrylic on gatorboard: 122 × 122 cm; *Infe©ted Rietveld* 1994. Lacquer, acrylic on found wood chair: 90 × 60.3 × 87 cm. Edition of five, plus 1 A/P, signed and numbered. Self-published. Collection of General Idea, Toronto. Photo credit: Peter MacCallum, Toronto, courtesy of AA Bronson.

General Idea's AIDS logo (1987), a plagiarism or simulacrum of Indiana's *LOVE*, was intended to escape copyright and travel freely through the mainstream of our culture's advertising and communication systems. And so it has. . . . *The Journal of the American Medical Association* carried it on its cover in 1992; . . . the Swiss art journal *Parkett* published sheets of AIDS stamps (1988) which the reader could inject into the postal system on envelopes and parcels – a sort of visual anthrax. (Bronson, 2003, 27)

In their final exhibition – *Infe©tions*, seen in Zurich, The Hague, Toronto, and Montréal in 1994–1995 (Fig. 38) – the ambiguous but cautionary politics of biological and fiduciary exchange became GI's additional element. The exhibition included transformations of works by Reinhardt, Rietveld, Duchamp, and Mondrian. In all but the Zurich installation, these pieces were seen against GI's AIDS wallpaper, thus bringing Indiana into this cycle of revisions and announcing the main theme. For sale at the exhibition was a limited edition book called *XXX Voto (to the Spirit of Miss General Idea)*, based explicitly on Yves Klein's 1961 textual and material *Ex-Voto for Saint Rita of Cascia*. As we've seen, Reinhardt's black paintings now included the AIDS logo. Rietveld's famous De Stijl chair sported green paint where the original had yellow. Where Duchamp retouched a mass-produced lithograph by daubing on a clichéd landscape, GI added their own "infected" colours in the form of pills. Finally and most dramatically, GI displayed seven carefully reproduced Mondrians, each again painted in green where he had used the primary colour yellow. All of the artists included here are paid a sort of homage. Bronson reports that he saw and admired paintings by Reinhardt at the National Gallery of Canada in the early 1960s and that "we were always great admirers of Mondrian" (1995). The 1995 exhibition in The Hague was sponsored by The Mondrian Foundation, and the Museum of Modern Art in New York considered showing the "Infected Mondrians" at the same time as the international retrospective of the artist's work that toured in 1995. That they backed away from this idea because they feared many would perceive the works as mockery (which happened for a short time when the AIDS-Indianas appeared in 1987), points again to the productive ambiguity cultivated by GI. Mondrian's grids had of course been subject to earlier revisions that took them out of their intended, pure contexts. The dress by Yves Saint Laurent (1965–1966) is a good example. Quoting modernist icons in general has become a common postmodernist strategy, adopted variously by Mike Bidlo, David Diao, Robert Gober, Sherrie Levine, Richard Prince, and others.[12] But GI's versions are both different and more effective because they make us think about our inheritance and about where further mutations might lead. Put another way, GI's Mondrians live out the experiment with the supplementary element envisioned by Malevich but made contemporary by GI. Mondrian himself dedicated his axiomatic 1920 essay "Neo-Plasticism: The General Principle of Plastic Equivalence" "to the men of the future."[13] Unpredictably, and certainly against Mondrian's purist wishes, some of

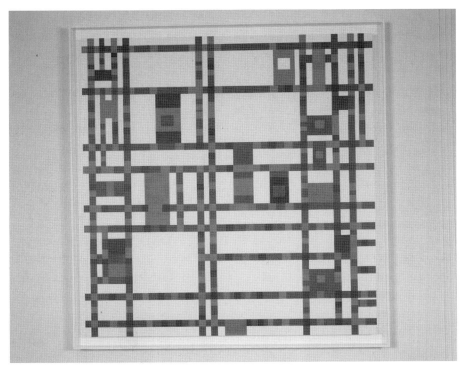

39. General Idea, *Infe©ted Mondrian #10*, 1994. Acrylic on gatorboard. 122 × 122 cm. Collection of General Idea, Toronto. Photo credit: Peter MacCallum, Toronto, courtesy of AA Bronson.

his inheritors turned out to be the GI trio. "Our interest in Mondrian is similar to our interest in Yves Klein and Ad Reinhardt," says Bronson. "They're all purists" (Hanna 14). The purity carried by these and other modernists was to be undone.

Mondrian abhorred and abjured green because it represented to him the imperfections and vagaries of nature. He notoriously expelled this and all other nonprimary colours from his work. GI reawakened this virus, as the AIDS wallpaper on which the Mondrians are displayed cues us to notice. Mondrian himself – like Malevich in his theories of the additional element – actively "infected" his world with the purist doctrines of Neo-Plasticism. His arrangements of his studio and living spaces are rightly famous in this respect. On the back of one of the studies for the "Infected Mondrians," done in mid-1993, Felix Partz quoted Mondrian's biographer Michel Seuphor to the effect that he, Seuphor, had never seen a real flower in the artist's studio, only an obviously artificial tulip whose leaves Mondrian painted white to banish green from his life. The study was titled "Mondriaids," reminding us that in the 1990s, such purist exclusions are no longer possible. In six of the seven *Infe©ted Mondrians*, the green is relatively subtle, merely insidious, a creeping illness. But in the remake of one of Mondrian's most famous paintings, *Broadway Boogie-Woogie*, there is so much green (replacing the predominant yellow) that the piece leaves its initial orbit completely (Fig. 39).

It has mutated into a new species. "It was convenient that we could use the green as a straight replacement, as a virus," Bronson states (Hanna, 1995, 14). But the green virus is not the only change introduced by GI. Though their Mondrians are meticulously rendered to scale, they are backed with foamcore, a fact that is high-lighted by the frames' oversized reveal. The works are not only "sick" with green pigment but also obviously simulated. In addition, both the surfaces and colours of GI's paintings look "more mechanical than the originals," as Bronson puts it (1995). They look silk screened rather than painted; Mondrian's touch is erased, just as his subtle but authoritative "P.M." signature is replaced by "G.I." These alterations in surface texture and materials return us to questions of genealogy, reception, and dissemination. How did GI (and many artists) know Mondrian? Through photographic reproductions that circulate the images indiscriminately. What they have reproduced in the *Infe©ted Mondrians* series, then, is the look of a photo using the materials of mass production. This procedure is consonant with their treatment of Rietveld chair. They were offered an original to alter, but this seemed inappropriate, given their interest in the circulation of images as viruses. Instead they bought and retouched a copy. In this series, GI works within the body of canonized Western art and its most distilled product.

GI's method of working from photos as a way to underline the effects of sim-ulation again brings us back to Taras Polataiko's meditation on Malevich's addi-tional element in the *Glare* series (Fig. 3). Perhaps as an antidote to an increasingly mechanized and commercialized culture, Malevich, Mondrian, and Reinhardt insisted on the essential purity of their practices as abstract painters. It was in the 1960s that this sense of originality and utopian purpose in art was challenged decisively by Pop Art and the other directions opposed so forcefully by Reinhardt. GI was part of the next generation, still the inheritors of the rhetoric of purity but no longer believers in or nostalgists for its promises. Polataiko – born in 1966 – senses the ghost of this past in its photographic simulacra, and as GI did with the AIDS and © icons, reproduces its transformative agents, not its desired immutabil-ity. Malevich wrote the prescription for "monochrome medicine" early in the last century. His "scientific" perception of the additional element put formal analysis in the service of social change. Analogously, the monochrome and other abstract idioms worked for Klein, Rauschenberg, General Idea, and indeed other artists as much more than a mere metaphor for individual, aesthetic, and societal transfor-mation. Today, inspired in part by this legacy, abstraction typically counteracts the once-pervasive aesthetics of autonomy. The modernist abstraction given a longer life by these contemporary artists is not the same as it was at the time of production. Like the drug AZT, which as GI has pointed out, goes by the commer-cial name "Retrovir" (1992, 64, n. 5), art viruses change things not only in the present, but also in the past and future. Polataiko and GI especially have shown how a discourse of impurity guarantees that abstract art has a future in its own mutations.[14]

2. Curative Abstraction?

I have brought the infection model of dissemination into the orbit of Klein's theatrical performance of absorption and GI's reenactment of the *Anthropometries*. Such practices create a social abstraction that again counteracts models of aesthetic purity and autonomy. One of the most extreme examples of this tendency is the installation work of Jessica Stockholder, whose exuberant, unfettered expansion of the languages of abstraction into the gallery space, although not unprecedented, enacts what she thinks of as a new way of staging the process of "meeting the world – the way it is, both physically and conceptually – with what I bring to it: a kind of abstract conceptual order and also an emotional chaos" (2000, 14). Stockholder's installations, large or small, are not abstract according to the usual art-historical definitions. They revel in using real wood, plastic, towels, and the like. Hanging pieces escape framing. Colour seems heightened for decorative effect. There is no reduction of means, and theatricality replaces any quest for a Greenbergian specificity of medium. It's easy to see why Stockholder claims Matisse as one of her inspirations. But one can see glancing allusions to conventions of abstraction in most of her sculptures, whether large or small. In one example, a piece of wood with an orange monochrome field leans against a low, half-black, half-purple table that looks sufficiently industrial to have pleased Donald Judd (before it was painted). The wall piece anatomizes the gesture of the hand and brush as a convention of expressionist painting. Cut-up photographs also cross the gilded frame here and epitomize flights from convention. Colour fields act out small plays of history. Was that an Ellsworth Kelly that fell off the wall and ended up in a new shape, draped over a fold of blue carpet? And as much as we might all wish that a black square could just be a black square, the ghost of Malevich's four black monochromes cannot be denied his (or is it now "her"?) appearance in *Ground Cover Season Indoors* (2002, Fig. 40), an expansive sculptural composition that abuts inside (artificial lighting, a chair with a cushion, an almost black monochrome painted on the wall) to outside (an elaborately festooned park bench). This apparition is tethered to the present and to the passing contemplation befitting the park bench. Stockholder runs sixteen colour-coordinated bungee cords (yellow, black, and one red, all with flecks that carry the eye from one tie to another) between the wall and seat in a mockup, or mockery, of the radiating lines in a diagram of one-point perspective. These lines of sight extend to define a new but as yet unpainted square, primed to overlap Malevich's. *First Cousin Once Removed or Cinema of Brushing Skin* (Fig. 41), a large installation from 1999, does not literally move, yet all its many components coalesce and disperse in a dynamic orchestration of abstract forms and references. "Hard edge" planes lift from their Modernist station on the wall; a floor grid initially reminiscent of Carl Andre or perhaps Rachel Lachowicz's *Homage to Carl Andre* (1991–1994; a floor piece made of lipstick and wax) ricochets in its incompleteness in the one-way glass of the gallery wall. Parts of this and other forms

40. Jessica Stockholder, *Ground Cover Season Indoors*, 2002. Bench, rope, hardware, blue and green Astroturf, electric cords, power bar, wooden chair, pillow, lamp, lamp shade, plaster and papier mâché, metal plant lamp, rooster lamp, two plastic containers, shower curtain plastic pieces, shellac based primer, acrylic paint. Artist's collection. Photo courtesy of Gorney, Bavin, and Lee, New York, installed at the Addison Gallery of American Art, Phillips Academy, Andover, Mass., for the exhibition *InSite: Nine Contemporary Artists*, May 4–July 31, 2002. Photo by Lesley Maloney.

end up across the border of the gallery wall, where a transport trailer fictively loads shapes and colours into the gallery, blending inside and outside. Or does it collect its cargo for dissemination? Stockholder's gift is to bring us back to the wonder of imagination, to what she calls "thinking processes as they exist before the idea is fully formed" (cited in Cooke). Her work is playful in the fullest sense, allowing us potentially to assess our own perceptions of space, colour, pattern, confusion, and regularity. She constructs and makes active the shifting perceptual and cultural intensities of a space in terms of its own multifarious components and what we contribute as interlocutors.

The social abstraction of Hamilton, Ontario artist C. Wells may be less known than much of the work I have discussed so far, but it is profoundly illustrative of the role abstraction can play in the contemporary art world. To be different from our everyday lives, yet to make a difference in them, works of art need to be at once approachable and strange. We require a connection – otherwise, we literally won't see – but there is little point in going exactly where we have been before. For progressive contemporary painters, the familiarity of the medium is a virtue that must also be challenged. Much of Wells' work in the exhibition *1911* seems familiar as painting, at least to those schooled in art history since the 1950s. At a glance, it looks like formalist abstraction. For example, *homophone (ks, x)*, from

the series titled *yellowyellow* (2000, Fig. 42), is strikingly reminiscent of Claude Tousignant's double-banded yellow monochrome *Hommage à van Gogh* (1956). Were they hanging side by side, we would of course also notice many subtle differences: size, a horizontal versus vertical format for the yellow bands, and the equality of the expanses of yellow in the Wells versus the smaller yellow strip at the top of the Tousignant. Similar as they nonetheless look, these paintings don't speak the same language. Where the Tousignant locates its homage in a radical

41. Jessica Stockholder, *First Cousin Once Removed or Cinema of Brushing Skin*, detail, 1999. Dimensions variable. Installed at the Power Plant, Toronto, June 26–September 6, 1999. Photo courtesy of the artist.

distillation of van Gogh's signature yellow pigment, Wells' painting is notably antiformal. In its unwavering regard for society and its norms, it is what he deems "post-aesthetic." Although his work is decidedly material – taking road lines, which Wells thinks of as painting's found object – into an art context, the work is for the same reason wedded to a tradition of conceptualism.

On what grounds might we claim that two works that look so neighbourly can be seen to inhabit very different worlds? We know, and can only know, by context. On their own, like words without a sentence, paintings as reductive as these don't tell us much about their possible interpretation. But neither are they meaningless or unchanging. Wells' work trades on how context drives change, how a familiar semiotic system – the yellow, white, blue, black, and (very rarely) red paint markings on roads and highways – gets us from one place to another without arousing much attention. His exploration is a conceptual in its consistent attention to understanding and finding schematic equivalents for the system, but it is, again, material in its rigorous restriction to the materials of road marking itself: the special line marker paint, the small vocabulary of shapes and widths, the restricted palette – chosen for its visibility – that, ironically, we usually only attend to peripherally. Wells' art is figural in its attention to landscape motifs yet also abstract in its historical and semiotic reference points. His pieces are antimimetic in the sense that he transposes rather than reproduces the line markings. But the resulting paintings, photographs, performances, and texts are at the same time postaesthetic because they can never remain in such an autonomous realm of contemplation. Wells' art is never far from the social concerns of travel, borders, and permissions. He paints over these social lines so that we may better see them. Reminiscent of Robert Smithson's dialectic of site and nonsite, in *1911*, what is outside art (road painting) crosses a line to the inside (the fine art of painting or photography), but only temporarily and conditionally.

It is one of the paradoxes of the genre that painting over, or "overpainting," can suggest either the erasure or accentuation of a painterly mark. One can paint over a mistake or revise a motif in a canvas and show something else entirely, or one can build up the pigment to emphasize one area. Road marking tends to the latter route, as Wells' reminds us by repainting these lines in *the hand loves that which is hard, #1, virtual* (2000–2002). Here he develops his initial image of a road line from the Trans-Canada Highway near Banff, Alberta, in 1996 into an ongoing performance, a ten-panel, ink-jet series in which the same road and line are placed in stereotypical landscapes in each Canadian province. His line repainting in situ on the McMaster University campus in Hamilton, Ontario, for this exhibition was part of this continuing series and underlined the fact that road lines are both highly specific to a place and instantly generalizable, both geographically and by medium. These humble sequences perform their delimiting safety functions without drama: line marker paint can appear to be the same, and function in the same way, in very different places. We have no trouble believing that the "same"

42. C. Wells, *homophone (ks, x)* from the *yellowyellow* series, 2000. Road line marker paint on canvas. 60 × 60 in. Photo courtesy of the artist.

line belongs in a road scene from British Columbia or Newfoundland. Wells calls attention to this necessary anonymity in what amounts to a portrait of the road line and his performance of its semiotic life: *PLEINAIRISME* (2001–2002). Taken from a high vantage point, a large, sharp-focused photograph shows the artist, back turned to us, working on a long, horizontal canvas. His subject? A line that poses cooperatively on a street in the distance and subsequently forms the right-hand part of this work. Using line marker white paint and observing the protocols of width and saturation set in municipal road regulations, Wells portrays this line. The nearly contiguous elements of this two-part work provide context for one another: we cannot go far in thinking that the canvas makes reference to either a materialist or transcendental strain in the history of abstract painting – no Newman zip here; Klee's quip that art is taking a line for a walk would also acquire new meaning – because the photo brings us back to "reality." Yet its quotidian existence, a line that we would walk across as a pedestrian or drive beside as a motorist with equal oblivion, is temporarily held open to conceptual inspection.

Wells moves road marks into the aesthetic sphere to encourage us to see them more completely. Typically, if we see them at all, it is when we are moving and when, in a sense, they move us from point to point. Thus in *parcel the journey with the destination* (2001–2002), a large photo mural of another, almost clichéd northern landscape, is painted over with the abstract codes of line markings. The transition from yellow lines to white, if we pay attention, means we have moved

from highway to town markers. A curve suggests that we can leave the road entirely and arrive. The system works in reverse upon departure. In seeking "unspoiled" nature, we move via the acculturated norms of the road. Our attention to this system is, again, brief at best, though Wells slows the pace for us here and again in a more overtly time-based piece whose title plays with that of the exhibition: *nein, teen, 11* (2001–2002, Fig. 43). Here Wells adopts a unique vehicle for his meditation, a "Rotographic" advertising board whose pyramidal bars rotate in unison to give us three related but discontinuous texts. Trying to read any one of the sequential texts that Wells has painstakingly applied to each bar can be frustrating because he has put far too much text on the accumulated surface. The machine inevitably accomplishes its interruptive move to the next panel before we have time to read many lines. Wells has calculated that it would take about forty minutes of sustained viewing – and an excellent short-term memory – to read the entire, 900-word sign completely. We travel with the text here, just as we do with the lines Wells writes about in this piece and both photographs and paints in others.

The first road marker lines were painted in 1911. Wells has repainted (or painted over) a section of this original site in a homage performance, reclaiming a history in Trenton, Michigan, where these first lines were set down. In the exhibition *1911*, we see his typically filtered versions of this memorial activity. The number 11, he muses, is in a sense a portrait of the common double road line. We see this image in the most abstract looking of the paintings in this exhibition: *threeway* (2000). Part of the *yellowyellow* series, this painting also builds on Wells' 1998 *two ways of achieving an* end. Instead of two double line "elevens," here we have three. Each "way" is strictly instrumental, a technique for marking a road's median, of warning drivers where their permission to travel ends. In the southwestern United States, Wells discovered, the blending of road, earth, and sky has necessitated the bold edging of a black line inside two yellows that we see on the left in *threeway*. Moving from left to right across this image, and also both geographically and temporally, we then see the most familiar portrait, the double yellow line. This version, however, is painted in the original yellow oil line marker paint. A newer version of this line marker paint, a yellow latex pigment, is seen on the right. In *homophone (ks, x)* (Fig. 42), Wells puts the two paint types side by side, with equal emphasis, so that one can see their subtle differences, their different "ways." The oil and latex yellows serve the same function on the "thruway" whose name he invokes, but in a painting, their discrimination matters.

Painting Ends (2000–2001) places the two yellows in a temporal display of literal over painting. Transposing two curb ends, each the standard six inches wide, Wells has painted latex yellow over the "older" oil, leaving overlaps to remind us of the painting over practices that we can see on the road itself, traces remaining as uses change or perimeters need to be remarked. As in *TRENTON* (2001), where lines from the road reveal their new inhabitation of high art painting by

43. C. Wells, *nein, teen, 11*, 2000. Text on electric rotating sign. 30 × 20 × 3 in. Photo courtesy of the artist.

fitting perfectly within the panels' boundaries, the "ends" here are schematic. They function as repeatable templates. Wells typically mixes historical research with conceptual questioning. He found out from a road painter in Calgary that lines, ends, and the like were, in the 1950s and before, set down by hand, using wooden templates. But *Painting Ends* is not produced this way, nor does it refer

solely to road painting. In this worldly genre, an "end" is a limit or perhaps a functional goal. In the history of abstract painting especially, "end" connotes a terminus, a point of either futility or transcendence that has been envisioned in monochrome painting since Malevich's Suprematism and Rodchenko's materialism. These speculations on the end of painting took place within a decade of 1911 and have been renewed several times since. Thinking of how Wells' paintings, photographs, and performances link the everyday world and that of painting's habits and traditions, however, we might well ask what his work can say about painting's ends, its role and purpose within the social. To this purpose, let me imagine a rotographic text piece that takes off from *PLEINAIRISME*, one that – following Wells' punning practices – I will call Plain/Heir/Ism.

In his two-part work with this name and in the exhibition generally, Wells plays with the tradition of painting outdoors, en plein air, in front of the motif, that we think of as quintessentially French. But as we have seen, he constantly schematizes, moves, and thus examines the ultimate outdoor painting, that done with line marker paint, by bringing it indoors and into "art." Substituting "plain" for "plein" suggests the connection to the semiotically saturated social world we live in, with its often invisible rules, boundaries, and materials. Plain is unpretentious but not unsophisticated: a new latex yellow superseding a slower drying oil. The line we see in *PLEINAIRISME*, framed by foliage and then by canvas, is plain in these ways. It works. "Heir" is of course what painting today is as a genre, the inheritor of high-art traditions. One does not need to paint consciously in the wake of these habits and reference points to have them figure in contexts of reception. To produce the abstract work in *1911* is to work in a line of production that includes the monochrome, field painting, formalism, conceptualism, and even the diagrammatic realities of Peter Halley's conduits, which I discuss below. In the same way, contemporary painting cannot but be the heir of many "isms," from the sweeping ones such as modernism and postmodernism, to those with more local inflections and varying suffixes. Especially when one paints in a way that looks abstract, "heir" and "ism" pull toward a separate world of aesthetic priorities and concerns. But in Wells' practice, "plain" keeps the social in our minds. Or perhaps he reminds us that the social has, more often than not, been in view in abstraction. Mondrian designed Neo-Plasticism to function as a template for ideal relations in society. Think of the spectacular career of Newman's *Voice of Fire* (1967), which was a touchstone of American cold-war liberty in the American Pavilion at Expo '67 in Montréal and then the butt of public outcries when purchased by the National Gallery of Canada in 1989.[15] Contexts and meanings change, as we see in the movement from the road to the gallery and back in Wells' work generally. Walking or driving down the street, we may well reconceive the evanescent social life of abstraction.

Abstractions by C. Wells and Ellsworth Kelly that look alike may not be at all alike when their visual appearance is contextualized. This point applies equally to

44. An Te Liu, still from *Prepared Ground*, 2003. Colour film transferred to DV, 13:30 loop. Photo courtesy of the artist.

the work of An Te Liu. The enticing title of his 2004 show at Artists Space in NYC – "Tackiness and Anti-Power" – might, in a Greenberg moment, seem to allude to kitsch or its defeat at the hands of purified abstraction. But no. His elaborate piece *Prepared Ground, (2 images)*, a sixteen-millimeter colour film transferred to digital video, has, when we admire a still, an immediate reference to Newman's signature zip paintings, some of which were green (Fig. 44). But what is that blur

on the right, and why are the surface and line so perfect? We can learn, but likely not exactly see, that the context is sport, specifically table tennis. "Tackiness" and "Anti-Power" are the names of energy-absorbing cushions – we might think of mats – used on ping pong bats. Liu recontextualizes other "abstract" sign systems found but again not much attended to in the world of recreation, such as marker lines on gymnasium floors. What he calls "game-space" is at once in dialogue with some of the abstract traditions we have been examining and also architectural. Liu's preoccupation with "surface" is evident, but it is a surface – whether of a floor or a paddle – that allows one to move socially. He claims to "unite the autonomous and the pure with the contingent, the real, and the possible" (Liu, 2003).

The purpose and production of a remarkable number of today's best known artists can be examined anew in the contexts of positive, social infection. Abstraction enters and contaminates social spaces, setting off reactions that test and reveal the resistance of both art and sociocultural systems. A short, representative, but by no means complete list would include Lydia Dona, Peter Halley, Fabian Marcaccio, David Reed, and Andres Serrano. Each one uses coordinates of abstraction discussed here to permeate the membranes between art and its social matrix. On a visual if not historical and theoretical plane, it would be productive to consider Jonathan Lasker's signature abstract units as infecting other such bodies. Are these diagrams intrusions into, interruptions of, conventional social relations? Connections of this sort could be multiplied with many other artists, but as usual in this book, I instead look in somewhat more detail at a much more confined set of instances. Serrano's early photographs of liquids are staged to look like neutral abstract art. But of course the potent associations of blood, milk, or urine spill over into social controversy.[16] *Milk, Blood* of 1986 was Serrano's first apparently abstract photograph, though it was followed soon by *Circle of Blood* (1987) and others. Without language and its potent associations (Serrano's additional element, perhaps), these works might retain the aloofness of autonomy, a "proper" distance from society's anxieties about sexuality, motherhood, and other mores. Instead, as bell hooks has noted, "it is precisely Serrano's strategic merging of traditional aesthetic concerns with the social and political that gives his work its particular edge . . . [His photographs] critically interrogate the structure of patriarchal Christianity" (hooks, 1995, n.p.) and, I would add, patriarchal modernism in the form of the monochrome and colour field abstraction. Serrano claims that *Milk, Blood* is "a reference to Mondrian," by which he likely refers to the restricted colour range. "The work is about abstraction," he goes on to say, I "was amazed and pleased that the fluids had a life of their own and I had no control over the final image. Monochromes are a dime a dozen in painting, but you don't often see them in photography" (1993, 120). Blood's new association with AIDS displaces here its sacramental meanings. It portends death via infection, not life. Serrano is also frank about the racial implications of being of "mixed" blood, as he is, a state, more cultural than biological, that Morrison has investigated brilliantly

in its appearances in monochromatic abstraction (2002). Abstraction was thus at the centre of the "culture wars" that began in the 1980s in the United States. There is also a filiation between Serrano and GI in both the theory of bodily and aesthetic transmutation and in its processing through abstraction. More distant but nonetheless resonant connections extend to the blood work of Polataiko in *Cradle* (Fig. 3) and Richter (Plate 4). In all these cases, a medical substrate raises issues in abstraction and its social crucible of disease, infection, and (potentially) a cure.

Fabian Marcaccio's "paintant" works take the sense of art as infected and mutant to the furthest possible extreme, both physically and in their assertiveness of cultural theory. This purposefully and happily tainted form of abstract painting, which he calls meta- or expanded abstraction, he suggests, "values mutation and corruption as producers of links and resonances with our contemporary multiple realities."[17] The "contaminated" spaces of collage are one important starting place. An early exhibition of such works was provocatively titled "The Altered Genetics of Painting" (1993). Formed of factitious materials such as silicone gel that constantly exceed the frame of painting and any aesthetic support yet simultaneously trap modernist elements such as the monochrome in their (genetic) webs, Marcaccio's works take on a life of their own as the rampantly metamorphosing nature of the present or near future (think of Margaret Atwood's chilling vision of "nature" in *Oryx and Crake* [2003]). "Paintant Stories" may join the gallery space with the outside world or, more accurately, escape from the former to the latter. A second exhibition in 1993 was called "Mutual Betrayal," a play on Mondrian's guiding concept of "mutual equivalence."[18] Here and elsewhere in this series, paintant "zones" confuse and merge the space and time of creator, material, and observer. Unwittingly close to Malevich's theory of the additional element, Marcaccio proposes "Bio-Paintant" areas, territories that are at once biographical and biological.[19] Monstrously large biomorphic installations such as *The Predator* (Plate 7, Fig. 45), constructed with Greg Lynn, and his Documenta contribution from 2002 bear comparison with Jessica Stockholder's ultimately more playful and tame abstract environments, as both move abstraction well beyond former limits in space or implication. Marcaccio's paintants inhabit the viewer's space in an aggressive and disturbing fashion. They seem out of control.[20] In this they offer an extreme instance of abstraction's break with the autonomy of the frame through infection. His work, he claims, is about "noise and contamination, instead of silence and purity"; it investigates "structures of power in a fluid society" (cited in Carrier, 1994a, 84). Abstract art has, of course, been socially minded in the past. This was the ultimate goal of De Stijl on the one hand and, much more idiosyncratically, of Kurt Schwitters' *Merzbau* spaces on the other. As we have seen, Malevich's Suprematism took to the streets and his theory of the additional element was, tragically, inspired there. It is the insistent protocols of much midcentury abstraction in the United States that are here reversed, but this

45. Fabian Marcaccio and Greg Lynn. *The Predator*, 2001. Vacuformed plastic, silkscreened and painted, dimensions variable. Photo courtesy of F. Marcaccio.

new emphasis is only based in part on the recollection of avant-garde modernist abstraction.

There are many other artists who deploy abstraction as an infectious agent in public contexts as a way to move art beyond the gallery frame and off the wall. Daniel Buren is the master of this sort of conceptual, performative disturbance. Finding and identifying (or denying) his simple stripes as art can occasion reflection on the body politic, its museological side underscored, that provides the protocols of what is and is not art. Abstraction is thus, as Buren claims, not a metaphor (1977, 26). It is an irritant, a microbe in Malevich's frame of reference. Buren reflects on the variations of making and finding what I would call abstraction outside the gallery: "Notions of wall on wall, white on white, painting on painting, poster on poster are evoked in turn, and those notions immediately intertwine to become, as the case may be, painting on wall, poster on painting, painting on poster, poster on wall, white on white on wall, painting on white on white…" (59). Recently, David Bachelor has taken up the social and aleatory aspects of such potential abstracts in his series *Found Monochromes of London* (1999–2003), photographs of white rectangles found posted across the city and turned into art references by the activities of visual and linguistic framing and display. Whether or not in reference to Buren's experiments, he explores what Buren calls the "fundamental notion…that a work of art before it means anything, is

in fact used as a signal somewhere on a wall" (63). Batchelor captures these accidental monochromes; he makes them into what they only might be. Why is this a more specific activity than the widespread questioning of art in the museum typical of art since the 1960s? It isn't inherently different, but when places in the context of the abstract as infection, as social agent, Bachelor's work resonates more compellingly. Add to this photographic series skateboard-like monochromes with wheels, made from found objects, such as *I Love King's Cross and King's Cross Loves Me*, (1997–1998), and you have not only an art form that gains access to society but also objects that permeate otherwise inaccessible territories, such as youth

46. Lydia Dona, *View and Speeds in the Sites of Abstraction*, 2000. Oil, acrylic, and sign paint on canvas. 84 × 64 in. Private Collection, New York. Photo: Kevin Noble, courtesy of the artist.

culture. And there is humour here, too, as Batchelor mobilizes again Klee's quip about taking a line for a walk by taking a monochrome for a ride.

Lydia Dona's flamboyant yet rigorous and subtle abstract paintings can be seen in many ways, given that her high-pitched colours and referential gestural techniques link to many other abstract practices. Colours and sometimes fleetingly identifiable forms sit on and yet also travel among many spatial dimensions (Fig. 46). She has called herself a conceptual artist who makes abstract paintings (Dona, 1991). Her reflexive but never didactic work presents itself on both a material and conceptual plane. Dona uses titles and critical writing in ways that make language a collaborator in her art; as in this example, there are indeed many "sites of abstraction." She encourages a range of response: "my work is ultimately open to a lot of variable interpretation and projection, and I enjoy that sense of communion that can exist between these variables" (Ryan, 2002, 59). One context that she suggests for the understanding of her typically dense surfaces is that elaborated in this chapter. "A passage might seem to invoke microbiology or a sense of viral infiltration," she declares in conversation with David Ryan (59). Without suggesting for a moment that the infection model is *the* way into her work, it does provide both a rubric through which to comprehend her relationship to the history of abstraction and her imperative to link her paintings with larger social issues. Biomorphic change is one of the concepts that animates her work and links it to that of other abstract artists today. Dona typically breaks her surfaces into different zones of articulation. Some are replete with painterly activity, whereas others act as monochromatic voids. Her long titles – analogous to those of Jessica Stockholder – assert the imbrication of written language and painterly gesture. They also make little overt sense and thus mirror the undecidable and unpredictable relationships between the pictorial zones they subtend. Colours and forms mutate across the surface, but she controls these experiments. Drips figure often in her work, "on the one hand," as she suggests, "as an index of Abstract Expressionism and, on the other hand, as a sign system of language and fluidity" (Dona, 1991). Sometimes she lets her running paint dry; at others she blows it around with a fan. Either technique acknowledges yet puts critical pressure on the iconic handwork and mythic immediacy of American abstract expressionism, turning it into a code that she can reference and manipulate. She builds a virtual and a viral reality in abstraction using its own languages mixed with those of her contemporary society. Her reference to "viral infiltration" can be understood in terms of what she allows into her work – the sense and abstract image of mutation and infection that so preoccupy us these days – *and* as a description of her paintings' relationship to the work of Jackson Pollock in particular. Dona's canvases balance on the edge of being almost expressionist. What they do, however, by compelling us to see a microbelike dimension in the drip and spatter, is to infect this paradigm with doubt as well as celebration.

47. Peter Halley, *Rob and Jack*, 1990. Acrylic, day-glo acrylic, and Roll-a-Tex on canvas. 97.5 × 190.25 in. Photo courtesy of the artist.

It might seem odd to place Peter Halley's conduit images into a discourse about infection, given that he explicitly contrasts and opposes the geometrical imperatives of our architectural and digital surroundings to nature and its processes. But several factors make at least a comparison between Halley's works and these impure discourses instructive. One is the crossover between natural and synthetic infection that I have mentioned. Although Halley's focus has been the power structures of the grid, which show how our lives are increasingly "abstract," he is clearly influenced by Michel Foucault's work on medicine as well as incarceration (Fig. 47). "Physics and biology," Halley writes, "are also governed by a highly codified concept of the combination and breakdown of neutral abstract units (be they subatomic particles or strands of DNA)" (Halley, 1997a, 29). Halley is a prominent spokesperson for and practitioner of the interface between a new form of abstraction and society. He asserts that in the wake of resistance to Greenberg's formalism, we wrongly but frequently "deny that abstraction is a reflection of larger historical and cultural forces" (25). Preferring the description "diagrammatic" to abstract, his famous conduit and cell paintings are reflections of a social reality dominated by geometric relations. What Halley's work shows – and this is its link to the discourse of infection – is how these unequal flows of information and Foucauldian power move and change. They map contamination, not by accident the title of a recent book using Halley's work (Griffin, 2002).[21] Contamination does not have to be biological, but in the popular imagination that drives Halley's work, it frequently has medical associations.[22] Although Halley believes in dialogue and in teaching, and doesn't exactly see this sort of crossing and mixing as curative, he is highly critical of moves in art and outside it that seek purity. Thinking perhaps of purified abstraction from the past but using the surprising example

of Jeff Koons' isolated vacuum cleaners, Halley points to this work as an example of Baudrillard's reflection on NASA. Koons has "created a universe 'purged of every threat to the senses, in a state of asepsis and weightlessness'" (1997b, 102). Separation, purification, aesthetic cleansing: Halley's imagelike abstractions work against these tendencies because they are indeed infected by "outside" forces and, in turn, release these putative pathogens back into the body of abstract art.

David Reed's ravishing paintings and challenging installations may also be seconded to many different art-historical narratives. They are in part meditations on his own conversations with earlier artists, particularly those of the Baroque.[23] They are technically arresting and thus lead to reflection on painting "itself." They move out into the realms of film, video, and installation and so generally counter the former desire for autonomy in abstraction. Neither Reed nor his many commentators employ the medical discourses of infection I have been establishing here to examine the effect of his work. To a limited but significant extent, however, Reed purposefully uses abstraction in a viral manner. It ends up where it "should" be – in bedroom video installations such as *Scottie's Bedroom* (1994). The "should" here is recovered from the popular, though not avantgarde, belief that abstraction is merely decoration, something important to a domestic context but not really seen (or heard). The two Reed abstracts in this work, however – one on the wall and another in the video loop that is part of the work – are jarringly out of place because we have to focus on them. They offer opportunities for reverie but not in the usual institution established for this purpose, the museum (though of course the installation is itself in a gallery). The video suggests this interpretation by showing Reed's work in Scottie's bedroom in an anachronistic and medium-crossing insert by Reed into Alfred Hitchcock's 1958 thriller *Vertigo*. A painting from the 1990s couldn't and shouldn't be there.[24] Stephen Berg has tellingly suggested that Reed has since at least the 1980s been concerned to reveal the "experience of a pre-existing secondary reality...deeply embedded" in his (and other) paintings (Berg, 2001, 60).[25] Two thoughts follow. There is a strong connection between his technique in paintings of the 1980s and 1990s to introduce an often-monochromatic element as a commentator, visual stoppage, or, I would say, infection, and his retroactive presence in Hitchcock's film and Scottie's bedroom. Perhaps Reed's (and abstraction's) surprising and even offensive presence where it shouldn't be therefore bears comparison with the relationship between Klein and Malevich discussed in Chapter 2. Reed and abstraction fictively predate Hitchcock and his film because the latter of course had to use an abstract painting, Reed's, on the set of *Vertigo*. Like Klein in my reading on the Malevich cartoon (Fig. 9), Reed knows this isn't the way things were but sees value in floating the possibility.

Another installation by Reed leads us to the context for infection and dissemination presented in Chapter 3, the mirror and its uncontrollability. His 1996

48. David Reed, *Mirror Room for Vampires*, installation shot of 1996 exhibition, Graz, Austria, Mirror Room of the Neue Galerie am Landesmuseum Joanneum. Photo © Neue Galerie am Landesmuseum Joanneum.

installation of the painting *#350* in the mirror room of the Rococo interior of the Neue Galerie am Landesmuseum in Graz, Austria, was part of his *Mirror Room for Vampires* project of that year (Fig. 48). Though Reed was not thinking in this direction and did not pick up on the infectious qualities of green that I have thematized, it is salutary to recall Robert Smithson's comments in 1969 on the effects of his Yucatán *Mirror Displacements* (Plate 5, Fig. 20), reflections in which he duplicates in language the refractive qualities of the mirror he describes:

> In the jungle all light is paralyzed. Particles of color infected the molten reflections of the twelve mirrors, and in so doing, engendered mixtures of darkness and light. Color as an agent of matter filled the reflected illuminations with shadowy tones, pressing the light into dusty material opacity. Flames of light were imprisoned in a jumbled spectrum of greens. Refracting sparks of sunshine seemed smothered under the weight of clouded mixtures – yellow, green, blue, indigo, violet. The word 'color' means at its origin to 'cover' or 'hide.' (Smithson, 1996, 124–5)

Reed was here fascinated not only by the vagrant and abstract colour and light reflections rampant in this space but also by the lore around vampires, that they have no reflection in a mirror. What he established in this installation was his own immediate and meta-consideration of the sources of both vision and art, a thinking through that we can compare to that of the Narcissus theme discussed

at length in Chapter 3. Dracula and Narcissus certainly make an odd pair, but the mythology around both gets to the heart of painting's reliance on both mimesis and invisibility through erasure.[26] Peter Weibel's masterly reading of this work's implications deserves to be cited at length:

> The doppelgänger and vampire motifs are metaphors for the crisis of both the social and the cultural orders, both of which were transformed by the industrial revolution. So when David Reed reflects upon the vampire motif in his painting, he is not concerned with the picturesque superficial elements of vampire stories. Rather he is involved with fundamental reflections on painting as a construction of representation and reality in the age of the machine, the media and the post-industrial revolution. Reed is reacting to the phantomization of painting by art requiring technical equipment, from photography, film and video, to computers. Reed reflects methodically on all the possibilities of modern-day technical machine image systems that replaced the historical systems. He uses them to visualize the status of painting as a phantom on the one hand, and, on the other hand, to overcome this status with new painterly methods. He is trying to make painting its own vampire and double. Reed's preoccupation with the vampire motif and his investigations into painting as a doppelgänger of video, computer and film (for example, the artificial, synthetic incorporation of his paintings into Hitchcock's film scenes – veritable metaphors of vampiric blood transfer), are a fundamental reflection of the changes undergone by painting in the age of the industrial and post-industrial revolution, the fundamental changes undergone by painting as a system of representation and construction of reality in the age of the machine. Precisely in this way, painting finds its way out of its condition of phantomization. (Weibel, 1996)

Talk of blood transfers and mirrors returns us to Polataiko's Narcissus-like *Cradle* (Fig. 3) and to Richter's blood red monochrome (Plate 4). And in another related though serendipitous connection, we can think too of Eliasson's projection of the monochrome in *Five-Fold Tunnel* (Fig. 16), which was presented in the same museum space. In general terms, these associations take us to the mixing of the social, abstract, and pictorial in discourses of infection and transmutation. Important, too, for Reed (as for Smithson, if one wants to draw the analogy) is the movement of abstraction beyond museological expectations. Here, however, the laudability of the attempt is purposefully allied to its difficulty: Reed's vampire installation appropriately takes place in a palace's mirror room, yet this space has been ingested by the institution of the museum in the form of the Neue Galerie am Landesmuseum Joanneum.

The work I have been considering to this point is part of an elaborate and increasingly complex Western discourse on the abstract. Even Lucy Lippard's celebrated 1966 exhibition "Eccentric Abstraction" – recently reinstalled in part at the Tate Modern in London – could be seen to acknowledge, while working against, the premises of formalist abstraction and the alternative offered by Pop Art. As Lippard wrote about the unusual work exhibited, however, "abstraction is a far more potent vehicle of the unfamiliar than figuration, and erotic sensation thrives

49. Byron Kim, *Synecdoche*, 1991–1992. Oil and wax on panel, 275 panels, 10 × 8 in. each.
Photo courtesy of Max Protetch Gallery, New York.

on the unfamiliar" (1966, 40). Her comment applies particularly to Louise Bour-
geois and Eva Hesse's pieces in this show.[27] Abstraction has also been deployed
to move beyond what we could think of for the sake of argument as a monocul-
ture, a North American and European tradition of abstraction. It is unfamiliar
abstraction in two senses, both in being relatively unknown and challengingly
different in terms of the cultural and racial vantage points of its producers. It
can best be described as "discrepant."[28] In the late 1980s with *Green Painting II*,
Rasheed Araeen, for example, working initially out of minimalism, presented an
apparently neutral abstract composition that in fact, again using green, proved to
be "infected" by social conflict. We see a grid forming a cross; the cross is made of
photographic panels that look like gestural brushstrokes but are in fact close-ups
of bloodstains from a goat slaughtered in a traditional Muslim ceremony. The
flanking green "monochromes" suggest the Pakistani flag and are accompanied
on the photo panels by lines of Urdu script, another intrusion into the calm of
abstraction. Although the strategic and disruptive use of the monochrome may
be comparable, the cultural specifics of the infected abstraction in view vary.

Byron Kim is more overtly critical of high modernist abstraction. He asserts
that "purity in abstraction is an anachronism" (Kim) and makes reference to the
purity of the monochrome and its potentially troubling social effects only to
offer a critique. In *Synecdoche*, begun in 1991 (Fig. 49), a work exhibited in the
Whitney Biennial in 1993 and for which he has become widely known, Kim

plotted hundreds of small monochrome panels in what might appear to be yet another version of the typical *Most Unwanted* painting by Komar and Melamid that I discussed in Chapter 1 or a revised Richter colour chart painting. But the closely modulated hues were chosen to reproduce the skin colours of friends and relatives. Here issues of both spectral and racial "purity" are explored through the monochrome as a social vehicle: colour is both specific and always meaningful. Though we don't think of the term this way, in its root meaning, "complexion," suggests a braiding together of skin colours akin to the combining of the bodily humours. There isn't just one final skin colour, as Kim shows. His work is thus an excellent locus for any examination of the implication of racially as well as aesthetically loaded terms such as hybridity and syncretism. Similarly in *Emmett at 12 Months* (1994), Kim carefully observed the variations in the colour of his son's skin and offered these colour chips as a statement of antipurity, a revelation of the fact that generalizing a person's colour is always misleading.

Robert Houle frequently abuts expressive colour field painting to images and documents that work to expose the historical dispossession of land and language experienced by First Nations peoples. Because he acknowledges his inspiration from Newman and Mondrian particularly, we must grapple with the startling propinquity of First Nations history and a form of abstraction that holds universalist aspirations. Discrepancies abound. There is no purity here in the sense of an unadulterated version of history, the painterly, or peoples' colour. Indeed the three bleed together in the resonant *Aboriginal Title* from 1989 to 1990 (Plate 8). Here we can discern the racial stereotyping of the "red man" and see the saturated field of colour, but dates standing for troubling historical moments in the interaction of the Canadian government and its aboriginal peoples cannot be erased (1763, The Royal Proclamation Act, which made most of North America officially British; 1867, when Canada became a federation under international law; 1876, the so-called Indian Act, a colonial document if there ever was one; 1982, the Constitution Act, when Canada took complete control of its own constitution and put in place a charter of rights). Houle records these dates again in a series called *Premises for Self Rule* (1994), in which each document supports arguments for aboriginal government.

How do the prominent abstract panels function? Possibly they convey emotion, even unspeakable emotion. In many cases Houle uses traditional colour symbolism but exploits the dissonances in colours' associations for the dominant and colonized peoples. In *Kanehsatake X* (2000), he recalls the incendiary standoff between Canadian troops and native protesters over land rights that took place at this spot in 1990. He uses "a mnemonic code, *me uhp* (an Ojibway phrase), to express anxiety and delirium, but particularly to experience an event which resonates . . . The blue panels recognize the cardinal directions, the greens evoke 'The Pines' of Oka [a nearby site] and the arrowhead pays homage to the endless endurance and remarkable patience of the Mohawk people in preserving

50. Robert Houle, *Palisade*, 1999. Oil on canvas, watercolour on paper, lithographic print. Collection of the MacKenzie Art Gallery, purchased with the financial support of the Canada Council for the Arts Acquisition Assistance Program. Photo Credit: Installation Photography Don Hall, courtesy of the MacKenzie Art Gallery and the artist.

and protecting their land" (Houle, 2000).[29] Houle's strategic deployment of a uniquely Western art form, abstraction, troubles the history he reveals and makes his point that in art as in society, aboriginal peoples cannot go back in time to a form or life free of colonization. And this troubling goes the other way, culturally and historically. There is justification for interpreting abstraction in Houle's work more radically as an infection, as both infected by a specific history and in turn plaguing our too easy assumption that the visual involves seeing alone. His *Palisade* series from 1999 (Fig. 50) makes direct visual reference to Newman's three-part abstractions, perhaps especially to the narrative effect of the cumulative and interreferential *Stations of the Cross*, and thus secures a place for these recent paintings within a high art context. What is released into this sometimes antiseptic progression of great Western artists and works, however, is an art virus, one that keeps an appalling history in view. The green and white vertical bands in these works index the typical formal structure and memorial function of Amerindian wampum belts. On one level, the eight paintings in this series are analogous hand made semiotic records of British garrisons captured in the conflicts of the mid-18th century by First Nations warriors in the Great Lakes region. Without, or maybe precisely as "texts," these abstracts (as well as his collage titled *Postscript*) also recall the tactics of General Jeffrey Amherst – commander of the British military in North America in the Seven Years' War (1756–1763) – specifically his diabolical presentation of purposefully tainted blankets and a snuff box containing smallpox-infected cloth to First Nations delegations. Amherst instructed his interlocutors not to open the boxed gift until they returned to their villages. Whether or not such "fomites," conveyors of infectious agents, worked effectively to the ends prescribed remains a matter of debate. The intention is not (Anderson, 2000, 542). Documentation from 1763 suggests that during Pontiac's resistance to the British, the "Confederacy" that sacked the eight forts, a specifically green-and-white wampum belt was used by the Chief to signify First Nations' military

strategy. "Pontiac's intended signal to his warriors to attack the occupants of Fort Detroit was to turn the wampum belt to show its green side" (Bell, 2001, 8). Pontiac apparently did not show the green side, but Houle's installation moves toward a darker and darker hue. What we have with the Newman-like *Palisade* is, first, a reminder of atrocity inscribed within the body of abstraction. There might at first be something unsavory in regarding abstraction as more than a mere metaphor for these historical travesties. Yet for Houle, and more generally, I am claiming, this mnemonic effect is real in important ways. Because there is a synecdochic relationship between the painting and virus, abstraction is both infected by history and in turn a potentially curative, homeopathic agent in our culture.[30]

The uneasy marriage of monochrome abstraction and photography to affect political commentary should be understood in its cultural specificity outside the Western tradition. At the same time, part of the arresting power of Houle's work comes from the mixed messages sent. Abstraction needs to be acknowledged as a Western language. More exactly, the monochrome/photograph dyad has a history in this tradition. Ian Wallace's work offers an excellent vantage point. As Jeff Wall shows, in the mid-1960s Wallace produced thin, vertically rectangular monochrome paintings (Wall, 1988). It was also at this time that Wallace completed a master's thesis on Mondrian's Neo-plasticism. But Wallace is known as a political artist profoundly committed to art's role in social critique. Wall sets out the apparent tension in Wallace's interests: "Wallace's pictorial art displays a long historical relationship to two apparently antithetical forms of the radical art of the early 1970s. The polemical, photographic, documentarist practice of . . . Hans Haacke, Victor Burgin, Steve Willats or Allan Sekula, and the monochromatic and reductivist painting of Robert Ryman, Neile Toroni, or Brice Marden were recognized at that time as the antipodes of radicality" (1988, 63). Wallace's strategy, looking back from 1990 but ongoing today, was to abut these apparent opposites, combining photography and the epitome of painting, the political and the apparently neutral: "through photography I could intersect everyday reality and the 'speech of the world' with the formal structures of abstract art, and open up a critical reading of 'nature' from the point of view of 'culture'" (Wallace, 1990, 30).[31] Well aware of and active in the critique of painting's authority, Wallace didn't want to jettison its history. Wall offers a meticulous and persuasive context for Wallace's mixed messages. "For Wallace, the 'mute ideal' of the blank surface . . . expresses the sublime refusal of the unwinnable struggle, a strategy essential for survival. Art is to be preserved as inwardness for the foreseeable future, and this future stretches back to the fin-de-siècle" (1988, 72–3). Wallace's is not a defeatist aesthetic. On the contrary, he sees art generally and his visual gesture to the double radicality of midcentury modernism as redemptive.

An excellent series in which to see both Wallace's technique and his belief that art is "philosophy embodied" (Wallace, 1990, 28) is *The Idea of the*

51. Ian Wallace, *The Idea of the University XIV* (*Searching the library listings*), 1990. Acrylic and photolaminate on canvas. 152 × 152 cm. Photo courtesy of Catriona Jeffries Gallery, Vancouver and the artist.

University (1990, Fig. 51). Reflecting on the invitation from the University of British Columbia's Art Gallery to exhibit creations of his choosing, Wallace recognized that although the idea of the university is an abstraction, it must play out in specific circumstances in interactions among specific people and places. He draws a parallel with the notion of art: these institutions must promise "truth," even though they cannot fully deliver. All of Wallace's work accepts the challenge to be present in the face of partial inadequacy. He photographs people in social situations, in this case those appropriate to the university. These work as images of "discourse (in the Habermasian sense)" (1990, 27). Bordering these subjects but not functioning as backgrounds are monochromatic panels in various colours. These can be seen as ciphers of the ideals of essentialist abstraction. They are perfect, still, untroubled, and as such witness the "unwinnable struggle" of the aesthetic. For Wallace, neither the photo nor the monochrome can stand effectively alone. It is "in the attempted realization of our idealizations that the possibility of redemptive knowledge can be even visualized. For me the search for redemptive knowledge is within the terms of the problematic of art" (1990, 28). That problematic, I would suggest, is art's necessary material incarnation and its goal, for Wallace and many others, to present itself theoretically and

conceptually as "opening the world to self-consciousness and criticism by reveal-
ing its ideological determinations" (26). The monochrome is a necessary player
in social critique, not only because of its associations but also because it remains
present and functional. More than as a memory, I submit that the monochro-
matic panels in Wallace's images perform again as "infections," putting the ideals
of the monochrome into new situations and encouraging viewers to work out
the syntax. Wall claims that by recalling the monochrome, Wallace predicts that
art will be "preserved as inwardness for the foreseeable future." Perhaps. But the
interaction of photographs and monochromes in his work leads instead to social
and potentially political commentary, not to inwardness. His monochromes are
abroad in the university community in this series, and "in the street," as he titled
a series from 1989. Wall's version of redemption is, if I read him correctly, close to
the thesis that art, especially abstraction, can cure society's ills by regrouping, by
becoming strategically inward. Charles Harrison writes: "'Abstractionist' [is] that
highly developed version of 'mainstream' Modernist theory which was current
during the 1960s and for which [Greenberg and Fried] were largely responsi-
ble...their notion of 'self-containment' in contemporary art [implies] a high
degree of abstractness in both painting and sculpture" (2001, 32–3). As we have
seen, however, this is but one option for abstraction. Malevich's theory of the
additional element is another. Before concluding with speculations on abstrac-
tion's curative potential recently, however, we need to look at a final symptom of
its "sickness."

The plague of iconoclastic vandalism often aimed at abstraction in today's
art world can productively be thought of as another dimension of the "social"
aspect of this form today. This is not to condone such destructiveness. As Charles
Harrison puts it with his usual verve, "an act of iconoclasm is after all the conse-
quence of a kind of 'reading', and it implies a form of idolatry" (2001, 191). Art
galleries do not reveal records of vandalism against work in their collections. To
prevent the spread of such destructive actions, they try to keep such attacks quiet
(Gamboni, 1997, 193). But the press cooperate. If large abstract works are not
attacked with greater frequency than other paintings, reporting makes it seem that
way. And paintings are not the only target, as the notorious removal of Richard
Serra's *Tilted Arc* from its commissioned site illustrates.[32] Of the nineteen major
assaults since 1982 recorded by the Artcrimes monitoring network, four have
been on abstract works (Fineman, 2004). There is no question that Barnett New-
man's sublime colour fields have suffered a disproportionate frequency and level
of abuse. Is it the taunting title *Who's Afraid of Red, Yellow, and Blue*[33] that presents
a red flag to the public? Perhaps it is the dangerous combination of size, apparent
simplicity (which translates for many as a low skill factor), and high monetary
value. For the arguments developed here, the question of motivation has to be
limited to determining whether the attacks on abstract art are meaningful to the

52. Barnett Newman, *Who's Afraid of Red, Yellow, and Blue IV*, 1969–1970. Oil on canvas. 274 × 603 cm. Inv. NG 5/82, FNG 40/82. Nationalgalerie, Staatliche Museen zu Berlin, Berlin, Germany. Photo: Joerg P. Anders. Photo Credit: Bildarchiv Preussischer Kulturbesitz/Art Resource, NY.

extent that they make a statement about this type of art specifically. For the famous assaults on Newman's works the answer would seem to be yes.

Gerard Jan van Bladeren, the self-described frustrated artist, knew what he was looking for when he ruined *Who's Afraid of Red, Yellow, and Blue III* at the Stedelijk Museum in Amsterdam in 1986. He brazenly sought out the same work again in 1997, with malicious intent. Unable to find it in the Stedelijk, he slashed *Cathedra*. Without giving his paranoid and troubling anti-Semitic ravings any air time, suffice it to say that these prejudices seemed to him to attach naturally to Newman and to abstraction. In 1989, a veterinary student named Josef Nikolaus Kleer attacked Newman's *Who's Afraid of Red, Yellow, and Blue IV* in the Berlin Nationalgalerie (Fig. 52). The assailant went to great trouble to make statements about the work, however incoherent. As Dario Gamboni reports in his recent book on modern iconoclasm, Kleer

"began by hitting the painting with one of the plastic bars used to keep visitors at a distance. He then placed several documents on and around the damaged work: on its blue part, a slip of paper inscribed 'Whoever does not yet understand it must pay for it! A small contribution to cleanness. Author: Josef Nikolaus Kleer. Price: on arrangement' and 'Action artist'; on the ground in front of it, a copy of the last issue of the magazine *Der Spiegel*, with a caricature of the then British Prime Minister Margaret Thatcher on the cover, appearing as a holy knight on a dark-blue background in a reference to the Falklands War; in front of the red part, a copy of the 'Red List,' an official catalogue of remedies published by the German pharmaceutical industry; in front of the yellow part, a yellow housekeeping book with a second slip of paper carrying the inscription 'Title: Housekeeping book. A work of art of the commune Tietzenweg, attic on the right. Not to be sold'; finally, lying somewhere on the ground, a red chequebook. These items enabled the police to find the culprit quickly." (207–8)

There is a connection between this attack, with its reference to the cost of Newman's art, and a more recent – and thankfully, more humorous – scandal that erupted in 1990 over the National Gallery of Canada's purchase of Newman's *Voice of Fire* for 1.76 million dollars. The affronts to this painting, its author, the National Gallery, and the Government of the day were numerous and sustained. None were physical, but the work was carefully guarded. Complaints fell into a surprisingly large number of categories, most of which are represented by the many cartoons generated during the controversy (and which merely take their place in the proud tradition of lampooning contemporary art). To summarize: first, grumpy, knee-jerk nationalism – many Canadian artists objected to such a large portion of the gallery's acquisition budget going for an American work, even though there was a Canadian context, given that the piece graced the American pavilion at Montréal's Expo '67. Second, The Offended Consumer – predictably, many people thought that they, or more likely their children, could accomplish as much for a better price. Canada was in a recession at the time and sensitivities to government spending ran high. Third, government watchdogs – most importantly, calls for the government to intervene to block the purchase were met with proclamations of the importance of the "arm's length" relationship legally binding on national institutions. The gallery's attendance went up twenty percent the year after the work was displayed. Fifty thousand copies of a free pamphlet about the picture were printed, but the high circulation only multiplied the gallery's public relations gaffes when it was noticed, by a seventeen-year old in Edmonton, Alberta, that the photo on the brochure was backwards. An exemplary teen, he realized that the "Levi's" label on one of the onlookers jeans in the photo was on the wrong side. How much of this public debate and public acrimony was about abstraction? There is evidence that this was a significant, perhaps deciding, motivation. When the same institution purchased Mark Rothko's *No. 16* in July 1993 for 1.8 million dollars, there was a brief public outcry.[34] Although there was another nasty debate over the acquisition in 1991 of Jana Sterbak's *Flesh Dress*, the most telling detail is that the purchase of *Europa & Jupiter* by the 17th-century Italian master Guido Reni in June 1992 went unremarked, even though the 3.45 million dollars it cost was the highest ever spent by the gallery on one work.

Thomas McEvilley has written that Clement Greenberg, accompanied by his hero, Immanuel Kant, keeps turning up in our discussions like a "zombie" (1996). I hesitate to invoke him again at the conclusion of this study, yet given the chronological frame in which our discussions of abstraction figures, his position as a touchstone is secure. Greenberg was a historical thinker, a "world historical" thinker in the Hegelian sense. He saw purified abstraction as an antidote – his term, as we have seen – to kitsch. To strengthen itself for this curative role, it seems that abstraction as the epitome of all high art required isolation. Abstract art was a defensive position, a retrenchment. What we see in many examples of recent and contemporary abstraction is purposeful immersion in, rather than

autonomy from, society and its ills. Contemporary abstraction's curative potential today depends on this profound circulation in its culture. In Chapter 1, I was at pains to show how Malevich's theory of the additional or supplementary element was, in spite of its origins in the realities of tuberculosis in Malevich's country and home, a positive discourse in its ability to affect transformations in art and society without transcending either realm in Hegelian fashion or, conversely, retreating to autonomy. Work as different as Christain Eckart's and Taras Polataiko's takes up Malevich's challenge to keep abstraction in circulation, to hope for change by participating in society. Versions of this principle have a long and substantial lineage. Sherri Levine hopes her appropriations will function as antidotes, as I note at the beginning of this chapter. Greenberg uses the same term, forging an odd linkage with figures after and before him. R. G. Collingwood makes the role of the artist as social diagnostician fundamental to the definition his 1938 art and artist: "As spokesman of his community, the secrets he must utter are theirs . . . For the evils which come from [society's] ignorance of the poet as prophet suggests no remedy, because he has already given one. The remedy is the poem itself. Art is the community's medicine for the worst disease of mind, the corruption of consciousness" (1974, 336). The Hegelian sense of consciousness to which Collingwood ultimately appeals was moved along its path to self-realization by art as an "infection."

Plato continues to cast a shadow over recent abstract art considered as infection and cure. He performs what we can call a "curatorial" function in art theory and practice still, despite the common knowledge that he banished artists from his republic. Many art historians who focus on contemporary art are themselves, or are in touch with, curators. So familiar is this role that I think we overlook not only the extraordinary contributions of these people to our understanding of the work we analyze but also that we forget the medical and managerial overtones of the designation "curator". A curator is one who takes care of others in the sense of assuming legal responsibility. A related connotation is the care of souls, hence a "curate" in a religious order. "Cure" in the medical sense is always in attendance (*Oxford English Dictionary*). Thus a curator in a museum today is not only in charge of a collection but is charged with the display of art to ameliorate public ills and instruct the soul. Plato can be said to have inaugurated this tradition with his notion of the "good physician" in the *Gorgias* (521A). Looking to statecraft in ways analogous how to the artists considered in this chapter use their abstractions, Socrates administers the "pharmakon," the medicine/poison to the Athenians, not for their pleasure but for their edification and betterment. Plato's "poison" was to seek an art form that transcended art and to banish practitioners. A precedent if not a model for Malevich's additional element, the formula for this ancient prescription was rewritten by Malevich the art doctor. Both Smithson and Turrell, as we have seen, play with and transform Plato's cave into a positive site for art. Abstraction stays in the state as a beneficial, transformative agent. So too

for Polataiko, whose glares and then cuts take up the role of antidote. Positive as the "curatorial" role of recent abstraction is, however, it resists Plato's banishment from society only by remaining present as an irritant, not by curing ills in any final sense. The masters of tainted circulation, GI, make this all too clear: "We designed prototypical viral-like vehicles to course the globe, intravenously, like plasma in the body. These germs of art discourse were made to be word-wise and parasitic, logo-logical, programmed to piggy-back on highly mobile continually mutating found-formats + available contexts + sympathetic susceptible carriers." But, they lament, "does art have a use-value? Puritanically we tried to separate this elusive germ from any of art's well-known pleasurable side-effects. But we could not. We could not document one single case of art as the direct cause of the remission of societal ills" (1992, 58–9). A discouraging conclusion? No, a realistic one that recognizes both abstraction's potency and impotence but refuses to banish it.

Notes

CHAPTER I. PAST TO PRESENT: A DIAGNOSIS OF RECENT ABSTRACTION

1. Malevich (1989, 37).
2. Hegel (1967, 530). My emphasis.
3. 1975, 91.
4. From the first word of my title to the last page, I use the term *abstract* and its cognates. It is my belief that artists, historians, and critics know what this very inclusive term denotes and that this familiarity and elasticity of meaning is, largely, an advantage. We also acknowledge that the term *abstract* is often vague and that it has frequently been challenged. Artists and artwriters have exercised themselves thoroughly on its inadequacies and nuances; I don't see the value in reviewing this literature, first, because it is contradictory, and second, because substitutes such as *concrete*, however validly defended, have not stuck in our vocabulary. When there is a good reason to make a distinction between, say, *nonobjective* and *nonfigurative*, I do so or point to those who do. For example, E. C. Goosen's important exhibition at MoMA in 1968, *The Art of the Real: USA 1948–1968* presented work by Paul Freely, Ellsworth Kelly, Morris Louis, Agnes Martin, Ad Reinhardt, and many others, all of which could easily be called abstract rather than "real." Embracing Sennett's notion of the uses of disorder, noted near the end of this chapter, I leave the field quite open and speak of abstraction. A final point: it may seem to some that the conventional contrast between abstract and figurative art is anachronistic in the contemporary art world. Certainly the borders are crossed and redrawn – and not for the first time. I would counter, however, that it's worth keeping the term *abstract* in mind because it recollects the history of a genre still potent today.
5. Mitchell (1987, 214). Unless Mitchell, in company with Danto more recently, is speaking world historically, he is misinformed. For example, see the list of exhibitions on the monochrome alone, ca. 1970–1990, in Riout (1996, 138), a pattern that continues into the first decade of the 21st century. In the critical literature, one can point to the extensive interviews and analyses published by Lily Wei (1987a and b), in *Tema Celeste* in three issues over 1991–1992, and by Raphael Rubenstein (1994, 1997). See also my bibliographic overview at the end of this chapter. Mitchell's contrast between history and memory is also problematic, I believe. For a full account of the interaction of these categories, or processes, in recent art, see Cheetham, *Remembering Postmodernism* (1991b).
6. See Cheetham (1991a), *The Rhetoric of Purity*.
7. Art seen as a disease to be purged from society has a much longer history. For example, the art historian Robert Wichman wrote in 1896, "For years have we, the German people, endured the bacchanalias of the new art with touching patience, in the hope that this thing would go out of fashion, destroyed by its own shallowness and falsity. Unfortunately, we have all been disappointed in this manner. Like an epidemic this sickness spreads, also infecting circles that have up to now been healthy; thus it is the duty of those who still have a feeling for the true and beautiful art handed down to us, to unite, in order to preserve, untouched and pure, the treasures which we have inherited and which we will pass on to those who follow us" (Kay, 2002, 83). My thanks to Mitchell Frank for bringing this reference to my attention.
8. Dario Gamboni examines Werner Hoffmann's claim that Luther liberated art by making it, in effect, autonomous from religious contexts, a move that Hoffmann sees leading eventually to Kant's quintessentially modernist "disinterested" contemplation

(1997, 30, 312). See Cheetham 2001, where I examine Clement Greenberg's relation to modernist abstraction through Kant. As I explain in Chapter 4, the context of iconoclasm is, paradoxically, crucial for an understanding of abstract art.

9. Bernard Smith (1998) has argued astutely that we need a new term for the identifiable period style that began in the 1880s and ended in the 1960s. His apt coinage *Formalesque* has the advantage of being more specific than either *formalism* or *modernism*, terms that are too inclusive. The purism in abstraction that is overturned is that of the formalesque. Nonetheless, and despite the problems, I will continue to refer to modernism and formalism, first, because these are the terms of the ongoing scholarly conversation that my work enjoins, and secondly, because as I have argued elsewhere (Cheetham, 1991a), the rhetoric of purity is both integral to modernism and much more than formalism.

10. I have investigated these connections in detail in Cheetham (1991a and 2001, respectively).

11. See especially David Craven's important analyses of Latin American abstraction in relation to Greenberg's purism and American abstract expressionism (Craven, 1991).

12. A good example of these tendencies is the catalogue *In Quest of the Absolute*. New York: Peter Blum Edition, 1996, and its essay by Erich Franz. See also my comments on Roald Nasgaard's exhibition, *Pleasures of Sight and States of Being: Radical Abstract painting since 1990*, below.

13. Troels Andersen, ed., *Essays on Art 1915–1928*. 4 vols: I, 38. Different translators were responsible for different volumes; see my *Works Cited* for a complete reference. Subsequent references appear in my text as "Malevich," followed by the volume and page number.

14. Hatch (1995).

15. On this topic in general, see Douglas (1984). Her foundational study does not identify the rhetoric of purity or suggest the argument I am presenting here.

16. The original Russian is "*formovoi pribavochnyi element.*" The German translation, *Ergäzungselement*, was used on the charts that supported lectures Malevich gave in Berlin in 1927 and in the publication of his *The World as Non-Objectivity* in the Bauhausbuch series, 1927 (Malevich, 1989, 38). "Zusätzliches Element" was the translation that appeared in Germany, mirroring the near synonymity of "supplementary" and "additional" found in English. French translations have used "l'élément ajouté" (Malevich, 1986) and "l'élément additionelle" (in Jean-Claude Marcadé's texts). Malevich was apparently delighted by the response to his ideas in Germany but frustrated both by what he understood, as a non German speaker, to be the inadequacies of the German text on the panels used there and by the shortcomings in translation and length of his theoretical tract. Malevich also regretted that he was unable, for financial reasons, to exhibit the charts in his retrospective at the *Grosse Berliner Kunstaustellung*, 7 May–30 September 1927, which was the reason for his trip through Warsaw to Germany in this year.

 I have come to the conclusion that although influences are to be found, Malevich's theory of the additional element was largely his own. Moving from a wide to a narrow focus, the organicism and vitalism of the notion is typical of the period and especially of French symbolism, with which Malevich was familiar (Douglas, 1984). His colleague and friend Mikhail Matiushin promoted such a worldview (Matiushin, 1976). Malevich was also part of the circle of Russian formalists, whose work is cited as a general inspiration for biological metaphors (Steiner and Davydov, 1977; Bois, 1992a), as shown below in the case of Victor Shklovsky. Looper (1995) has analyzed the connection between tuberculosis and the additional element. My only criticism of his excellent research is that he doesn't address the significant positive element of infection in Malevich's theory. Towering literary figures of the time, two of them Russian, thematized tuberculosis: Tolstoy, Chekhov, and Mann.

17. Malevich also called the domain of his research "psychobacteriology" (Karasik).

18. Demosfenova (1998, 15), quoting from a document from the State Central Archive for Literature and Art in Sankt-Peterburg. This and subsequent quotations from Russian sources were translated by Anete Ivsiṇa.

19. See Tomes (2000) for an analysis of the late 19th-century shift from miasmic to germ theories of contagion.

20. The term *culture* has both medical and humanistic connotations in Russian as well as English, a doubleness exploited in this text by Malevich. On this issue and all pertaining to Russian translation, I am indebted to my main research assistant for this project, Anete Ivsiṇa.

21. Its founder, Samuel Hahnemann (1755–1843), "a German physician, first coined the word *homeopathy* (*homoios* in Greek means similar; *pathos* means suffering) to refer to the pharmacological principle, the law of similars, that is its basis . . . [This law] was previously described by Hippocrates and Paracelsus and was utilized by many cultures, including the Mayans, Chinese, Greeks, Native American Indians, and Asian Indians, but it was Hahnemann who codified [it] into a systematic medical science" (Ullman).

22. As noted, a series of illustrated and annotated didactic charts – Malevich's Power Point – was prepared by his students and used in a lecture Malevich delivered in Berlin in the spring of 1927. He had presented versions of both the textual and visual components of his theory in Leningrad in 1925 and used them in his teaching there. For analysis, see Douglas (1991, 16). All twenty-two diagrams have been reproduced with accompanying texts translated from the Russian (Malevich, 1989).

23. The Dearstyne (Malevich, 1959) translation of the German text of Malevich's essay on the additional element, although based on the abridged German translation, has the virtue of making easily available a version of what was printed in Malevich's 1927 Bauhausbuch and includes the original illustrations. In this case, see Fig. 47.

24. Petri was one of Koch's pupils. He developed the technology that bears his name to aid in the isolation and identification of disease-bearing bacteria.

25. Clark's assertion that students were bored by Malevich's additional element is contradicted by the archival record. The idea was extraordinarily influential, and continues to be. One contemporary example: "Malevich was a wonderful lecturer. According to his listeners' remembrances, his lectures were a free improvisation or a reading from his notebook of some text that was followed by discussion. He tested the ideas of his theoretical work and teaching methods on his students in Vitebsk and in Petrograd-Leningrad. 'We were his guinea-pigs,'" A. A. Leporskaya jokingly remembers of her practice at GINKhUK "(Demosfenova, 1998, 11). Leporskaya was one of several assistants who helped prepare Malevich's didactic charts (Malevich, 1989, 37). See Karasik for additional examples.

26. I return to this issue in Chapter 4. Here it is important to emphasize that metaphors of infection, because they are historically inflected and merge with "real life," need to be employed with precision. Yve-Alain Bois' otherwise sound description of the additional element slides from Malevich's concerns with bacteria to the obsession with viruses typical of our time. The sign in Cubism, he writes, is not used semiologically but "in a *bacteriological* sense; for such a conception, the pictorial 'sign' is *one* among many other elements of the canvas, but it is not constitutive of its organization as such. Like a *virus* in one's body, it produces various effects when it inflects a pictorial order, but it remains dispensable; it is not essential" (1992a, 185–6; final emphasis added). What Bois encapsulates so well here is, first, the interpretive power of Malevich's model and secondly, its "supplemental" nature in Derrida's sense.

27. Nazi censorship that resulted in the notorious *Entartete Kunst* exhibitions of 1937 is the most virulent example of this pattern. Hitler notoriously used the diseased artist image in his speech opening the "Great Exhibition of German Art" in Munich in 1937.

Not only did he think possible that "pitiful misfortunates who quite obviously suffer from an eye disease" are responsible for the distortions of modern art, he sought to curtail their activities in the most chilling manner by suggesting that the "ministry of the Interior of the Reich . . . would . . . take up the question of whether further inheritance of such gruesome malfunctioning of the eyes cannot at least be checked" (Chipp, 1968, 480). In art history, the Austrian scholar Hans Sedlmayr (1896–1984) applied a negative version of the art-as-disease model to buttress his arguments for the purity and autonomy of each art form. "Anyone who is capable of seeing" the changes in the arts since the French Revolution, he wrote, "not merely as historical facts but as symptoms, will be able as a result . . . to form a diagnosis of the malady that affects our time. For there can be no doubt that many people really feel that our age is sick" (1958[1948], 1). To reveal fundamentals and thus perceive deleterious change in the arts, he recommends a process of medical-aesthetic purification: "Let us proceed to eliminate bit by bit from each art what allegedly constitutes a foreign element within it; let us, for instance, eliminate from painting the element of the three-dimensional, the element of line, of architecture and of the theatre, the transcendental and literary element . . ." (79). The ideology of purification, its perversion of Hegelianism and its social implications, subtends this argument for art as autonomy. "When art reaches its zenith . . . it becomes fully conscious of its individuality and of the uniqueness of its own laws. Then the pictorial element is eliminated and art attains, or at any rate strives for, an autonomy which recognizes only it peculiar laws of composition" (80). More recently, Demitrio Paparoni has employed a discourse of illness and cure with respect to abstraction and more generally. His interest, however, is more psychoanalytic than mine and derives ultimately from Bataille (correspondence with the author, May 6, 2004).

To see germs and infection as somehow positive is all the more unusual when one understands the military context typical of their popular reception. Gradmann's "Invisible Enemies: Bacteriology and the Language of Politics in Imperial Germany," reveals the extent to which Koch and other scientists cast their findings in militaristic terms. Here we have a revealing instance of the perpetually interacting circuit of cultural metaphor and scientific research that I will address several times in this study. On the imbrication of scientific discourse and metaphor see Braide (1999), Keller (1995), and Wald *et al.* (2002).

28. See Cheetham (1997) for an intimation of this argument. By coincidence, the only other examination of impurity in abstraction that I know of appeared in the same year, though with different examples and conclusions. See Buci-Glucksmann 1997.
29. Polataiko (1995c).
30. "Reflections connect two bodies of work." *The Star Phoenix*, Saskatoon, Saskatchewan, Canada, Nov. 25, 1995.
31. Artist's notes (1995).
32. Polataiko (1995a).
33. "Virus" is one of the ruling metaphors of our time. We can all provide anecdotal evidence of this fact. Mine would be the existence in Toronto of a gallery called Virus Arts. A symposium in 2002 considered the boundary-crossing nature of this image (http://www2.kah-bonn.de/fo/virus/programm.htm).
34. On Greenberg's Kant, see Cheetham (2001). A comment in Bürger's *Theory of the Avant-Garde* makes me wonder whether Greenberg was extrapolating Kant's thinking or whether he read Schiller, too. Bürger argues: "Schiller attempts to show that it is on the very basis of its autonomy, its not being tied to immediate ends, that art can fulfill a task that cannot be fulfilled any other way: the furtherance of humanity" (1984, 44). This is precisely Greenberg's argument for abstraction over kitsch ca. 1939–1940.
35. Florida State University Museum of Fine Arts, Tallahassee, Feb. 16–Apr. 1, 2001.
36. Bois (1986).

CHAPTER 2. WHITE MISCHIEF: MONOCHROMES

1. Reza (1996, 20). The cover of the English translation shows what appears to be a white slashed canvas by Lucio Fontana. Yve-Alain Bois claims that Martin Barré, who died in 1993, "was the basis for the creator of the canvas in . . . Art, the populist satire of abstract painting." He points out that Barré did not do a white monochrome himself, though he was enthusiastic about both Malevich and Klein, illustrating my claim that "white" is a description variable enough to stand in initially for all monochromes (Bois, 1999b, 145).

2. McEvilley (1993) and Gibson (1992) remain two of the most penetrating studies of the monochrome. On monochromes and "blankness," see de Duve (1990), Harrison (2001, 143ff.), Gilbert-Rolfe (1997a), and especially the PhD dissertation by Morrison, which makes important connections with race theory (2002). Gilbert-Rolfe brilliantly expresses the contradictions of what I call abstraction vis-à-vis painting in general in "Irreconcilable Similarities" (1995, 44). There are critical issues to be debated when painting, even modernism, is reduced to a much more specific category such as abstraction. What is lost in such a simplification? At the same time, when we think historically we are always simplifying, so on historical grounds, I cannot agree with Stephen Melville's warnings against conflating painting with abstraction (2001, 2). That move happened repeatedly. What we need is another way of understanding how abstract art escaped this narrow paradigm.

3. See Epperlein (1997, 249–50) for the most complete list. An early example is *Monochrome Malerei*, curated by Udo Kulturmann at the Museum Schloß Morsbroich in 1960. More recent was the focus on monochromes at the XXIV Bienal de São Paulo in 1998. As I write this chapter, a large exhibition on the monochrome is on view at MNCARS in Madrid, organized by colour. I was not able to consult the catalogue by Barbara Rose *et al.* before this book went to press. One of the most extensive collections of monochromatic work is the Natalie and Irving Forman Collection, seen at the Albright-Knox Art Gallery, May 6–July 3, 2005. Monochromes appear in exhibitions devoted to abstraction more generally: see M. Rosenthal and the catalogue *Critiques of Pure Abstraction*. Arthur Danto, following Kierkegaard, used the monochrome in his philosophical demonstrations at the beginning of *The Transformation of the Commonplace: A Philosophy of Art*. He devotes a chapter to the genre in *After the End of Art*. An especially interesting source is monochrome painter Marcia Hafif's article on the 1988 exhibition *La Couleur Seule: L'Expérience du Monochrome* (Hafif, 1989). Madoff (1986) detailed the "return" of abstraction to New York in the mid-1980s. Many examples in *Pour un art concret* (2004) are of monochromes. Wallach (2003) provides a useful survey of the ongoing resurgence of interest in abstract art generally.

4. *White Mischief* (1987) is a murder mystery that exposes the decadent exploits of the expatriate British upper class in Kenya in the 1940s. It is based on the true story of the death of Lord Erroll. Adapted from the novel by James Fox and directed by Michael Radford, the movie was released in 1987.

5. Epperlein details the breakdown of this "Farbhierarchien" (1997, 84ff.), as does Hafif (1989, 133). From Derrida's "White Mythology" to O'Doherty's white cube, Mark Wigley's reflections on white in fashion, and the many studies of race (see Morrison, 2002), the contemporary cultural discourse on whiteness is vast and eclectic. Monochromes can often be thought of as the face or mirror of these deliberations. One of many examples of the white monochrome performing this broad function is the so-called "White Website" of Hans Ulbrich Obrist: http://www.ubermorgen.com/ THE_WHITE_WEBSITE/HANS_ULRICH_OBRIST_WHITE/HANS_ULRICH_OBRIST_ BERNHARD.HTM). The meaning and fate of white canvases by Ilya Kabakov and by Eric Bulatov in the Soviet Union of the 1970s are detailed by Tupitsyn (2002, 113ff.).

6. Just who was the first to rework the original monochromes is a question dependent on and as fraught as that of initial priority. Bois suggests that the "first monochromes proper" were by Rodchenko and Strzeminski, but as we have seen, "proper" is a matter of definition not fact (Bois, 1999a, 1990), turning in part on one's estimation of Malevich's black squares of 1913–1915 and the judgment about their status as monochromes. Riout especially has also followed the early examples of monochromes appearing in books – Stern's *Tristram Shandy* (1759–1767) is the most famous but not the first example – from the 17th to the 19th centuries. Though I address these issues at several points in this book, my emphasis is not on precedence but on factors that led to the genre's ongoing vitality. Lucy Lippard has made the important observation that what is taken as a monochrome has changed over time (and will presumably continue to evolve). She notes that "in 1918, and in fact until the late fifties, a monochrome canvas in which the values were fairly close looked monotonal or blank to many people" (1967, 59). We now notice differences in hue in the same works and may therefore be inclined to disqualify them from a strictly defined group of monochromes. Thus Lippard is able to write, without contradiction, that "the first and best-known monochrome painter was of course Kazimir Malevich" (58) and that "in retrospect, it is clear that Malevich and Rodchenko were not making monotonal paintings" (59). As with the category "abstract," which we can specify endlessly, then, I use *monochrome* in an inclusive sense governed not by principle but by reception.

7. On the neo-avant-garde, see especially Buchloh, Bürger, and Foster.

8. Although scholars have certainly acknowledged the Zen attributes of Klein's work, judo as an ongoing inspiration for what I am arguing is his active "Do Zen" performance of these principles in his art has not been sufficiently emphasized. The most complete account of Zen influence in the art of this period is Westgeest (1996). See also McEvilley, whose interpretation of Ad Reinhardt's only apparently formalist reductivism, in writing as in his canvases, he relates to "Ch'an and Zen books on painting" (1993, 46).

9. Riout discusses humour and parody in the monochrome (1996, 141ff.). A fine example that he doesn't give is the work of François Morellet (b. 1926), where Malevich's perfect forms slip off into sculptural space or indeed drown, as in *Le Naufrage de Malevitch*.

10. See Bois (1999a) for this view. However, Douglas (1994) routinely refers to the black squares as monochromes. In what remains the most comprehensive examination of these works, Bois rightly insists that the figure–ground relationship here is "undecidable" (1978, 34). It could as easily be white on black as black on white, even though recent technical analyses have established that the black was applied first with the white coming second as a "border." We also know that red as well as text is visible through the black in the 1915 version, shown in the 0.10 exhibition.

11. Toronto artist Gordon Lebredt, who has much experience with the conundrums of monochromy, makes the point this way: "One can understand why Malevich thought it necessary to retain the figure of the black square within what could be construed as a mat or pass-partout, a sort of DMZ, a provisional buffer-zone or prosthesis for that which, at the time, could not stand on its own." Personal correspondence, February 2004. On the placement of how these works, see Malevich (1975).

12. Significantly, however, the group edited out both Malevich's last self-portrait and *Peasant Woman* of ca. 1930, both of which accompanied the black square in the ensemble. See Crone and Moos for a reading of how these works function together (1991, 198).

13. "NSKte in Time." http://www.nskstate.com/athens/irwin/texts/nsk-state-in-time.asp.

14. See Bois (1990) on Strzeminski and Kobro's fate as the overlooked in the history of the genre, one that Klein partly sealed and which I am, regrettably, continuing.

15. The elision of Klein's judo passions and their connection to Zen and to his art is typified by David Hopkins, who writes: "Zen Buddhism, which he became aware of on a trip to Japan in 1952–3, similarly embraces 'nothingness'" (2000, 79).

16. This trend continues in an explicitly Zen form of judo, a wealth of historical and philosophical material about which can be found at http://zenjudo.co.uk/zenjudo/main_site/rules_history/zen_hist.htm

17. As translated by Keiko Fukuda in Ohlenkamp (1999).

18. McEvilley has established that Klein's sense of impregnation and absorption derives from Max Heindel's Rosicrucian writings (1982a, 245). Before making them into works of art, whether in his reliefs or as sculptures, the sponges were also applicators of pigment.

19. The intricacies of Klein's stay in the United States are discussed fully by Stich (1994, 232ff.).

20. Benjamin Buchloh has, more than any other scholar, articulated post-1960s art in Europe and the United States in terms of its status as "neo" avant-garde. See especially "The Primary Colors for the Second Time" (1986). As my arguments reveal, I am largely in agreement with his point of view, but I do not debate this issue with him point by point.

21. Buchloh (1986, 45). In another superb essay on these themes, however, Buchloh slips into the art historian's game against which he cautions here. He claims that Ellsworth Kelly's experiments in France ca. 1950 were the first of "the postwar moment to resuscitate monochromy in a programmatic fashion" (2000[1998], 263). There are of course other competitors for this prize, including Fontana, who worked with (arguably) monochromatic black light in 1949 and Clifford Still at about the same time. Buchloh is also sure to take a "correct" stand against the admitted excesses of Yves Klein, who delivered the message of the neo-avant-garde's decline: "it has sometimes been difficult not to resent the messenger for delivering the message," he writes in what pretends to be a review of Stich's 1994 catalogue and exhibition but is more an assessment of Klein the person. Although it is certainly true that Klein actively suppressed his debts to other artists, Buchloh's charge that "Duchamp's rotoreliefs, Jean Dubuffet's eponges, Man Ray's rayo-grams, Ellsworth Kelly's monochrome paintings, Robert Rauschenberg's blueprints . . . all resurface in Klein's opus, covered in a homogenizing layer of IKB, and with an average delay of about ten years" (1995, 98) both is inaccurate – there is no indication that he knew of Kelly's work, for example, and as Molnar has shown, these surfaces are not literally of one colour – and assumes that Klein's neo-avant-garde revisions were simple repetitions. Buchloh is aware of this tension yet constantly falls back on a discourse of priority, which of course is central to the disciplinary protocols of art history. For a full review of Stich's exhibition, see Phillips (1995).

22. Riout's tradition of "fictive monochromes" is one revealing context in which to place Klein's 1954 gesture, both *Yves: Peinture* and the so-called *Haguenault: Peintures*, which included records of the collections in which Klein's monochromes from as early as the late 1940s were held. Both "Haguenault" and the collections are fictitious (1996, 187ff.). Stich also emphasizes the comparison with Alphonse Allais's *Album primo-avrilesque* of 1897, which contained monochrome images (48). Another context is Klein's early recognition of the potential of "readymade" colour chips, used around the same time by Kelly and with great effect subsequently by Gerhard Richter especially. Duchamp's *La boîte-en-valise* (1936–1941) offers yet another point of comparison for Klein's fabrications.

23. Continuities between Rauschenberg's and Klein's monochromes have of course been noted. See especially Epperlein (1997, 128ff.) and Pierre Restany (1990), who included both artists in exhibitions in the early 1960s. In "The Dematerialization of Art," originally published in 1968, Lucy Lippard included both artists in a long list of

mostly Americans interested in this direction (Lippard, 1971[1968]). Yve-Alain Bois makes the comparison in terms of "base materialism" (Bois and Krauss, 1997, 59). Rauschenberg seemed not to hold whatever grudge there may initially have been. He owned Klein's 1961 *Untitled Blue Monochrome* and loaned it for McEvilley's Klein retrospective in 1982–1983.

24. Predictably, Kelly and Rauschenberg remember their first meeting differently: Rauschenberg recalls the other's outrage at the white paintings: "He was furious I had stolen his idea." Kelly recalls pointing to a yet earlier precedent for this work, that of his friend Alain Naudé and Rauschenberg's negative response to the comparison. See the excellent discussion in Joseph (2003, 73ff.).

25. This term could be used in the almost colloquial sense of "meaningless" and "against art" as well is in the more rigorous, dialectical manner in which Adorno, for example, criticized John Cage's interests in the ego-less aspects of chance and Zen. Joanne Morra discusses the association of Rauschenberg with neo-Dada and also develops a new perspective on the use of autobiography in his work (2002).

26. See Hopps and Davidson (1997) for a complete exhibition history. The fullest discussion of the *White Paintings* is in Joseph (2000).

27. These dimensions are discussed in Feinstein (1986, 28).

28. Joseph discusses Rauschenberg's attitude to this work (2003, 9).

29. We can draw a parallel here with Malevich's practice, certainly unknown to Rauschenberg, of dating all four of his black square paintings to 1913 when he and most others knew that even this original date was two years early (Balakhovskaya). With their predating schemes both artists asserted the unity of the monochromes and their common sources.

30. Joseph makes the persuasive argument that Rauschenberg's understanding of these paintings evolved considerably as his friendship with John Cage developed from 1952. Although Rauschenberg "may well have initially understood his *White Paintings* as a final stage on a path of modernist reduction . . . by 1953 he had come through his association with Cage to regard them as something more: as exemplifications of a positive force of difference made visible through their 'transparency' to temporal and environmental factors" (2003, 80).

31. On Cage, see also Joseph (1997a, 1997b; 2003) as well as Tan (1989).

32. On Cage and Zen, see Tan (1989) and Westgeest (1996).

33. Akin to the notion of "nothing," that of "blankness" is both central to the monochrome and has generated important commentary. See de Duve (1990) and Gilbert-Rolfe (1997a).

34. Hopps and Davidson record this list (1997, 570) but do not include *Collection*, a very early *Combine* painting that, as emphasized by Hopps (1991) and Joseph (2003), began as a red, yellow, and blue triptych. As I suggest in Chapter 4 with reference to work by Robert Houle and Ian Wallace, monochromatic panels are often found embedded in larger paintings and installations. In one sense, they are thus no longer monochromes, but they do, I believe, still potentially allude to the monochrome tradition and its multiple connotations.

35. My interpretation of the role of these monochromes stands in contrast to Jeremy Gilbert-Rolfe's, for example, who claims that here "Rauschenberg certainly produces a reduction that is more or less irrelevant to painting, while being for that reason a source of perpetual delight to the death-of-painting crowd . . ." (1997b, 60).

36. I am well aware that this positive view of postmodernism, which I happily share with Joseph, is controversial and always in need of justification. It would be possible to construe narratives about recent abstraction in terms of a modern/postmodern paradigm and indeed beginning with Rauschenberg. Leo Steinberg realized in 1968, when he was one of the first to use the term *postmodern*, that Rauschenberg's art was

"part of a shakeup which contaminates all purified categories" (1975[1968], 91). That I have not done so to any extent follows from my sense that (1) terminological wrangles tend to dominate any such discussion, (2) weary of these, the art world and most scholars have "moved on," and (3) I have recorded my views in print (Cheetham, 1991b).

37. See Potts for an important reassessment of the division of media in this period.

38. Rauschenberg confirmed in 1999 that the sequence moved from left to right in the order red, yellow, blue and that the red particularly has faded. It now appears pink (Joseph, 2003, 75, n. 7). Hopps established the connection between Rauschenberg's 1951 white triptych and *Collection* (Rauschenberg, 1976, 77).

39. Joseph (2003, 78, 98). See also Bois on Kelly's work in France (1992b, 27).

40. The definitive readings of this discourse are to be found in Bois's and Crow's essays in the catalogue *Endgame: Referent and Simulation in Recent Painting and Sculpture* (1986). Bois argues what is demonstrated in this case and many others, that "the end has to be endlessly worked through" from the beginning (47).

41. Rauschenberg refers to his tutelage from Joseph Albers, whose *Homage to the Square* works could easily have be seen to extend the use of the "image" in abstraction.

42. Steinberg, writing in 1968 when Greenberg's ideas still had great authority, speculated that the reasons for this power were to be found in the man's "unshakable self-assurance" (1975, 23). Others – I have had this conversation with David Carrier particularly – find that Greenberg's paradigms powerfully explained the art of his time. Given the very different story about abstraction that I am telling here, I'm inclined to agree with Steinberg.

43. Again I have been highly selective in the artists and works I discuss. Other monochromes beyond the traditional frame are found in the work of, for example, Larry Bell, Jeremy Blake, Anish Kapoor, Robert Irwin, Donald Moffett, Nam June Paik, Adrian Schiess, and Douglas Wheeler, among many others. Photographer Hiroshi Sugimoto's long exposure shots of movie screens yield elaborately framed white monochromes, as I suggest below. Derek Jarman's 1993 film *Blue* was a homage to Klein. See Butterfield (1993) and Schwarz (1998) for an examination of these and other related artists' works emphasizing light. See also Buci-Glucksmann's evocative "Icarus Today: The Ephemeral Eye" (1999). The exhibition *Abstraction Now* at the Künstlerhaus Wien in 2003 focused on "abstract" work in new media formats (http://www.abstraction-now.net\?introduction). It might seem odd not to examine the light and space work of Dan Flavin. However, although his late interior for Santa Maria in Ciesa Rosa, Milan (1997), for example, does feature an ambient, monochromatic light relevant to the contexts established here, in general, he "uses light generated by means of luminescent material. Light...is thus...the means of presentation; it is a thing depicted, or it denotes a thing signified" (Schenker, 1991, 70). On the theme of "L'Art en Tube" generally, see Bourriaud.

44. Moholy-Nagy's light experiments were also important in this context, though I believe less so for the history of the monochrome.

45. See, for example, Foster's complaint that Klein's (supposedly) "dadist provocation was turned into bourgeois spectacle" (1996, 11), a view that misunderstands and short changes Klein's relationship to Malevich and the avant-garde generally. I would argue that in his relationship with Malevich's black square, Klein performed what Foster hopes to achieve with his own study, "a temporal exchange between historical and neo avant-gardes, a complex relation of anticipation and reconstruction" (13, italics removed).

46. Self-consciously or not, the artists Komar and Melamid repeated this process of chromatic impregnation at the New York opening of "The Most Wanted Painting" in 1994 by serving blue vodka to guests.

47. Bruce Nauman's *Yellow Triangular Room (Installation with Yellow Light 1973)* (1975) stands in this tradition, as does James Turrell's procession of Ganzfeld rooms seen at the Stedelijk Museum in Amsterdam in 1976. A Ganzfeld or "total field" space is one contrived to present as little as possible by way of "normal" reference for the eye. It is homogeneous and thus disorienting.

48. Although some abstract art concerns itself with the specificities of perception – examples include works by Bridget Riley and Esther Stocker – I would argue that this scientific inspiration is not widespread. The inaugural exhibition and catalogue at the Kunsthaus in Graz, Austria – *Einbildung: Das Wahrnehmen in der Kunst* (2003) – represented a different take on this interaction by including a high proportion of abstract work. See also Eliasson 2001c.

49. For a full sense of the context of these works, see the 2005 exhibition *Bewegliche Teile – Formen des Kinetischen*, curated by Heinz Stahlhut at the Museum Tinguely, Basel (http://www.tinguely.ch/exhibition/bewegliche_follow.html).

50. Mack has recently returned to painting, about which he says the following: "I consider those paintings to be the best in which color is fully in and of itself, autarchic and autonomous in the sense that it is completely and perfectly self-sufficient. The conditions in which this occurs are so complex and intuitively present, and require such concentration on that which is essential for me, that I have no energy to expend on the expectations and demands of problems that lie outside pure painting" (http://www.mack-kunst.com/homepage.html).

51. "A special type of complex mirage, one that sometimes gives the impression of a castle half in the air and half in the sea, is named after Fata Morgana. She was known to live in a marvelous castle under the sea. Sometimes the enchantress made this castle appear reflected up in the air, causing seamen who mistook it for a safe harbor to be lured to their deaths. The fata morgana mirage is one that can occur only where there are alternating warm and cold layers of air near the ground or water surface. Instead of traveling straight through these layers, light is bent towards the colder, hence denser, air. The result can be a rather complicated light path and a strange image of a distant object. A fata morgana actually is a superposition of several images of one object. Typically one image is upright more or less above two inverted images that may be mingled together. The images may undergo rapid changes as the air layers move slightly up and down relative to the observer." Davis (1978; http://www.gi.alaska.edu/ScienceForum/ASF2/261.html).

52. Lynne Herbert writes in her essay for a 1998 catalogue accompanying a Turrell exhibition at the Contemporary Arts Museum, Houston, that "Henry James did a study of Stonehenge and concluded with a remark that one could apply to Turrell's work: '[it] stands as lonely in history as it does on the great plain'" (Herbert, 1998, 20).

53. Turrell has acknowledged parallels with Rothko and Newman, however.

54. Tempted to understand Klein exclusively in terms of the occult, Craig Adcock, in the most complete scholarly assessment of Turrell's art, suspends a comparison with Klein as soon as he acknowledges Turrell's connection to the flame works. "Such comparisons are of limited utility," he writes, because "unlike Klein, Turrell was not interested in the symbolic or ritual implication of fire" (Adcock, 1990, 6).

55. Adock (1990, 6). Surely both students and teachers alike have had a similar realization. Teaching classes on abstract art, I have often teased the students about the "blank" Malevich-like image that appears when a slide fails to fall. More recently, moving to digital projection, I have advanced chronologically to the Kleinlike blue monochromes that glow expectantly when this apparatus is in ready mode.

56. Georges Didi-Huberman also makes reference to Plato in his discussion of Turrell, though in very different terms. Bruno Latour's comments on leaving the cave are also pertinent (2004, 10ff.).

57. See Cheetham and Harvey (2002) for a discussion of caves and vision in the Western imagination.

58. Recognizing monochromatic screens in social contexts, as Sugimoto has done, allows us to think simultaneously of the abstract tradition in painting and of typically more socially integrative artistic choices. To add just one example of many, Heibo Zobernig's untitled installation in the Shigemori Residence, Kyoto, in 2001 employed a translucent white screen to intercede in the usually unobstructed sight line from inside the house to the traditional formal garden. In some light conditions, this screen appeared as a hard white monochrome; in others, shadows and backlighting revealed its fragility and vulnerability to change.

CHAPTER 3. MIRROR DIGRESSIONS: STAGES OF NONREPRESENTATION

1. Alberti (1991[1435], 61).

2. "A Mirror is the Perfect Artist. The Painter Gerhard Richter on his Abstract Art. An Interview with Jan Thorn-Prikker." September 2004. Goethe Institut (http://www.goethe. de/kug/kue/msg/thm/en163404.htm).

3. I have argued elsewhere that Plato's *Republic* offers a glimmer of hope that a nonmimetic visual art form could supply the metaphysical security that mimesis would always lack. In this hypothetical sense, Plato was the first to envision a non-representational art and his doctrines were used as an authority for the abstraction of Mondrian and Kandinsky in the early 20th century. Nonetheless, the negative lesson of the cave typically accompanies his accusation that painting is a mirror, and it is this Plato who is brought into the history of recent abstract art. See Cheetham (1991a, Chapter 1).

4. On this relationship, see Graziani (2004), Linsley (2000) and, Melville (1996) and Reynolds.

5. Rosalind Krauss writes of the literal and metaphorical "disappearance of the first person" (1997, 78). The scholarly literature on Smithson is large and growing rapidly. I have drawn especially on excellent readings by Shapiro (1995), Krauss (1997), Reynolds (2003), and Roberts (2004).

 Reynolds discusses Smithson's own early abstract work and his relationship to Greenberg's theories of contemporary abstract art in Chapter One of her study of Smithson. Although our analyses are compatible, her emphasis is on the coordinates of art discourses in the 1960s – what Smithson knew and what was possible for him – where mine is on Smithson's use of mirrors as a way to understand their more recent and ongoing importance in abstract art. Her excellent discussion of Smithson's connection to but distance from 1960s interests in perceptual theory and Op Art is again different from mine but results in similar conclusions.

6. Shapiro has discussed this work as a parody of Plato's myth of the cave. Reynolds elaborates the importance of salt for Smithson. See also Cheetham and Harvey for an analysis of visual culture and the anatomy of caves in general.

7. I use Duchamp's term to allude to his importance in any discussion of the mirror in 20th-century art. On the *mirrorical return*, see Singer. John Cage also mined the Duchampian lineage when he discussed mirroring.

8. A full discussion of the Narcissus myth can be found in Bann and in Bal. Both scholars articulate its relation to contemporary art but not to abstraction.

9. Benjamin Buchloh reminds us of a series of drawings from 1975 in which Richter projected "the construction of a military barracks/administrative building as a museum for a thousand monochrome paintings" (2002, 14). Buchloh does not mention the perhaps obvious though nonetheless chilling allusion to the "1000-year Reich."

Abstraction's history is by turns complicit with and critical of totalitarianism, as I have suggested at some length (Cheetham, 1991a).

10. One excellent source is *Gerhard Richter: Mirrors*. Exh. Cat. London: Anthony d'Offay Gallery, 1991.

11. I thought that I had coined this description until discovering that Riout uses it (1996, 126) and that it was suggested by Smithson in 1965 (Smithson, 1996, 328), as noted above. Foster provides an excellent summary of the import of the readymade since its invention by Duchamp. His overall point is that "most Duchamp readymades proposed that objects of use value be substituted for objects of aesthetic and/or exchange/exhibition value..." (1996, 109). Foster and others who write on recent abstract art also make the point that abstraction has, since the 1980s, become a readymade in the sense of an available language. Mirrors that become monochromes never quite relinquish their use value, I would argue, because reflection remains. Mirrors and monochromes are often part of a discourse of abstraction, as in the work of Lucas Samaras – mirror rooms from the mid-1960s and abstracts from the early 1990s – which includes both elements, however fragmentarily.

12. An important reference point is Imi Knoebel's work with stretchers and frames, such as the *Raum* series from the late 1960s.

13. Texts are from the artist's Web site: http://www.christianeckart.com/facelift/center.html

14. Why it is that so relatively few women have been interested in abstraction, let alone mirror abstraction, remains an important question. The issues and possible answers are canvassed by Gibson.

15. These are all early Eckart series, now concluded. I have written about them in detail in Cheetham (1996).

16. One example from this series was included in *Christian Eckart: Disturbing Abstraction*, a 1996–1998 traveling exhibition that I curated (Cheetham, 1996). When I uncrated *Noumena* for the inaugural exhibition, condition report in hand, I noticed an eerie though not unattractive light green square centred perfectly within the dimensions of the work. Caused by the packing materials pressing against the tain of the mirror, the result looked like a subtle but purposeful allusion to Albers' famous *Homage to the Square* series. When reported this "damage" to Eckart, he was outraged, exclaiming that he did not want an image within a frame. I remain grateful to him for demonstrating to me so graphically how such details can be of the utmost importance, as we saw above when Yves Klein looked back on Malevich's framed black square.

17. Many of Eckart's works find a home for their reflective activity in corporate settings. In conversation, he suggests that he sees his seductively beautiful but ultimately transcendent works as infiltrating these contexts in a (positive) viral manner. See Chapter 4 for a full discussion of this process in the work of other contemporary artists.

18. Much of Kapoor's recent work could be understood through the rubrics developed here. *Sky Mirror III* (1999), installed outdoors in Nottingham, UK, for example, is a large and highly polished stainless steel disk (243 × 270 × 151 cm), which, like a visual radio telescope, looks skyward to receive data. *Blood Mirror* (2000), which uses a reflective surface to stain its environment and interlocutors, and *Blood Cinema* (2000), which is translucent.

19. Correspondence with the author, May 18, 2000. A studio shot of Polataiko reflected in *Cradle* bears comparison with the famous image of Smithson mirrored in the water beside *Spiral Jetty*, mentioned above.

20. Communication with the author, August 22, 2004.

21. Hiring nonartists to make art is a strategy Polataiko often uses. He interviewed patiently to find the stereotypical "babushka" for his meditation on surface and authenticity discussed above (Fig. 6) and for other works that fall outside the context of this book.

CHAPTER 4. POSSIBLE FUTURES: ABSTRACTION AS INFECTION AND CURE

1. Interview with Lilly Wei (1987b, 114).
2. Interview with Lilly Wei (1987b, 171).
3. I thank Serge Guilbaut for insisting on this point in a conversation.
4. I have argued elsewhere for the social and political potency of some postmodern art. See Cheetham (1991b).
5. *General Idea: Pharma©opia*. Exh. Catalogue. Barcelona: Centre d'Art Santa Mònica (1992, 60). AA Bronson, the surviving member of GI, has confirmed to me in conversation that very little has been written about the group's interactions with Yves Klein.
6. Allan Doyle pointed out to me that a recent version of this work, *XXX Rose*, was performed in 2003 at the MIT List Visual Arts Center at as part of the exhibition "Influence, Anxiety, and Gratitude."
7. Polataiko (1995b).
8. I use this term to allude to Christian Eckart's purposeful use of "interference" paints on his recent monochromes, pigments that change hue as one's viewpoint moves. These finishes are usually reserved for high-end automobiles but have been deemed illegal for this purpose in some jurisdictions.
9. See Chapter 1 for connections between purism and totalitarianism drawn by Danto (1997) and Cheetham (1991a).
10. To acknowledge here just one of many fellow travelers who see modernist theory and the paradigms of purist abstraction as declining in the mid-20th century, see Harrison (2001, 88–89).
11. Interview with the author, Toronto, December 2, 1995.
12. See *The Charade of Mastery: Deciphering Modernism in Contemporary Art* (New York, Whitney Museum, 1990).
13. See Cheetham (1992) for a reading of the gender implications of Mondrian's abstraction.
14. The intriguing work of Keith Coventry underlines the social side of infectious abstraction. In two canvases presenting apparently randomly arranged black rectangles against a white ground that from afar and close up look very much like Malevich's Suprematism – *East Street Estate* of 1994 and *Heygate Estate* of 1995 – Coventry mirrors not a transcendental nonobjectivity but rather the visual code of building placement on housing estate orientation boards in England. The unmistakable visual reference to Malevich is, I suggest, an infection that asks us to consider the imbrication of a utopian vision of society with a less than ideal realization, both in the present.
15. For a full account and analysis, see Barber *et al.* (1996).
16. It would be instructive to compare the censorship of Serrano's "abstract" photos with that of Serra's *Tilted Arc* from the perspective of the denigration of abstract art.
17. Quotations are from Marcaccio's Paintant Web site: http://www.paintants.com/
18. I consider Mondrian's obsessions with balance and harmony in detail in *The Rhetoric of Purity* (Cheetham, 1991a).
19. David Moos alerted me to the work of Stephen Hendee, which offers a synthetic, cyber-alternative to the biomorprphic instigation of change in environments such as *Dead Collider* (2004) made of polypropylene, black glue, tape, fluorescent lights, and light gels. It is a digital world, but of course susceptible in the extreme to "viruses." Infection and mutation occur in our society (and its imagination) in decidedly nonbiological spaces as much as in the organic emphasized by Marcaccio. Hendee's environments may seem alive but they are not nature. But as in the case of bacterial and viral infection discussed in Chapter 1, overlap is more the rule than the exception, which is

why I believe, first, that a connection exists between the work of Hendee and those artists I have placed in Malevich's Nachlass, and second, why it is at least provisionally worthwhile to think of all this work as abstract. More comparisons arise in this train of thought than is the case if we decide that abstraction is passé. For example, the exhibition *Remote Viewing* (*Invented Worlds in Recent Painting and Drawing*), curated by Elisabeth Sussman at the Whitney Museum of American Art (Sussman, 2005), brought together an engaging range of expansively abstract practices without belabouring the category. Matthew Ritchie absorbs abstract form into possible visual narratives exactly in the terms I set forth in this chapter. About his habits of electic synthesis he writes: "You've got these things…that are still very powerful, like a virus lying around – deactivated now, but if you touch it, you'll probably still get sick" (Sussman, 2005, 58).

20. I would say that they are contrived to look this way, however, especially given Marcaccio's retro interest in performance painting set to music. Echoing Klein to the extent that he is the orchestrator of events, Marcaccio now envisions music/painting happenings such as *Pulsation* (2005), which yield a wall work in an hour.

21. This publication strikes me, however, as sadly superficial. Tim Griffin's text discusses "design" as a "delivery system" (but of what?) in our society, so the notion of contamination and dissemination is clear enough. But both the text and Leeta Harding's photos – which place Halley works in all sorts of settings, from the windows of an office building to the floor of apartment interiors – are no more than stylish. Why are these Halleys everywhere? Are they the same in every context? To me, Halley's infection of society with cells and conduits is here demoted to surface design that we cannot (and do not seem to want to) escape.

22. Connections between the events and fear of contamination of many sorts and the medical discourses of infection are relevant to my project but too extensive to allow analysis here. Artists who in all senses cross these boundaries with abstraction are Andy Warhol in his *Oxidation Paintings* from the late 1970s, Olafur Eliasson, considered here in some detail, and Sigmar Polke, whom I will recognize, incompletely, only for his practices of using toxic substances in his work and influence on Lydia Dona.

23. See Reed (1990) for statements to this effect. Carrier (1994b) and Bal (1999) provide extensive analyses of his relationship to art history.

24. Permission or its refusal in this context depends on once powerful doctrines of media specificity and autonomy. Although these no longer hold, there is sufficient memory in the art world of their sway to allow for surprises such as those provided by Reed. There is a remarkable history of art and art history in film, but its inclusion is more often than not an occasion for mockery. See Barber (1998).

25. Reed is also known for taking off pigment in certain areas of his canvases, a practice that allows us to compare the presence/absence motif of infection with Dona's procedures as well as with the thinning techniques used by Callum Innes.

26. Reed's installation in the mirror room was part of his larger exploration through the "Vampire Study center," established he writes to pursue the question "Is looking at an abstract painting similar to a vampire's not reflecting in a mirror?" (http://thegalleriesatmoore.org/publications/vampirestudy/index.shtml).

27. Fer (2004) provides an excellent account of this exhibition.

28. I borrow the term *discrepant abstraction* from the title of a symposium at inIVA in London, England, in February 2005. I was fortunate enough to participate in this discussion, led by Kobena Mercer, just as I was finishing this book. My sincere thanks for stimulating conversation and generous commentary to coconspirators Kobena Mercer, Kellie Jones, Stanley Abe, David Clarke, and Angeline Morrison.

29. Interview with the artist (http://www.ciac.ca/biennale2000/en/images/Houle.htm).

30. There is a comparison to be made between Houle's politicized use of Newman and that of Frank Bowling in *Whose Afraid of Barney Newman* (1968), where the outlines

of the continent of South America and his family home lift up through the abstract surface.

31. Wallace and Houle are certainly not the only artists to forge a combination of powerful imagery with monochromatic inserts or interlocutors. Warhol is a precedent in work such as *Double Silver Disaster* of 1963 (Tate Modern), in which the electric chair image, though presented on one panel, looks like it is on two contiguous surfaces because the line between the silk screened images divides the surface into what appear as monochrome and pictorial panels.

32. The circumstances surrounding this celebrated case are only thought of as vandalism by some, but that number includes the artist. For a full account, see Senie (2002).

33. On works taking up this challenge, see Py (2003).

34. I visited the gallery shortly after the Rothko went on display and asked the guard standing near this work if the gallery was especially worried about vandalism. She said "no," but I observed that she didn't move, then or later.

Works Cited

Abstraction Now. 2003. Norbert Pfaffenbichler and Sandro Droschl, curators. Exhibition at the Künstlerhaus Wien, August 29–September 28 (http://www.abstraction-now.net/?introduction).

Adcock, Craig E. 1990. *James Turrell: The Art of Light and Space.* Berkeley: University of California Press.

After the Fall: Aspects of Abstract Painting since 1970: March 27–September 7, 1997, Newhouse Center for Contemporary Art. 1997. Staten Island, N.Y.: Snug Harbor Cultural Center.

Alberti, Leon Battista. 1991[1435]. *On Painting.* Trans. Cecil Grayson; with an introduction and notes by Martin Kemp. London: Penguin; New York: Viking Penguin.

Anderson, Fred. 2000. *Crucible of War: The Seven Years' War and the Fate of Empire in British North America, 1754–1766.* With illustrations from the William L. Clements Library. New York: Alfred A. Knopf.

Andrews, Richard. 1992. "1982 Interview with James Turrell." In *James Turrell: Sensing Space*, eds. Richard Andrews and Chris Bruce, 37–41. Catalogue of an exibition held at the Henry Art Gallery, University of Washington, Seattle, Washington, October 9, 1992–January 3, 1993, and Institute of Contemporary Art, University of Pennsylvania, Philadephia, September 10–October 31, 1993. Seattle: Henry Art Gallery, University of Washington.

Ashton, Dore, *et al.* 1996. "Kelly Read." *Artforum International* 35(2): 86–97.

Bal, Mieke. 1999. *Quoting Caravaggio: Contemporary Art, Preposterous History.* Chicago and London: The University of Chicago Press.

Balakhovskaya, Faina, and Zelfira Tregulova. 2004. "Black Square by Kazimir Malevich" (http://www.interros.ru/eng/doyouknow/8/).

Bann, Stephen. 1989. *The True Vine: On Visual Representation and the Western Tradition.* New York: Cambridge University Press.

Barber, Bruce. 1998. "Art History's Significant Other . . . Film Studies." In Cheetham, Holy and Moxey, 262–87.

Barber, Bruce, Serge Guilbaut, and John O'Brian, eds. 1996. *Voices of Fire: Art, Rage, Power, and the State.* Toronto: University of Toronto Press.

Bell, Michael. 2001. *Robert Houle's Palisade.* Published on the occasion of an exhibition held at Carleton University Art Gallery, November 13, 2000–January 28, 2001. Ottawa: Carleton University Art Gallery. Ottawa: Carleton University Art Gallery.

Belting, Hans. 1987. *The End of the History of Art?* Trans. Christopher S. Wood. Chicago: University of Chicago Press.

Benjamin, Andrew E. 1996. *What Is Abstraction?* London: Academy Editions; Lanham, Md.: Distributed in the United States by National Book Network.

———, ed. 1995. *Abstraction.* London: Academy Editions; New York, NY: Distributed in the United States by St. Martin's Press.

Berg, Stephan. 2001. "Technicolor-Vampire." In *David Reed: You Look Good in Blue*, eds. Konrad Bitterli and Stephan Berg, 58–69. Catalogue of exhibition held at Kunstverein St. Gallen Kunstmuseum from September 1 to November 11, 2001; and at Kunstverein Hannover from January 25 to March 31, 2002. Nürenberg: Verlag für moderne Kunst Nürenberg (http://www.davidreedstudio.com/texts_Berg.html)

Bewegliche Teile: Formen des Kinetischen. Moving Parts: Forms of the Kinetic. 2004. Catalogue of an exhibition held at Kunsthaus Graz, October 9, 2004–January 16, 2005 and the Museum Tinguely, March 8–June 26, 2005. Cologne: W. König.

Bois, Yve-Alain. 1999a. "Declaration of Absence: The Non-Compositional Drive in Twentieth-Century Art." Lecture, July 8, University of Rochester.

_____. 1999b. "La Peinture apres l'Abstraction." *Artforum International* 38(4): 144–45.

_____. 1999c. "The Art of Gutai: Missing in Action." *Artforum International* 37(9): 152–53.

_____. 1992a. "The Semiology of Cubism." In *Picasso and Braque: A Symposium*, organized by William Rubin; moderated by Kirk Varnedoe; proceedings edited by Lynn Zelevansky, 169–208. New York: The Museum of Modern Art.

_____. 1992b. "Ellsworth Kelly in France: Anti-Composition in Its Many Guises." In *Ellsworth Kelly: The Years in France, 1948-1954*, eds. Yve-Alain Bois, Jack Cowart and Alfred Pacquement, 9–36. Published in connection with an exhibition organized by and held at the Galerie nationale du Jeu de Paume, Paris, March 17–May 24, 1992, at the Westfälisches Landesmuseum, Münster, June 14–August 23, 1992, and at the National Gallery of Art, Washington, November 1, 1992–January 24, 1993. Washington, D.C.: National Gallery of Art; Munich, Federal Republic of Germany: Prestel-Verlag.

_____. 1991. "The Limit of Almost." In Reinhardt 1991b, 11–33.

_____. 1990. "Strzeminski and Kobro: In Search of Motivation." In *Painting as Model*, 123–55. Cambridge and London: MIT Press.

_____. 1989. "Fontana's Base Materialism." *Art in America* 77(4): 238–49.

_____. 1986. "Painting: The Task of Mourning." In *Endgame: Reference and Simulation in Recent Painting and Sculpture: September 25–November 30, 1986*, Yve-Alain Bois *et al.*, 29–49. Catalogue of an exhibition held September 25–November 30, 1986, at the Institute of Contemporary Art, Boston. Boston, Mass.: Institute of Contemporary Art; Cambridge, Mass.: MIT Press.

_____. 1978. "Malévich, le carré, le degree zéro." *macula* 1: 28–49.

Bois, Yve-Alain, and Rosalind E. Krauss. 1997. *Formless: A User's Guide*. Catalogue of an exhibition held May 21–August 26, 1996, at the Centre Georges Pompidou, Paris. New York: Zone Books; Cambridge, Mass.: Distributed by MIT Press.

Bourriaud, Nicolas. 1990. "L'Art en Tube." *Beaux Arts Magazine* 83 (October): 106–11.

Braide, Michael. 1999. "Science and Metaphor." *Biology and Philosophy* 14: 159–66.

Bronson, AA. 2003. "Copyright, Cash, and Crowd Control: Art and Economy in the Work of General Idea." In General Idea 2003, 25–7.

_____. 1995. Interview with the author, Toronto, December 2.

Brown, Julia. 1985. "Interview with James Turrell." In *Occluded Front: James Turrel*, ed. Julia Brown, 13–47. Published in conjunction with the James Turrell exhibition at The Museum of Contemporary Art, Los Angeles, November 13, 1985–February 9, 1986. Los Angeles: Fellows of Contemporary Art, Los Angeles; Larkspur Landing, Calif.: The Lapis Press.

Buchloh, Benjamin H. D. 2002. "Gerhard Richter's *Eight Gray*: Between *Vorschein* and *Glanz*." In *Gerhard Richter: Eight Gray*, 13–28. Catalogue of an exhibition held at the Deutsche Guggenheim Berlin, October 11, 2002–January 5, 2003. Berlin: Deutsche Guggenheim Berlin.

_____. 2000. *Neo-Avantgarde and Culture Industry: Essays on European and American Art from 1955 to 1975*. Cambridge, Mass.: MIT Press.

_____. 1996. "Divided Memory and Post-Traditional Identity: Gerhard Richter's Work of Mourning." *October* 75: 60–82.

_____. 1995. "Into the Blue: Klein and Poses." *Artforum International* 33(10): 92–7.

_____. 1986. "The Primary Colors for the Second Time: A Paradigm Repetition of the Neo-Avant-garde." *October* 37: 41–52.

Buci-Glucksmann, Christine. 1999. "Icarus Today: The Ephemeral Eye." *Public* 18 (Fall): 1–5 (http://www.yorku.ca/public/public/backissu/v18_1.html).

_____. 1997. "Une Abstraction Impure: De Marcel Duchamp a la Cartographie." *Trans> arts, culture, media* 1–2 (3–4): 130–41.

Buren, Daniel. 1977. *Reboundings: An Essay*. Trans. Philippe Hunt. Brussels: Daled & Gevaert.

Bürger, Peter. 1984. *Theory of the Avant-Garde*. Trans. Michael Shaw; foreword by Jochen Schulte-Sasse. Minneapolis: University of Minnesota Press.

Butterfield, Jan. 1993. *The Art of Light and Space*. New York: Abbeville Press.

Cage, John. 1990. *I-VI/John Cage*. The Charles Eliot Norton Lectures series. Cambridge, Mass.: Harvard University Press.

Carr, C. 2003. "A World of Their Own." *The Village Voice* June 18–June 24, 200: 54.

Carrier, David. 1994a. "Fine Young Cannibal: Fabian Marcaccio." *Artforum International* 33, 1 (September): 84–87.

———. 1994b. *The Aesthete in the City: The Philosophy and Practice of American Abstract Painting in the 1980s*. University Park: Pennsylvania State University Press.

Cavalcanti, H. B. "A Brief History of Zen Judo." n.p. (http://zenjudo.co.uk/zenjudo/main_site/rules_history/zen_hist.htm)

The Charade of Mastery: Deciphering Modernism in Contemporary Art: Whitney Museum of American Art, Downtown at Federal Reserve Plaza, October 31, 1990–January 11, 1991. 1990. New York, N.Y.: Whitney Museum of American Art.

Chassey, Eric de. 2001. *La peinture efficace: une histoire de l'abstraction aux Etats-Unis (1910–1960)*. Paris: Gallimard.

Cheetham, Mark A. 2003. "Acute Serendipity: The Half-Life of Taras Polataiko." *Canadian Art* 20, 3 (Fall): 94–97.

———. 2002a. "Infectious Hauntings: The Transformative Art of Taras Polataiko." In *Taras Polataiko*, 15–23. Catalogue of an exhibition held at the Art Gallery of Hamilton, Feb. 14–April 7, 2002. Hamilton, Ont.: Art Gallery of Hamilton.

———. 2002b. "Mirror Digressions: Narcissus and the Readymade Monochrome." In *Slippage: Taras Polataiko, Lucio Fontana, Gerhard Richter*, 19–25. Catalogue of an exhibition held Nov. 24, 2000–Feb. 11, 2001 at the Art Gallery of Greater Victoria. Victoria, B.C.: Art Gallery of Greater Victoria.

———. 2001. *Kant, Art, and Art History: Moments of Discipline*. Cambridge: Cambridge University Press.

———. 1997. "Recent Rhetorics of Purity in the Visual Arts: Infection, Dissemination, Genealogy." *Paedagogica Historica* (Belgium) 33, 3 (Autumn): 861–80.

———. 1996. *Christian Eckart: Disturbing Abstraction*. Catalogue of an exhibition held at the Artlab, London, Ont., November 14–December 6, 1996 and travelling to other galleries. London, Ont.: ArtLab.

———. 1992. "Purity or Danger: Mondrian's Exclusion of the Feminine and the Gender of Abstract Painting." In *Women and Reason*, eds. Elizabeth D. Harvey and Kathleen Okruhlik, 187–200. Ann Arbor: University of Michigan Press.

———. 1991a. *The Rhetoric of Purity: Essentialist Theory and the Advent of Abstract Painting*. Cambridge New Art History and Criticism series, ed. Norman Bryson. Cambridge: Cambridge University Press.

———. 1991b. *Remembering Postmodernism: Trends in Recent Canadian Art*. Oxford and Toronto: Oxford University Press.

Cheetham, Mark A., and Elizabeth D. Harvey. 2002. "Obscure Imaginings: Visual Culture and the Anatomy of Caves." *Journal of Visual Culture* 1 (1): 105–26.

Cheetham, Mark A., Michael Ann Holy, and Keith Moxey, eds. 1998. *The Subjects of Art History: Historical Objects in Contemporary Perspective*. Cambridge: Cambridge University Press.

Chipp, Herschel B. 1968. *Theories of Modern Art: A Source Book by Artists and Critics*. With contributions by Peter Selz and Joshua C. Taylor. Berkeley: University of California Press.

Clark, T. J. 1999. *Farewell to an Idea: Episodes from a History of Modernism*. New Haven: Yale University Press.

Collingwood, Robin George. 1974 [1938]. *The Principles of Art*. Oxford: Oxford University Press.

Colpitt, Frances, ed. 2002. *Abstract Art in the Late Twentieth Century*. Cambridge, UK; New York, NY, USA: Cambridge University Press.

———. 1988. "Abstraction at Eighty: Theory and Experience of Painting." In *Abstract Options*, ed. Phyllis Plous and Frances Colpitt, 11–36. Catalogue of an exhibition held at the University Art Museum, Santa Barbara, 6 January–26 February, 1989, Mary and Leigh Block Art Gallery, Northwestern University, Evanston, 4 April–18 June, 1989, and at de Saisset Museum, University of Santa Clara, 9 July–3 September, 1989. Santa Barbara, Calif.: University Art Museum, Santa Barbara; Seattle: Distributed by University of Washington Press.

Cone, Michèle. 1990. "The Late Fifties in Europe: A Conversation with Pierre Restany." *Arts Magazine* 64(5): 66–70.

Cooke, Lynne. 1996. "Jessica Stockholder: Your Skin in this Weather Bourne Eye-Threads and Swollen Perfume." n.p. (http://www.diabeacon.org/exhibs/stockholder/skin/index.html)

Coplans, John. 1985. "Projected Light Images." In *Occluded Front: James Turrel*, ed. Julia Brown, 71–93. Published in conjunction with the James Turrell exhibition at The Museum of Contemporary Art, Los Angeles, November 13, 1985–February 9, 1986. Los Angeles: Fellows of Contemporary Art, Los Angeles; Larkspur Landing, Calif.: The Lapis Press.

Cornford, Francis MacDonald. 1941. "Introduction." In *The Republic of Plato*. Translated with introduction and notes by Francis Macdonald Cornford. Oxford: Clarendon Press.

Craven, David. 1991. "Abstract Expressionism and Third World Art: A Post-Colonial Approach to American Art." *Oxford Art Journal* (UK) 14 (1): 44–66.

Critiques of Pure Abstraction. 1995. Mark Rosenthal, guest curator. A traveling exhibition organized by Independent Curators, Incorporated, New York. Catalogue of an exhibition held at the Sarah Campbell Blaffer Gallery, University of Houston, Jan. 28–Mar. 26, 1995 and at 6 other locations through June 15, 1997. New York: Independent Curators Inc.

Crone, Rainer, and David Moos. 1991. *Kazimir Malevich: The Climax of Disclosure*. Chicago: University of Chicago Press.

Crow, Thomas, *et al.* 1997. "This Is Now: Becoming Robert Rauschenberg." *Artforum International* 36(1): 94–101.

———. 1986. "The Return of Hank Herron." In *Endgame: Reference and Simulation in Recent Painting and Sculpture: September 25–November 30, 1986*, Yve-Alain Bois *et al.*, 11–27. Catalogue of an exhibition held September 25–November 30, 1986, at the Institute of Contemporary Art, Boston. Boston, Mass.: Institute of Contemporary Art; Cambridge, Mass.: MIT Press.

Danto, Arthur C., *et al.* 2003. "The Mourning After." *Artforum International* 41(7): 206–11.

———. 1997. *After the End of Art: Contemporary Art and the Pale of History*. Princeton, NJ: Princeton University Press.

———. 1981. *The Transfiguration of the Commonplace: A Philosophy of Art*. Cambridge, Mass.: Harvard University Press.

Davis, Neil T. 1978. "Fata Morgana." Article no. 261, Sept. 1 (http://www.gi.alaska.edu/ScienceForum/ASF2/261.html).

de Duve, Thierry. 2001. *Look: 100 Years of Contemporary Art*. Trans. Simon Pleasance and Fronza Woods. Revised and enlarged edition of the book published in French and Dutch on the occasion of the exhibition *Voici, 100 ans d'art contemporain*, Palais des beaux-arts, Brussels, November 23–January 28, 2001. Ghent: Ludion.

———. 1990. "The Monochrome and the Blank Canvas." In *Reconstructing Modernism: Art in New York, Paris, and Montreal, 1945–1964*, ed. Serge Guilbaut, 244–310. Cambridge, Mass.: MIT Press.

———. 1989. "Yves Klein or the Dead Dealer." Trans. Rosalind Krauss. *October 49* (Summer): 73–90.

de Kooning, Elaine. 1957. "Pure Paints a Picture." *Art News* 56(4): 85–7.

Demosfenova, Galina, L. 1998. "Predislovie." *Kazimir Malevich: Sobranie sochinenii v piati tomakh*, redaktsionnaia kollegiia, D. V. Sarabianov (predsedatel) *et al.*, t. 2, red. G. L. Demosfenova i A. S. Shatskikh, 7–22. ["Preface." In Kazimir Malevich, *Collected Works in Five Volumes*, ed. D. V. Sarabianov *et al.*, vol. 2, eds. G. L. Demosfenova and A. S. Shatskikh, 7–22.] Moscow: Gilea.

Derrida, Jacques. 1982. "White Mythology: Metaphor in the Text of Philosophy." In *Margins of Philosophy*, 207–71. Trans. Alan Bass. Chicago: University of Chicago Press.

––––––. 1987. *The Truth in Painting*. Trans. Geoff Bennington and Ian McLeod. Chicago: University of Chicago Press.

Didi-Huberman, Georges. 1999. "The Fable of the Place." In *James Turrell: The Other Horizon*, ed. Peter Noever, 45–56. Catalogue of an exhibition held Dec. 2, 1998–Mar. 21, 1999, at the Österreichisches Museum für Angewandte Kunst in Vienna. Ostfildern-Ruit, Germany: Cantz; New York, NY: Distribution in the United States, D.A.P.

Dona, Lydia. 1991. "Interview with Klaus Ottmann." *Journal of Contemporary Art*. n.p. (http://www.jca-online.com/dona.html)

Douglas, Charlotte. 1994. *Kazimir Malevich*. New York, N.Y.: H. N. Abrams.

––––––. 1991. "Biographical Outline." In *Malevich: Artist and Theoretician*, 8–24. Trans. Sharon McKee; text edited, introduced and commented by Galina Demosfenova. Paris: Flammarion.

––––––. 1989. "Behind the Suprematist Mirror." *Art in America* 77, 9(September): 164–77.

––––––. 1984. "Evolution and the Biological Metaphor in Modern Russian Art." *Art Journal* 44 (Summer): 153–61.

––––––. 1980. *Swans of Other Worlds: Kazimir Malevich and the Origins of Abstraction in Russia*. Ann Arbor, MI: UMI Research Press, 1980.

Eckart, Christian. (http://www.christianeckart.com)

Eco, Umberto. 1984. *Semiotics and the Philosophy of Language*. Bloomington: Indiana University Press.

Einbildung – Das Wahrnehmen in der Kunst: Kunsthaus Graz am Landesmuseum Joanneum Okt 25, 2003–Jan 18, 2004. 2003. Herausgeber Peter Pakesch. Köln: König.

Eliasson, Olafur. 2003. *Olafur Eliasson: The Weather Project*. Ed. Susan May. Catalogue of an exhibition held at Tate Modern, London, October 16, 2003–March 21, 2004. London: Tate.

––––––. 2001a. *Olafur Eliasson: Your Only Real Thing is Time*. Ed. Jessica Morgan. Catalogue of an exhibition held at the Institute of Contemporary Art, Boston, January 24–April 1. Ostfildern-Ruit: Hatje Cantz Verlag; Boston, MA: Institute of Contemporary Art.

––––––. 2001b. *Projects 73: Olafur Eliasson–Seeing Yourself Sensing*. Exhibition brochure, n.p. New York: MoMA.

––––––. 2001c. *Olafur Eliasson: Surroundings Surrounded. Essays on Space and Science*. Ed. Peter Weibel. Published on the occasion of an exhibition held at Neue Galerie am Landesmuseum Joanneum, Graz, Austria, March 30–May 21, 2000 and ZKM Center for Art and Media, Karlsruhe, Germany, May 31–August 26, 2001. Graz, Austria: Neue Galerie am Landesmuseum Joanneum; Cambridge: MIT Press.

Epperlein, Beate. 1997. *Monochrome Malerei: zur Unterschiedlichkeit des vermeintlich Ähnlichen*. Nürnberg: Verlag für Moderne Kunst.

Feinstein, Roni. 1986. "The Early Work of Robert Rauschenberg: The White Paintings, the Black Paintings, and the Elemental Sculptures." *Arts Magazine* 61 (September): 28–37.

Fer, Briony. 2004. *The Infinite Line: Re-making Art After Modernism*. New Haven, Conn.; London: Yale University Press.

––––––. 1997. *On Abstract Art*. New Haven and London: Yale University Press.

Foster, Hal, ed. 2002a[1998]. *The Anti-Aesthetic: Essays on Postmodern Culture*. New York: New Press.

_____. 2002b. *Design and Crime: And Other Diatribes*. London and New York: Verso.

_____. 1996. *The Return of the Real: The Avant-Garde at the End of the Century*. Cambridge: MIT Press.

Fineman, Mia. 2004. "Art Attacks." *New York Times*, December 12: 4.

Franz, Erich. 1996. "The Presence of the Absolute." In *In Quest of the Absolute*, exhibition catalogue, 13–89. Trans. Mary Fran Gilbert and Keith Bartlett. New York: Peter Blum.

Fried, Michael. 1998. "An Introduction to My Art Criticism." In Michael Fried, *Art and Objecthood: Essays and Reviews*, 1–74. Chicago: University of Chicago Press.

Freud, Sigmund. 2003[1919]. *The Uncanny*. Trans. David McLintock; with introduction by Hugh Haughton. London: Penguin.

Gagnon, F.-M., L. Dorais, and P. S. Doyon. "A Borduas Chronology." *ArtsCanada* (Canada) 35, 4 (December 1978–January 1979): 2–5.

Gamboni, Dario. 1997. *The Destruction of Art: Iconoclasm and Vandalism since the French Revolution*. London: Reaktion Books.

General Idea (GI). 2003. *General Idea Editions: 1967–1995*. Ed. Barbara Fischer. Catalogue raisonné of the editions produced by General Idea, 1967–1994, to accompany an exhibition held at the Blackwood Gallery, University of Toronto at Mississauga, Jan. 16–Feb. 16, 2003, and travelling to other galleries. Mississauga, Ont.: Blackwood Gallery.

_____. 1995. *XXX Voto (to the Spirit of Miss General Idea)*. Montreal: Galerie René Blouin; Toronto: S. L. Simpson Gallery.

_____. 1992. *General Idea: Pharma©opia, 15 setembre–10 novembre 1992, Centre d'Art Santa Mònica, Barcelona*. Catalogue published in conjuction with the exhibition "Pharmacopia" at the Centre d'Art Santa Mònica, Barcelona. The same exhibition was shown under the title "Fin de siècle" at Württembergischer Kunstverein Stuttgart, Apr. 30–June 14, 1992 and other institutions in Europe and the United States through Sept. 1993. Barcelona: Generalitat de Catalunya, Departament de Cultura.

_____. 1984. *General Idea, 1968–1984: [Ausstellung], Kunsthalle Basel, [30 Oktober–4 November 1984]; Stedelijk Van Abbemuseum Eindhoven*. Basel: Kunsthalle.

Gibson, Ann. 1992. "Color and Difference in Abstract Painting: The Ultimate Case in Monochrome." *Genders* (U.S.A.) 13 (Spring): 123–52.

Gilbert-Rolfe, Jeremy. 1998. "Notes on Being Framed by a Surface." *Art/Text* (Australia) 62 (August–October): 42–5.

_____. 1997a. "Blankness as Signifier." *Critical Inquiry* 24 (Autumn): 159–75.

_____. 1997b. "How to be Tangential: Ellsworth Kelly and American Art." *Art/Text* (Australia) 57 (May–July): 58–65.

_____. 1995. *Beyond Piety: Critical Essays on the Visual Arts, 1986–1993*. Cambridge Studies in New Art History and Criticism. Cambridge and New York: Cambridge University Press.

Godet, Robert J. 1952. *Tout Le Judo: histoire, technique, philosophie, anecdotes*. Paris: Amiot-Dumont.

Golden, Janet, and Charles E. Rosenberg, eds. 1992. *Framing Disease: Studies in Cultural History*. New Brunswick, N.J.: Rutgers University Press.

Goossen, E. C. 1968. *The Art of the Real: USA, 1948–1968*. Catalogue of an exhibition, July 3–Sept. 8, 1968. New York: Museum of Modern Art.

Gradmann, Christopf. 2000. "Invisible Enemies: Bacteriology and the Language of Politics in Imperial Germany." *Science in Context* 13(1): 9–30.

Graham, Dan. 1999. *Two-Way Mirror Power: Selected Writings by Dan Graham on His Art*. Ed. Alexander Alberro. Cambridge, MA: MIT Press.

Graziani, Ron. 2004. *Robert Smithson and the American Landscape*. Cambridge; New York: Cambridge University Press.

Greenberg, Clement. 1986–1993. *The Collected Essays and Criticism*. 4 vols. Ed. John O'Brian. Chicago: University of Chicago Press.

Gregory, Richard Langton. 1997. *Mirrors in Mind*. Oxford; New York: W. H. Freeman/ Spektrum.

Griffin, Tim. 2002. *Peter Halley: Contamination*. Milano: A. Cetti Serbelloni.

Grynsztejn, Madeleine. 2002. *Olafur Eliasson*. With Daniel Birnbaum and Michael Speaks. London: Phaidon.

Guilbaut, Serge. 1990. "Postwar Painting Games: The Rough and the Slick." In *Reconstructing Modernism: Art in New York, Paris, and Montreal, 1945–1964*, ed. Serge Guilbaut, 30–79. Papers from the "Hot Paint for Cold War Symposium," held at the University of British Columbia, Vancouver, Canada, September 1986. Cambridge, Mass.: MIT Press.

Guston, Philip. 1960. "The Philadelphia Panel." *It Is* 5 (Spring): 34–38.

Hafif, Marcia. 1989. "True Colors: La Couleur seule: l'experience du monochrome; Various Locations, Lyons." *Art in America* 77 (June): 128–39.

Halley, Peter. 1997a. *Recent Essays 1990–1996*. New York: Edgewise Press.

————. 1997b. *Peter Halley: Collected Essays, 1981–1987*. Zurich and New York: Bruno Bischofberger Gallery/Sonnabend Gallery.

Hanna, Deirdre. 1995. "General Idea's Fab Last Stand Mocks Modernism." *Now* (Toronto), June 8: 14.

Harrison, Charles. 2001. *Essays on Art and Language*. Cambridge: MIT Press.

Hatch, John. 1995. "Nature's Laws and the Changing Image of Reality in Art and Physics: A Study of the Impact of Modern Physics on the Visual Arts, 1910–1940." Thesis (Ph.D.). Essex: University of Essex.

Hegel, G. W. F. 1967[1931]. *Phenomenology of Spirit*. Trans. J. B. Baille. New York: Harper & Row.

Herbert, Lynne M. 1998. "Spirit and Light and the Immensity Within." In *James Turrell: Spirit and Light*, Lynn M. Herbert *et al.*, 11–23. Published to accompany the exhibition, June 6–July 26, 1998, at the Contemporary Arts Museum, Houston. Houston: Contemporary Arts Museum.

Herrigel, Eugen. 1999. *Zen in the Art of Archery*. Trans. R. F. C. Hull; foreword by D. T. Suzuki. New York: Vintage.

Hockney, David. 2001. *Secret Knowledge: Rediscovering the Lost Techniques of the Old Masters*. London: Thames & Hudson.

hooks, bell. 1995. "The Radiance of Red: Blood Works." In *Andres Serrano: Body and Soul*, n.p. New York, NY: Takarajima Books.

Hopkins, David. 2000. *After Modern Art: 1945–2000*. Oxford; New York: Oxford University Press.

Hopps, Walter, ed. 1991. *Robert Rauschenberg: The Early 1950s*. Published in conjunction with an exhibition held at the Corcoran Gallery of Art, Washington, D.C., June 15– Aug. 11, 1991 and at three other U.S. museums through Aug. 2, 1992. Houston: The Menil Collection: Houston Fine Art Press.

Hopps, Walter, and Susan Davidson, eds. 1997. *Robert Rauschenberg: A Retrospective*. Catalogue of an exhibition held simultaneously at the Solomon R. Guggenheim Museum, the Guggenheim Museum Soho, and the Guggenheim Museum at Ace Gallery, N.Y., September 19, 1997–January 7, 1998, and at three other museums through Febuary 1999. New York: Guggenheim Museum.

Houle, Robert. 2000. Peggy Gale's interview with Robert Houle, July, Toronto (http://www. ciac.ca/biennale2000/en/visuels-artistes-houle.htm)

Hübl, Michael. 2001. "The Sublime Was Yesterday: Über das Erhabene: Mark Rothko, Yves Klein, James Turrell." *Kunstforum International* 157: 274–76.

Hybrid Neutral: Modes of Abstraction and the Social. 1988. Tricia Collins and Richard Milazzo, guest curators. Exhibition catalogue. New York: Independent Curators Incorporated.

Joseph, Branden Wayne. 2003. *Random Order: Robert Rauschenberg and the Neo-Avant-Garde*. Cambridge, Mass.: MIT Press.

———. 2000. "White on White." *Critical Inquiry* 27, 1 (Autumn): 90–121.

———. 1997a. "John Cage and the Architecture of Silence." *October* 81: 80–104.

———. 1997b. "Robert Morris and John Cage: Reconstructing a Dialogue." *October* 81: 59–69.

Kant, Immanuel. 1987[1790]. *Critique of Judgment*. Trans. Werner S. Pluhar. Indianapolis: Hackett.

Karasik, Irina, comp. 2000. *V kruge Malevicha: soratniki, ucheniki, posledovateli v Rossii 1920–1950-kh*. [In Malevich's Circle: Confederates, Students, Followers in Russia, 1920s–1950s.] Gosudarstvennyi russkii muzei, Sankt-Peterburg (Russia): Palace Editions.

Kay, Carolyn. 2002. *Art and the German Bourgeoisie: Alfred Lichtwark and Modern Painting in Hamburg, 1886–1914*. Toronto: University of Toronto Press.

Keller, Evelyn Fox. 1995. *Refiguring Life: Metaphors of Twentieth-Century Biology*. New York: Columbia University Press.

Kim, Byron. n.d. "Artist's Statement." New York: Protetch Gallery.

King, Elaine A. 2002. "Into the Light: A Conversation with James Turrell." *Sculpture* 21, 9 (November): 24–31.

Klein, Yves. 1999. *Tinguely's Favorites: Yves Klein/Museum Jean Tinguely Basel*. Catalogue of an exhibition held at the Museum Jean Tinguely Basel, Basel, Switzerland, December 1, 1999–April 9, 2000. Basel, Switzerland: Museum Jean Tinguely Basel.

———. 1974. *Yves Klein, 1928–1962: Selected Writings*. Eds. Jacques Caumont and Jennifer Gough-Cooper; trans. Barbara Wright. London: Tate Gallery Publications.

———. 1973 [1961]. "Truth becomes Reality." In *Zero*, 91–94.

———. 1954. *Les Fondements du Judo*. Paris: B. Grasset.

Kostelanetz, Richard. 1968. "A Conversation with Robert Rauschenberg." *Partisan Review* 25, l (Winter): 92–109.

Krauss, Rosalind E., ed., *et al.* 1997. "October: The Second Decade, 1986–1996." Cambridge, Mass.: MIT Press.

———. 1981 [1977]. *Passages in Modern Sculpture*. Cambridge, Mass.: MIT Press.

Kunst-und Ausstellungshalle der Bundesrepublik Deutschland. 2002. *Virus! Internationales symposium, 17–19. Januar: Geschichte, Medizin, Computer, Politik, Kunst* (http://www2. kah-bonn.de/fo/virus/programm.htm)

Kuspit, Donald B. 1986. "Concerning the Spiritual in Contemporary Art." In *The Spiritual in Art: Abstract Painting 1890–1985*, eds. Maurice Tuchman, Judi Freeman, and Carel Blotkamp, 313–25. Catalogue of an exhibition at the Los Angeles County Museum of Art (opening Nov. 1986); Museum Contemporary Art, Chicago; and Haags Gemeente-museum, the Hague. New York: Abbeville Press.

Latour, Bruno. 2004. *Politics of Nature: How to Bring the Sciences into Democracy*. Trans. by Catherine Porter, Cambridge, Mass.: Harvard University Press.

Lebredt, Gordon. 2004. Correspondence with the author, February.

Linsley, Robert. 2000. "Mirror travel in the Yucatan: Robert Smithson, Michael Fried, and the New Critical Drama." *Res* (Cambridge, Mass.) 37(Spring): 7–30.

Lippard, Lucy R. 1971[1968]. "The Dematerialization of Art." In *Changing: Essays in Art Criticism*, 255–76. New York: Dutton.

———. 1967. "The Silent Art." *Art in America* 55, 1 (January–February): 58–63.

———. 1966. "Eccentric Abstraction." *Art International* 10, 9 (November 20): 28–40.

Liu, An Te. 2003. "Tackiness, Anti Power, and the Surface-Space of Vert Ping Pong: A Specific Study of Painting and Architecture." Artist's proposal.

Looper, Matthew G. 1995. "The Pathology of Painting: Tuberculosis as a Metaphor in the Art Theory of Kazimir Malevich." *Configurations* 3(1): 27–46 (http://www.tamu.edu/mocl/picasso/study/3_flooper.html)

Lum, Ken. 1998. *Ken Lum, photo-mirrors = Ken Lum, photos-miroirs = Ken Lum, foto-espelhos*. Catalogue of an exhibtion at the XXII Bienal Internacional de São Paulo, Oct. 3–Dec. 13, 1998, and at the Walter Phillips Gallery. Banff: Banff Centre for the Arts, Walter Phillips Gallery.

Lyotard, Jean François. 1984. *The Postmodern Condition: A Report on Knowledge*. Trans. Geoff Bennington and Brian Massumi; foreword by Frederick Jameson. Manchester: Manchester University Press.

Mack, Heinz. *Light and Color*. (http://www.mack-kunst.com/ homepage.html)

———. 1973[1961]. "The Sahara Project." In *Zero*, 180–184.

Madoff, Steven Henry. 1992. "A New Lost Generation." *ARTnews* (U.S.A.) 91, 4 (April): 72–77.

———. 1986. "The Return of Abstraction." *ARTnews* (U.S.A.) 85, 1 (January): 80–85.

Malevich, Kazimir. 2002. *The White Rectangle: Writings on Film*. Ed. Oksana Bulgakowa. Berlin: Potemkin Press.

———. 1993[1977]. *Le miroir suprématiste: tous les articles parus en russe de 1913 à 1928: avec des documents sur le suprématisme*. Traduits et annotés par Jean-Claude et Valentine Marcadé; préface d'Emmanuel Martineau. Lausanne: l'Age d'homme.

———. 1989. "Malevich's Teaching Diagrams." *Art and Design*, 5(6): 37–44.

———. 1986. *Écrits: Kazimir Malevitch*. Présentés par Andréi Nakov; traduits du russe par Andrée Robel. Paris: G. Lebovici.

———. 1975. *Malevich: The Graphic Work, 1913–1930: A Print Catalogue Raisonné*. Donald Karshan, in collaboration with Stedelijk Museum, Amsterdam, Musée d'art moderne de la ville de Paris, Städtische Galerie im Lenbachhaus, Munich. Published on the occasion of the exhibition held at the Israel Museum, November 1975–January 1976. Jerusalem: Israel Museum.

———. 1970. *Malevich: Catalogue Raisonné of the Berlin exhibition, 1927, Including the Collection in the Stedelijk Museum Amsterdam, with a General Introduction to His Work*. Comp. Troels Andersen. Amsterdam: Stedelijk Museum.

———. 1968–1978. *K. S. Malevich: Essays on Art*. Ed. Troels Andersen. 4 vols. V. 1, 1915–1928, and v. 2, 1928–1933, trans. Xenia Glowacki-Prus and Arnold McMillin (1968); v. 3, *The World as Non-Objectivity: Unpublished Writings, 1922–1925*, trans. Xenia Glowacki-Prus and Edmund T. Little (1976); v. 4, *The Artist, Infinity, Suprematism: Unpublished writings, 1913–1933*, trans. Xenia Glowacki-Prus (1978). Copenhagen: Borgen.

———. 1959. *The Non-Objective World*. Trans. from the German by Howard Dearstyne. Chicago: P. Theobald.

Matiushin, Mikhail. 1976. "Russkie kubo-futuristi." [The Russian Cubo-Futurists."] In *K istorii russkogo avangarda (The Russian Avant-Garde)*, Nikolai Khardzhiev, Kazimir Malevich, Mikhail Matiushin; s poslesloviem Romana Jakobsona, 135–58. Stockholm: Gileia; distributed by Almqvist & Wiksell International.

May, Susan. 2003. "Meteorologica." In *Olafur Eliasson: The Weather Project*, ed. Susan May, 15–28. Catalogue of an exhibition held at Tate Modern, London, October 16, 2003–March 21, 2004. London: Tate.

———. 1996. "The Tomb of the Zombie: AICA 1994." *Art Criticism* (U.S.A.) 11(1): 62–9.

McEvilley, Thomas. 1993. *The Exiles Return: Toward a Redefinition of Painting for the Post-Modern Era*. Cambridge (England) and New York: Cambridge University Press.

———. 1982a. "Yves Klein: Conquistador of the Void." In *Yves Klein, 1928–1962: A Retrospective*, 19–87. Catalogue of an exhibition at Rice Museum, Houston, Febuary 5–May 2, 1982, and elsewhere June 18, 1982–May 1983. Houston: Institute for the Arts, Rice University; New York: Arts Publisher.

———. 1982b. "Yves Klein and Rosicrucianism." In *Yves Klein, 1928–1962: A Retrospective*, 238–54. Catalogue of an exhibition at Rice Museum, Houston, Feb. 5–May 2, 1982, and elsewhere June 18, 1982–May, 1983. Houston: Institute for the Arts, Rice University; New York: Arts Publisher.

McKendry, Maxime de la Falaise. 1976. "Robert Rauschenberg Talks to Maxime de la Falaise McKendry." *Interview* (New York) 6(5): 34–6.

Melchior-Bonnet, Sabine. 2001. *The Mirror: A History*. Trans. by Katharine H. Jewett, with a preface by Jean Delumeau. New York: Routledge.

Melville, Stephen W. 2001. "Counting / As / Painting." In *As Painting: Division and Displacement*, eds. Philip Armstrong, Laura Lisbon, and Stephen Melville, 1–26. Catalogue of an exhibition held May 11–August 12, 2001 at Wexner Center for the Arts, the Ohio State University, Columbus, Ohio. Columbus, Ohio: Wexner Center for the Arts, The Ohio State University; Cambridge, Mass.: MIT Press.

———. 1996. *Seams: Art as a Philosophical Context*. Edited and introduced by Jeremy Gilbert-Rolfe. Amsterdam: G+B Arts.

Miller, Jonathan. 1998. *On Reflection*. Ed. Valerie Mendes. Published to accompany an exhibition entitled *Mirror image: Jonathan Miller on Reflection*, at the National Gallery, London, September 16–December 13, 1998, London: National Gallery Publications; New Haven, Conn.: Distributed by Yale University Press.

Mitchell, W. J. T. 1989. "Ut Pictura Theoria: Abstract Painting and the Repression of Language." *Critical Inquiry* (U.S.A.) 15(2): 348–71.

———. 1987 [1986]. *Iconology: Image, Text, Ideology*. Chicago: University of Chicago Press.

Molnar, François. 1992. "Yves Klein le polychrome." *Revue d'Esthétique* 21: 71–80.

Monochrome: Art of the Single Color. 2005. Barbara Rose *et al*. Museo Nacional Centro de Arte Reina Sofia, Madrid, 2004. London: Merrell Publishers Ltd.

Moos, David, *et al*. 1997. *New York Abstraction: A Symposium*. Guelph, Ontario: Macdonald Stewart Art Centre.

Morra, Joanne. 2002. "Rauschenberg's Skin: Autobiography, Indexicality, Auto-Eroticism." *New Formations* 46(Spring): 48–63.

Morris, Robert. 2000. *From Mnemosyne to Clio: The Mirror to the Labyrinth (1998–1999–2000)*. Milano: Skira; Lyon: Musèe d'art contemporain de Lyon.

———. 1979. *Robert Morris, Mirror Works 1961–1978*. Exhibition catalogue. New York: Leo Castelli.

Morrison, Angeline Dawn. 2002. "Liminal Blankness: Mixing Race and Space in Monochrome's Psychic Surface." Thesis (Ph.D.). Plymouth: University of Plymouth.

Nakov, Andrei B. 2002. *Kazimir Malewicz: catalogue raisonné*. Paris: A. Biro.

Nasgaard, Roald. 2001. *Pleasures of Sight and States of Being: Radical Abstract Painting Since 1990*. Catalogue of an exhibition held at Florida State University Museum of Fine Arts, Febuary 16–April 1, 2001, and Appleton Museum of Art, Ocala, Florida, May 1–June 25, 2001. Tallahassee, Fla.: Florida State University Museum of Fine Arts, School of Visual Arts & Dance.

———, *et al*. 1988. *Gerhard Richter: Paintings*. Exhibition coorganized by I. Michael Danoff, Museum of Contemporary Art, Chicago and Roald Nasgaard, Art Gallery of Ontario, Toronto. With an essay by I. Michael Danoff and an interview with Gerhard Richter by Benjamin H. Buchloh; edited by Terry A. Neff. Exhibition held at the Art Gallery of Ontario, Toronto, April 29–July 10, 1988, and at three other museums, September 17, 1988–May 28, 1989. New York, N.Y.: Thames and Hudson.

Nekes, Werner, und Landesmuseum Joanneum. 2003–2004. *Die Wunderkammer des Sehens: Aus der Sammlung Werner Nekes*. Einl. von Peter Weibel. Katalog. Landesmuseum Joanneum, Bild-und Tonarchiv, Museumgebäude, November 7, 2003–March 21, 2004. Graz: Landesmuseum Joanneum.

"NSK State in Time." (http://www.nskstate.com/athens/irwin/texts/nsk-state-in-ime.asp)

Obrist, Hans Ulbrich. "The White Website by Hans Bernhard: On the Iconoclasm of Modern Art." (http://www.ubermorgen.com/THE_WHITE_WEBSITE/HANS_ULRICH_OBRIST_WHITE/ HANS_ULRICH_OBRIST_BERNHARD.HTM)

O'Doherty, Brian. 1999. *Inside the White Cube: The Ideology of the Gallery Space*. Introduction by Thomas McEvilley. Berkeley: University of California Press.

Ohlenkamp, Neil. 1999. "Kodokan Judo." (http://www.judoinfo.com/jhist1.htm)

Ovid. 1916. *Metamorphoses*. With an English translation by Frank Justus Miller. Loeb Classical Library. London: Heinemann.

Paparoni, Demetrio. 2004. Correspondence with the author, May 6.

Pelzer, Birgit. 2001. *Dan Graham*. With Mark Francis and Beatriz Colomina. London: New York: Phaidon.

Pendergrast, Mark. 2003. *Mirror, Mirror: A History of the Human Love Affair with Reflection*. New York: Basic Books.

Petersen, Stephen. 2000. "From Matter to Light: Fontanas Spatial Concepts and Experimental Photography." *Art on Paper* (New York) 4, 4 (March–April): 52–7.

Phillips, Christopher. 1995. "All about Yves." *Art in America* 83(5): 86–91.

Philostratus the Athenian. 1960. *Imagines; Callistratus, Descriptions*. With an English translation by Arthur Fairbanks. The Loeb Classical Library. Cambridge: Harvard University Press.

Piene, Otto. 1973. "On the Purity of Light." In *Zero*, 46–7.

Pistoletto, Michelangelo. 2000. *Michelangelo Pistoletto*. Co-ordinaton Anna Jiménez Jorquera and Anna Tetas. Trans. Michael Benis and Paul Hammond. Catalogue of an exhibition held at the Museu d'Art Contemporani de Barcelona (MACBA), January 27–March 29, 2000. Barcelona: Actar: Museu d'Art Contemporani de Barcelona (MACBA).

Polataiko, Taras. 2000. Correspondence with the author, May 18.

———. 1995a. Correspondence with the author, Dec. 13.

———. 1995b. Correspondence with the author, Dec. 12.

———. 1995c. Correspondence with the author, Dec. 6.

———. 1995d. Artist's Statement.

Postmark: An Abstract Effect. 1999. Curated by Bruce W. Ferguson and Louis Grachos. Catalogue of an exhibition held at SITE, Santa Fe, March 27–June 13, 1999. Santa Fe: Site Sante Fe.

Potts, Alex. 2004. "Tactility: The Interrogation of Medium in Art of the 1960s." *Art History* (UK) 27, 2 (April): 282–304.

Pour un art concret: donation Albers-Honegger. Konkrete Kunst: Schenkung Albers-Honegger. 2004. Ed. Michel Baverey. Paris: Isthme: Centre national des arts plastiques.

Py, Jacques. 2003. *Qui a peur du rouge, du jaune et du bleu?*. Catalogue of exhibition held at Centre d'art de l'Yonne, June 2–Sept. 28, 2003. Auxerre: Centre d'art de l'Yonne.

Rauschenberg, Robert. 1987. *Rauschenberg: An Interview with Robert Rauschenberg by Barbara Rose*. Elizabeth Avedon editions: vintage contemporary artists. New York: Vintage Books.

———. 1976. *Robert Rauschenberg*. Eds. Carroll S. Clark and Kathleen A. Preciado. Prepared in conjunction with an exhibition organized by the National Collection of Fine Arts, Smithsonian Institution, and shown at National Collection of Fine Arts, Washington, D.C. [and other museums] October 30, 1976–January 15, 1978. Washington: National Collection of Fine Arts, Smithsonian Institution.

Reed, David. 1990. *David Reed*. Ed. William S. Bartman. Los Angeles, Calif.: A.R.T. Press / William S. Bartman Foundation.

Reichman, Lee B., and Janice Hopkins Tanne. 2002. *Timebomb: The Global Epidemic of Multi-Drug Resistant Tuberculosis*. New York: McGraw-Hill.

Reinhardt, Ad. 1991a. *Art-as-Art: The Selected Writings of Ad Reinhardt*. Ed. and with an introduction by Barbara Rose. Berkeley: University of California Press.

———. 1991b. *Ad Reinhardt*. Published to accompany an exhibition at the Museum of Modern Art, New York, May 30–September 2, 1991, and the Museum of Contemporary Art, Los Angeles, October 13, 1991–January 5, 1992. New York, N.Y.: Rizzoli International Publications.

Restany, Pierre. 2000. *Avec le Nouveau Réalisme, sur l'autre face de l'art*. Nimes: Éditions Jacqueline Chambon.

_____. 1990. *Yves Klein: le feu au cœur du vide*. Paris: La Différence.

Reynolds, Ann Morris. 2003. *Robert Smithson: Learning from New Jersey and Elsewhere*. Cambridge, Mass.: MIT Press.

Reza, Yasmina. 1996. *Art*. Trans. Christopher Hampton. London: Faber.

Richter, Gerhard. 1995. *The Daily Practice of Painting: Writings and Interviews, 1962–1993*. Ed. Hans-Ulrich Obrist. Trans. David Britt. London: Thames and Hudson: Anthony d'Offay Gallery.

_____. 1991. *Gerhard Richter: Mirrors*. Exhibition held April 22–June 17 at Anthony d'Offay Gallery, London. London: Anthony d Offay Gallery.

Riout, Denys. 1996. *La peinture monochrome: histoire et archéologie d'un genre*. Nîmes: Editions J. Chambon; Arles: Diffusion, Harmonia mundi.

Rivers, Larry. 1967. "Blues for Yves Klein." *Art News* 65, 10 (Febuary): 75–6.

Roberts, Jennifer L. 2004. *Mirror-Travels: Robert Smithson and History*. New Haven, Conn.: Yale University Press.

Robertson, Sheila. 1995. "Reflections connect two bodies of work." *The Star Phoenix*, Saskatoon, Saskatchewan, Canada, November 25: C18.

Rose, Barbara. 1991. "Introduction." In Reinhardt 1991a, xi–xvii.

Rosenthal, Mark. 1996. *Abstraction in the Twentieth Century: Total Risk, Freedom, Discipline*. Catalogue of an exhibition held at the Guggenheim Museum, Febuary 9–May 12, 1996. New York, N.Y.: Guggenheim Museum; Distributed by Abrams.

Rosenthal, Nan. 1982. "Assisted Levitation: The Art of Yves Klein." In *Yves Klein, 1928–1962: A Retrospective*, 89–135. Catalogue of an exhibition at Rice Museum, Houston, February 5–May 2, 1982, and elsewhere June 18, 1982–May, 1983. Houston: Institute for the Arts, Rice University; New York: Arts Publisher.

Rot, gelb, blau: die Primärfarben in der Kunst des 20. Jahrhunderts. 1988. Herausgegeben von Bernhard Bürgi [im Auftrag des Kunstvereins St. Gallen in Zusammenarbeit mit Veit Loers, Museum Fridericianum Kassel]. Stuttgart: Gerd Hatje; Teufen: A. Niggli.

Rubenstein, Raphael. 1997. "Abstraction out of Bounds." *Art in America* 85, 11 (November): 104–16.

_____. 1994. "Abstraction in a Changing Environment." *Art in America* 82, 10 (October): 102–9.

Ryan, David. 2002. *Talking Painting: Dialogues with Twelve Contemporary Abstract Painters*. London and New York: Routledge.

Schapiro, Meyer. 1978[1937]. "The Nature of Abstract Art." In *Modern Art: 19th and 20th Centuries. Selected Papers*, Meyer Schapiro, 185–211. New York: G. Braziller.

Schenker, Christoph. 1991. "Empire des Lumieres." In *James Turrell: First Light*, eds. Josef Helfenstein and Christoph Schenker, 69–77. Trans. David Britt. Publikation anlässlich der Ausstellung, James Turrell, First light and Catso White, Kunstmuseum Bern, January 8–March 10, März 1991. Stuttgart: Cantz.

Schwabsky, Barry. 1997. *The Widening Circle: Consequences of Modernism in Contemporary Art*. Cambridge and New York: Cambridge University Press.

Schwarz, Michael, ed. 1998. *Licht und Raum: Elektrisches Licht in der Kunst des 20. Jahrhunderts*. Köln: Wienand.

Sedlmayr, Hans. 1958[1948]. *Art in Crisis: The Lost Center*. Trans. Brian Battershaw. Chicago: H. Regnery Co.

Senie, Harriet F. 2002. *The Tilted Arc Controversy: Dangerous Precedent?* Minneapolis: University of Minnesota Press.

Sennett, Richard. 1970. *The Uses of Disorder: Personal Identity and City Life*. New York: Knopf.

Serrano, Andres. 1993. "Interview." In *Talking Art I: Chris Burden, Sophie Calle, Leon Golub, Dan Graham, Richard Hamilton, Susan Hiller, Mary Kelly, Andres Serrano, Nancy Spero*, ed. Adrian Searle, 119–28. London: Institute of Contemporary Arts.

Shapiro, Gary. 1995. *Earthwards: Robert Smithson and Art After Babel*. Berkeley: University of California Press.

Sheehan, Nik. 1995. "The Infectious Glamour of General Idea." *XTRA!* (Toronto) 277, June 9: 28.

Singer, Thomas. 2004. "In the Manner of Duchamp, 1942–47: The Years of the 'Mirrorical Return.'" *Art Bulletin* 86(2): 346–69.

Smith, Bernard. 1998. *Modernism's History: A Study in Twentieth-Century Art and Ideas*. New Haven, Conn.: Yale University Press.

Smithson, Robert. 1996. *The Collected Writings*. Ed. Jack Flam. Berkeley: University of California Press.

Solomon, Larry J. 2002. "The Sounds of Silence: John Cage and 4'33"" (http://music. research.home.att.net/4min33se.htm)

Sontag, Susan. 1990. *Illness as Metaphor; and, AIDS and its metaphors*. New York: Farrar, Straus and Giroux.

Stafford, Barbara Maria, and Frances Terpak. 2001. *Devices of Wonder: From the World in a Box to Images on a Screen*. Catalogue of an exhibition held at the J. Paul Getty Museum from November 13, 2001 through Febuary 3, 2002. Los Angeles: Getty Research Institute.

Stallabrass, Julian. 2001. "Michelangelo Pistoletto." *Tate: TheArtMagazine* 25: 42–49.

Steinberg, Leo. 2000. *Encounters with Rauschenberg: (A Lavishly Illustrated Lecture)*. Houston: The Menil Collection. Chicago: University of Chicago Press.

———. 1975[1968]. *Other Criteria: Confrontations with Twentieth-Century Art*. New York: Oxford University Press.

Steiner, Peter, and Sergej Davydov. 1977. "The Biological Metaphor in Russian Formalism: The Concept of Morphology." *Sub-Stance* 16: 149–58.

Stich, Sidra. 1994. *Yves Klein*. Catalogue of an exhibition held at the Museum Ludwig, Cologne and the Kunstsammlung Nordrhein-Westfalen, Düsseldorf, Nov. 8, 1994–Jan. 8, 1995, the Hayward Gallery, London, Febuary 9–April 23, 1995, and at the Museo Nacional Centro de Arte Reina Sofia, Madrid, May 24–August 29, 1995. Stuttgart: Cantz.

Stockholder, Jessica. 2000. "Interview: Jessica Stockholder and Marc Mayer." In *First Cousin Once Removed or Cinema of Brushing Skin: Jessica Stockholder*, Marc Meyer, 9–21. Catalogue of an exhibition held at the Power Plant Contemporary Art Gallery at Harbourfront Centre, June 26–September 6, 1999. Toronto: Power Plant Contemporary Art Gallery.

Stuckey, Charles F. 1997. "Rauschenberg's Everything, Everywhere Era." In Hopps and Davidson, 30–41.

Sussman, Elisabeth. 2005. *Remote Viewing (Invented Worlds in Recent Painting and Drawing)*. Exh. Cat. New York: Whitney Museum of American Art, June 2–October 9, 2005.

Tan, Margaret Leng. 1989. "'Taking a Nap, I Pound the Rice.' Eastern influences on John Cage." In *John Cage at Seventy-Five*, eds. Richard Fleming and William Duckworth, 34–57. Lewisburg: Bucknell University Press; Toronto: Associated University Presses.

Tema Celeste. 1991–1992. Special issues on abstraction: 32–33 (Autumn) 1991; 34 (January–March) 1992; 35 (April–May) 1992.

Thiel, Wolf-Günter. 1995. "Yves Klein: Prometheus and Empedocles." *Flash Art* 28, 181: 82–5.

Thorn-Prikker, Jan. 2004. "A Mirror is the Perfect Artist. The Painter Gerhard Richter on his Abstract Art. An Interview with Jan Thorn-Prikker," n.p. Trans. Heather Moers. September. Goethe Institute. (http://www.goethe.de/kug/kue/msg/thm/en163404.htm)

Tomes, Nancy. 2000. "The Making of a Germ Panic, Then and Now." *American Journal of Public Health* 90(2): 191–8.

Tomkins, Calvin. 2003. "Flying into the Light: How James Turrell Turned a Crater into his Canvas." *New Yorker*, January 13: 62–7.

Tsai, Eugenie. 1991. *Robert Smith Unearthed: Drawings, Collages, Writings*. Catalogue of an exhibition held at the Miriam and Ira D. Wallach Art Gallery. Columbia Studies on Art; no. 4. New York: Columbia University Press.

Tupitsyn, Margarita. 2002. *Malevich and Film*. With essays by Kazimir Malevich and Victor Tupitsyn. Published on the occasion of the exhibition Malevich e o cinema, Lisbon, May 17–August 18, 2002 and Malevich y el cine at Fundacíon La Caixa, Madrid, November 20, 2002–January 19, 2003. New Haven; London: Yale University Press, in association with the Funação Centro Cultural de Belém.

Turrell, James. 2000. "On Roden Crater." In *Art in the Landscape*, 75–92. Marfa: Chinati Foundation.

Ullman, Dana. 1991. "A Condensed History of Homeopathy." Excerpted from *Discovering Homeopathy: Medicine for the 21st Century*, Berkeley, Calif.: North Atlantic Books. (http://www.healthy.net/asp/templates/article.asp?PageType=Article&ID=860)

Wald, Priscilla, Nancy Tomes, and Lisa Lynch. 2002. "Introduction: Contagion and Culture." *American Literary History* 14(4): 617–24.

Wall, Jeff. 1988. "La Melancholie de la Rue: Idyll and Monochrome in the Work of Ian Wallace 1967–82." In *Ian Wallace: Selected Works 1970–1987*, 63–75. Catalogue of an exhibition held Feb. 5–Apr. 3, 1988. Vancouver, B.C.: Vancouver Art Gallery.

Wallace, Ian. 1990. "The Idea of the University." In *Ian Wallace: The Idea of the University*, 23–32. Catalogue of an exhibition held at the UBC Fine Arts Gallery, University of British Columbia, Vancouver, February 7–March 17, 1990, Agnes Etherington Art Centre, Queen's University, Kingston, August 12–October 17, 1990. Vancouver, B.C.: UBC Fine Arts Gallery.

Wallach, Amei. 2003. "Driven to Abstraction." *ARTnews* (U.S.A.) 102(10): 148–51.

Wei, Lilly. 1987a. "Talking Abstract: Part One." *Art in America (U.S.A.)* 75(7): 80–97.

_____. 1987b. "Talking Abstract: Part Two." *Art in America (U.S.A.)* 75(12): 112–29, 171.

Weibel, Peter. 1996. "Phantom Painting. Reading Reed: Painting between Autopsy and Autoscopy." In *New Paintings for the Mirror Room and Archive in a Studio off the Courtyard by David Reed*. Catalogue of an exhibition held at the Neue Galerie Graz am Landesmuseum Joaneum. Graz: Neue Galerie Graz am Landesmuseum Joaneum. (http://www.thegalleriesatmoore.org/publications/vampirestudy/ weiben12.shtml)

Weitemeier, Hannah. 1994. *Yves Klein, 1928–1962: International Klein Blue*. Köln: Benedikt Taschen.

Welish, Marjorie. 1999. *Signifying Art: Essays on Art After 1960*. Contemporary Artists and Their Critics series. Cambridge, England; New York; Melbourne; Madrid: Cambridge University Press.

Westgeest, Helen. 1996. *Zen in the Fifties: Interaction in Art between East and West*. Zwolle: Waanders Publishers; Amstelveen: Cobra museum voor moderne kunst.

Wigley, Mark. 1993. "White-Out: Fashioning the Modern." Part 2. *Assemblage* 22 (December): 7–49.

Wittgenstein, Ludwig. 1977. *Remarks on Colour*. Ed. G. E. M. Anscombe, trans. Linda L. McAlister and Margaret Schättle. Berkeley: University of California Press.

Zero. 1973[1958 and 1961]. Reprint with introd. and English translations added. Trans. Howard Beckman. Cambridge, Mass.: MIT Press.

Zhadova, Larissa A. 1982. *Malevich: Suprematism and Revolution in Russian Art, 1910–1930*. Trans. Alexander Lieven. New York, N.Y.: Thames and Hudson.

Index